Celebrating the Seasons in Watercolor

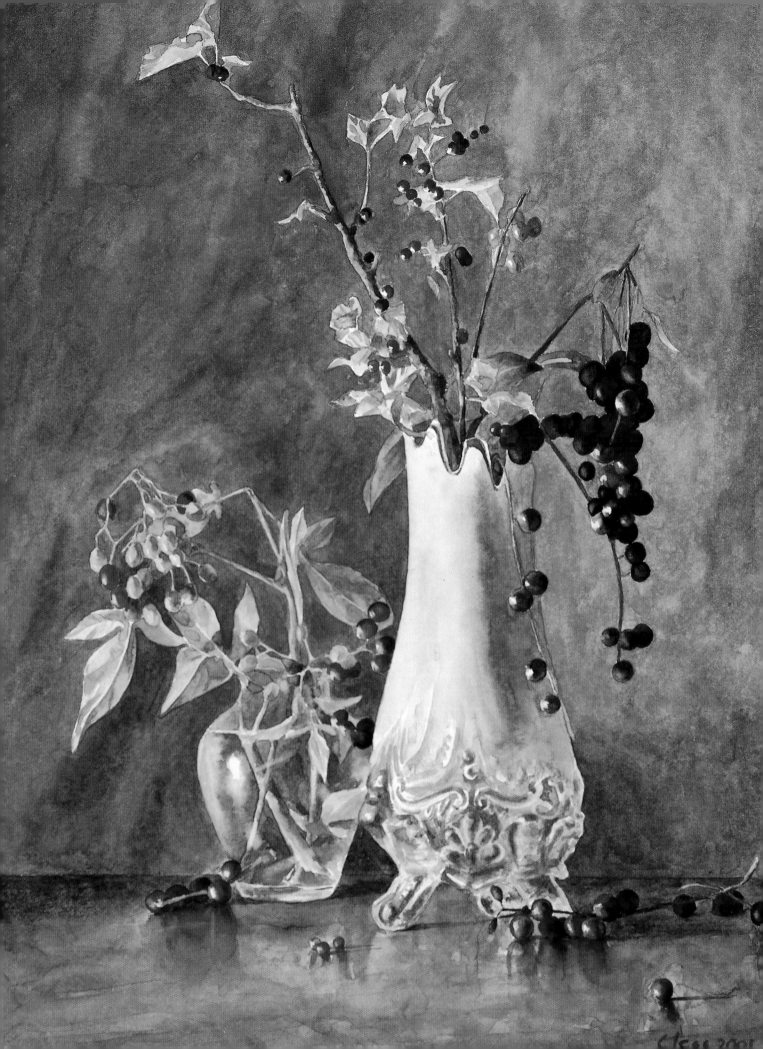

Celebrating the Seasons in watercolor

DONALD CLEGG

NORTH LIGHT BOOKS
CINCINNATI, OHIO
www.artistsnetwork.com

About the Author

Donald Clegg is a professional artist residing in Spokane, Washington. He began painting when he was 23, completely ignoring the fact that he didn't have any training at that time. He's now been at it for half his life, and somewhere along the way, he acquired the skills that people call "talent." Except for a twice-a-week class, repeated several times, Don is a self-taught painter. He taught painting and drawing for a decade at local art schools and now holds occasional workshops.

Donald has participated in over 125 juried and invitational shows, including many national exhibitions such as the Northwest Watercolor Society, the Hilton Head Art League, Watercolor USA, and the Adirondacks National Exhibition of American Watercolors. He is also a signature member of the National Watercolor Society. His work has appeared in several magazines, including features in *The Artist's Magazine*, *Southwest Art Magazine* and *Watercolor Magic*. His work is collected across the country.

In addition to his painting, Don is a longtime organic gardener and wields a deft brush in the kitchen. He shares his home with his wife, Kat, and three spoiled cats.

You can learn more about Don and see his work at **www.donaldclegg.com**.

Metric Conversion Chart

to convert	to	multiply by
Inches	Centimeters	2.54
Centimeters	Inches	0.4
Feet	Centimeters	30.5
Centimeters	Feet	0.03
Yards	Meters	0.9
Meters	Yards	1.1
Sq. Inches	Sq. Centimeters	6.45
Sq. Centimeters	Sq. Inches	0.16
Sq. Feet	Sq. Meters	0.09
Sq. Meters	Sq. Feet	10.8
Sq. Yards	Sq. Meters	0.8
Sq. Meters	Sq. Yards	1.2
Pounds	Kilograms	0.45
Kilograms	Pounds	2.2
Ounces	Grams	28.3
Grams	Ounces	0.035

Library of Congress Cataloging-in-Publication Data
Clegg, Donald
 Celebrating the seasons in watercolor / by Donald Clegg. – 1st ed.
 p. cm.
Includes index.
ISBN 1-58180-285-4 (hc.: alk.paper)
1. Still-life painting--Technique. 2. Watercolor painting--Technique. 3. Seasons in art.
I. Title
ND2290 .C57 2003
751.42'2435—dc21 2002037953

Edited by Jennifer Lepore Kardux and Bethe Ferguson
Designed by Wendy Dunning
Interior production by John Langdon
Production coordinated by Mark Griffin

From Lanell's Garden
18" × 16" (46cm × 41cm)
Private collection

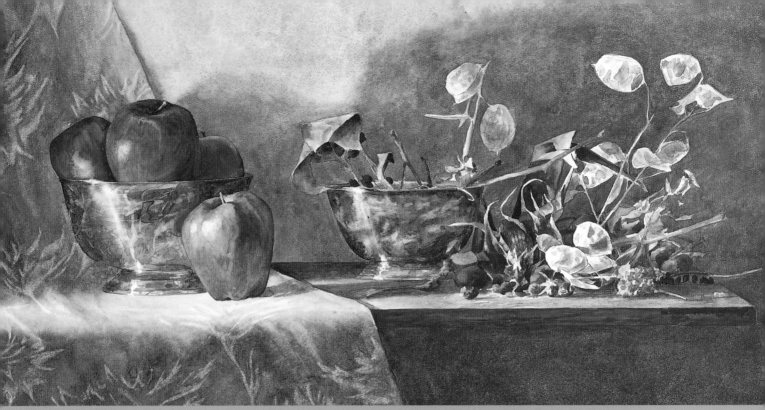

Still Life With Studio Flotsam
15" × 30" (38cm × 76cm)
Private collection

Dedication
For Kat

Acknowledgments

Without North Light's willingness to go along with my occasional forays into kitchen and garden, this book would have been less work, but less fun, too. Thanks to Rachel Wolf for proposing to include these side tips. My fine editor, Jennifer Lepore Kardux, did a great job of putting it all together, also coping well with a major computer meltdown that struck early on when I was still clueless and panicking over lost time. Thanks to Bethe Ferguson who took over the editing chores toward the conclusion, and also did a great job. Thanks to Wendy Dunning, Mark Griffin and John Langdon, who turned loose copy and graphics into a real book.

This is my first book, and my inclination is to try to mention everyone who's ever helped me in my art. That's impossible, of course, so I hope those of you who have accompanied me along the way just know that you're in my thoughts. A few special thanks: Stan, for getting me started in the first place and being a good friend for so long. Mason, my photographer, who took the large format shots for the book and loaned me his old photofloods for my personal use for the duration. Penny, for being a good "e-buddy," talking back and forth as we both worked on books for North Light. Thanks to Ricko on the radio, partly for promoting me shamelessly, but mostly for entertaining me for years as I've worked in my studio. Finally, and no mention can be enough, my wife, Kat, whose love, friendship, support and patience over the years have helped my art career blossom.

Table of Contents

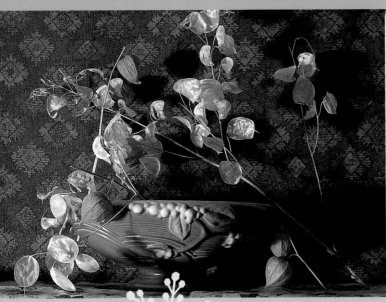

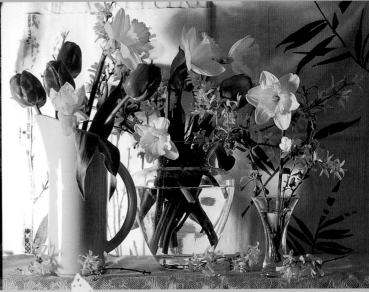

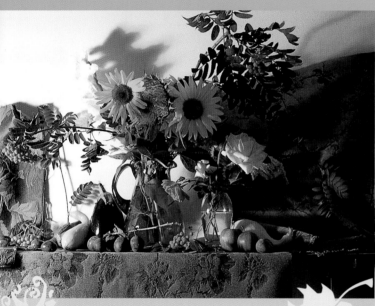
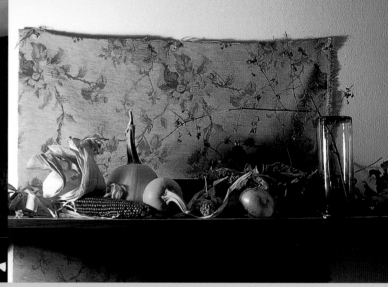

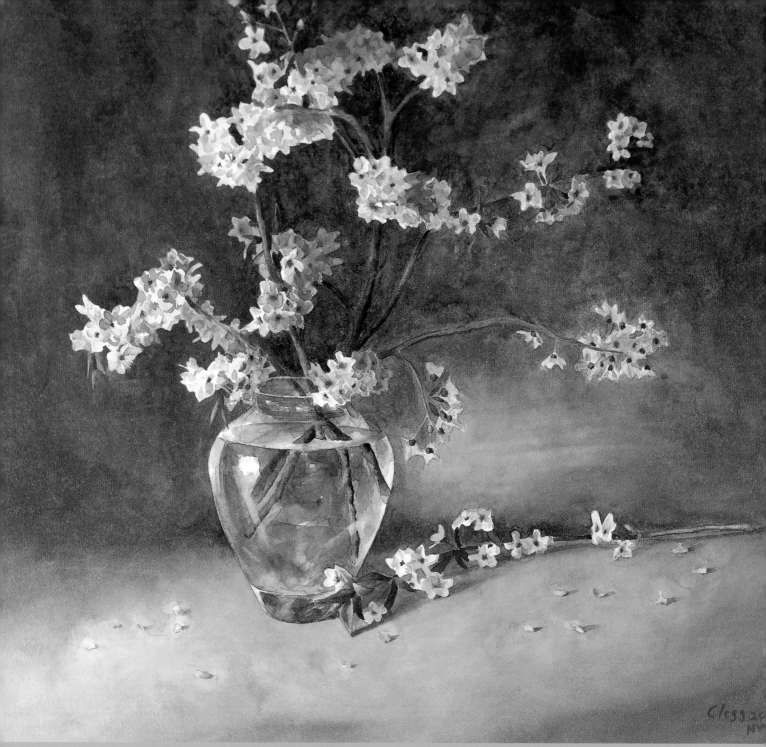

Arrangement in Pink and Gold
18" × 20" (46cm × 51cm)
Collection of the artist

Introduction

At various times—thankfully not all at once—I've been a poor cook, an inept gardener and a bad painter. But, time, study and practice have given me the skills to prepare delicious dishes, an attractive and productive garden and better paintings than I'd ever hoped for. You can learn, too.

This is a book on painting, of course, but the garden is in my still lifes, and its bounty also finds its way to our dinner table. I have a lot to say about watercolor, but am just as fond of talking about the best heirloom tomatoes or how to make my own flavorful paprika.

Art has become the chief filter through which I view life, and I attribute much of my growth in other arenas to lessons of the paintbrush.

Designing a Garden

When my wife and I bought our current home, I was excited about the prospect of growing a vegetable garden. As I learned to move from straight rows to curving, raised beds, principles of painting were as much a guide as my gardening books.

As I designed the garden from year to year, I began to think not just in terms of cukes, tomatoes and beans, but of dominant and repeated shapes. Now, I fill the beds with a pleasing pattern of flowers to complement the veggies—yellow pansies against the purple of eggplants, tall sunflowers to bring height and expanse to the space. Interplanting reduces pests, attracts beneficial critters and it's simply pretty.

Rewarding the Palate

Once I had a garden, a kitchen with real dishes and actual spices, I began to do some cooking. I have found that I enjoy it nearly as much as painting. Once again, painting made itself a home. In cooking, warm and cool hues become sweet and sour. Just as complementary colors enliven a painting, sweet caramelized onions are tastier with a generous splash of tangy vinegar. Rosemary is the cool blue against the Burnt Sienna of the dried chiles.

Celebrating the Seasons

With an opportunity to share my passions, it's as hard for me to separate painting from gardening and cooking as it is to isolate the movement of one season into another. Each has its own mood and vicissitude, its own personality, yet each is connected. Spring is garlic greens and dill, blossoms on the trees and paintings that reflect this transience. Summer is a bold season, with the grill's coals echoing summer's heat, and my palette is rewarded with its colors.

Developing Your Skills is Worth the Effort

We live in a day and age where practically everything is prepackaged and designed to save us time, as if our hours on this earth are a parking meter we hate to feed. If you make a tomato sauce from scratch, carefully adding fresh garden herbs and garlic and reducing it to a flavorful thickness, you'll need at least a two-hour meter. Getting a jar from the store requires only a minute in the loading zone.

The hours I've spent in my studio, kitchen and garden have been among the best, most fulfilling, most fruitful of my life. Does it take time to acquire the skills to paint a rapidly moving tulip from life? To maintain an organic yard and garden? To prepare a fresh-grilled gazpacho with ingredients you just harvested? You bet, and every brushstroke or bite lets you know it's been worth every minute on the meter.

I hope that you'll park in a comfortable place and spend some time sharpening your own skills. I think you can expect to see your knowledge of composition and design increase a great deal as you read and work along through this book. You'll see why a good background can make the foreground seem much stronger; how to use your colors to better effect, especially in mixing grays that enrich the other colors; how good use of the negative space in your paintings can enhance the appeal of any subject.

Along the way, I hope you also gain an appreciation for the natural beauty that surrounds us every day. I find continual inspiration for my paintings right in the backyard, and friends offer up their abundance, as well. I'm happy to return the favor with something that's ready to pick—no one turns down ripe garden tomatoes!

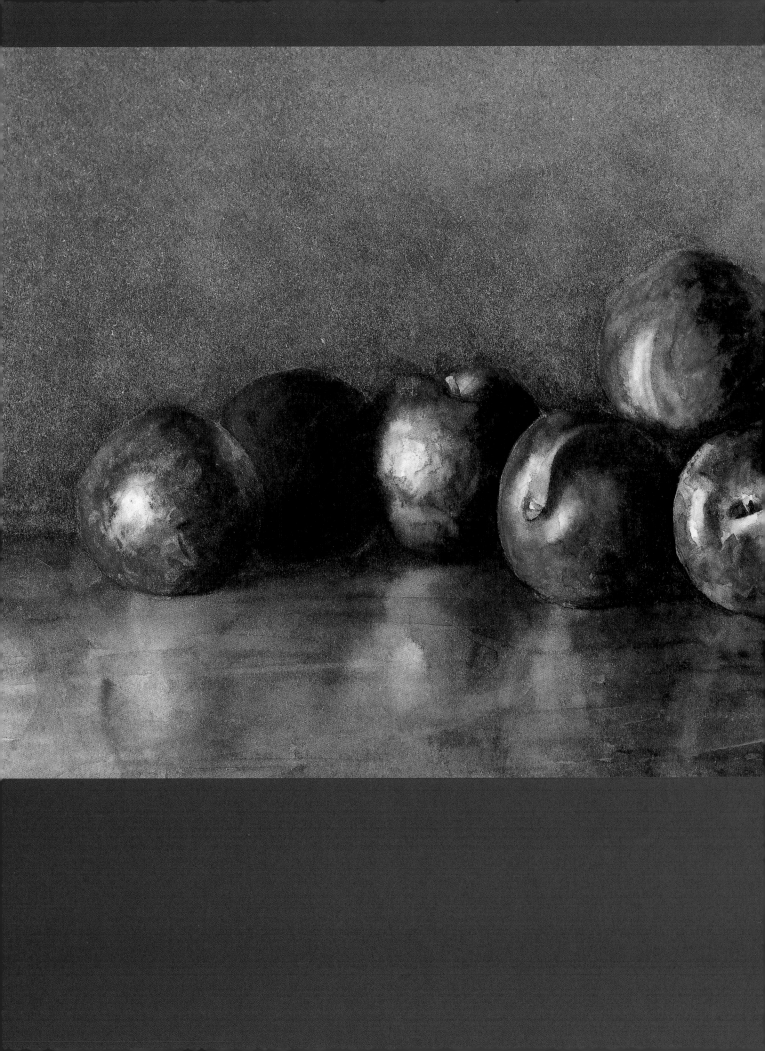

Get ready to paint

§1

For beginning painters, as well as those with a fair amount of experience, it's easy to feel intimidated by that sheet of glaring white paper staring back at you. How do you start? What to do first? What colors to use? Which brushes? These are areas of concern, but your ultimate success depends less on these technical issues and more on the framework that underlies all good art—or cooking and gardening, for that matter.

　　Some of the best work you do occurs not on paper, but between your ears. Preliminary planning—of a painting, a meal or raised garden beds—greatly increases your odds of success. You can just dive in, of course, and you might get lucky, but do you want to always depend on luck rather than skill?

　　My goal is to get you off to a good start by focusing on the foundation you'll build on. You wouldn't plant seeds without first preparing your beds, and I hope you'll never start a stir-fry without having everything chopped and ready. Take a seat, and let's see where good paintings come from.

PREPARATION IS KEY

Paintings, like gardens and good meals, require the right ingredients, preparation and time. Everyone already has time, and ingredients are easy enough to acquire: paints and paper; soil and seed; fresh food and spices.

　　Preparation is the rub, consisting as it does of two things—timing and skill. Time and study have given me the timing and skill to prepare a good meal, a productive garden and better paintings than I'd ever hoped for. You can learn, too.

Black and Red Plums
9" × 15" (23cm × 38cm)
Collection of the artist

Four Aspects of Painting
"The Three-Legged Stool"

It helps to break the process down into its constituent parts and recognize where your strengths are, as well as the areas that need improvement. Paintings have only four aspects: technique, mood, content and design. I visualize these properties as a three-legged stool; technique, mood and content are the legs, but design is the seat you sit on. If it's comfortable, even with a wobbly leg or two, you'll be fine.

TECHNIQUE
Though technique is the area most beginners understandably focus on, it's perhaps the least important. You can't avoid technique. It is there from the first brushstroke. While it may appear weak, shaky, muddy—any number of things you may not like—it's still present and will in time develop into a look that you do like.

Too much focus on technique too soon, though, can be a real weakness. If, for instance, instead of making a passage as dark as it should be, your concern is making it look like a pretty wash, the lesson is lost. Lay down that heavy, muddy black! You can always back off later, but without learning how to make really dark values, your ability to fully express what you see is limited. Keep in mind, too, that whatever your flaws might be, they are probably consistent, and that consistency is itself a unifying look. That is technique!

MOOD
Mood is a tougher topic to deal with. Since it is heavily influenced by personal experience, the moods viewers feel from a particular work can be quite different. Your painting of a rainy forest may feel peaceful to someone and depressing to someone else, while you may well have intended an entirely different mood!

You can't control how others view your work, but you can learn to critique it more successfully yourself. Everyone wants mood in his or her paintings, and when the look you are after isn't there, it's depressing. But it's worth remembering that mood can only exist in the arrangement of shapes, values, colors, and edges (and drawing, as an aspect of those areas).

If your foggy day doesn't feel very foggy, there's a good chance that the problem lies in edges. If the silver dollars in one of my arrangements don't stand out the way they do when I look at the setup, it's likely that the problem lies in values. Fix the technical problem, and lo and behold, the mood you're after suddenly emerges!

CONTENT
While most nonartists (and many artists, too) focus on subject matter as the content of a painting, the real subject might be something else entirely. For instance, though I mainly paint representational still lifes, I think light is the real content of many of my paintings. In a good painting the subject matter is simply the vehicle an artist uses to express something more personal. When you find something that interests you, figure out why you'd like to paint it and what about it most intrigues you. Once you can answer that, then you're well on your way.

DESIGN
As far as I'm concerned, design is more important than any other aspect of a painting, If placed poorly, the most exquisitely rendered subject results in an image that is hard to look at. Conversely, if a couple stool legs are shaky but the seat is comfortable, you at least have a visually interesting painting.

As I write this, I'm looking up at an old landscape I painted on location in the Swiss Alps over twenty years ago. The technique leg is a bit beat up: only adequate drawing, no color to speak of (a lot of "mud") and the handling is nothing to write home about. The content leg (meadow and mountain) has supported a million other stools. And the mood leg needs propping, too (relatively boring light). But the composition is just fine, and I still enjoy the painting, despite its other flaws.

When all is said and done, paintings are simply shapes, values, edges and colors. The good news is that you can use basic design principles (as explained on the the next few pages) that will help you make good compositions from the start.

Windfalls With Autumn Berries
16½" × 14½" (42cm × 37cm)
Private collection

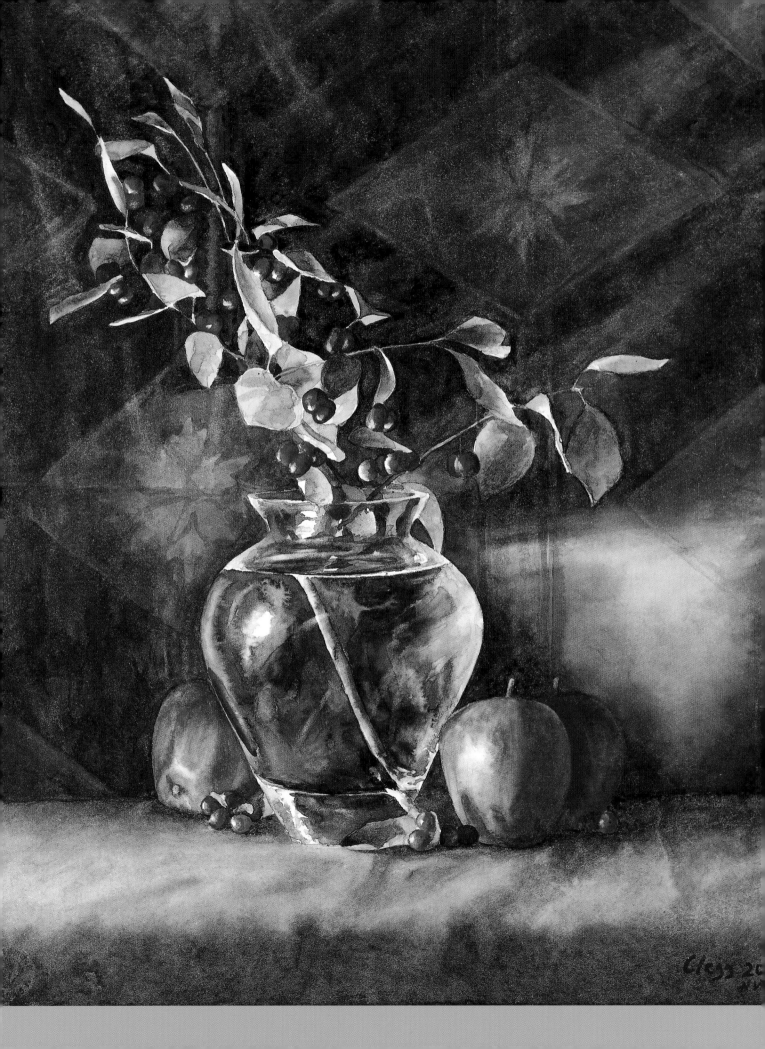

Painting
Ingredients

Everyone has, or develops, preferences. For my working methods, the tools in this book serve me well.

Whatever supplies you decide to use, be especially careful to buy quality paper, paint and brushes. Without quality products, a good watercolor painting is almost impossible. Avoid student-grade supplies; the results they give you aren't worth the money you save.

PAINT

All of the pigments I use are rated ASTM Class One. These are the most permanent pigments available. I see no reason to paint with color that will disappear in a few weeks or a few years.

While there are many reliable paint manufacturers, I primarily choose to use colors by Daniel Smith, M. Graham & Co. and Holbein. These brands are reasonably priced and provide the colors that work for me.

I choose to mix all my own greens and grays from the pigments already on my palette. This keeps my colors harmonious and natural.

PALETTE

I've used the same John Pike palette for over twenty years. (I think the available design is a little different now.) It has twenty wells and a cover that keeps paints moist and serves as an extra mixing area. I double up colors in some wells, and I try to keep a couple empty in case I'm trying out a new pigment or two. This palette is tough, too—I've stepped on mine more than once while painting on location.

PAPER

There are so many different watercolor papers, it's tough to choose. For me, the ideal paper requires no stretching, is tough enough to withstand scrubbing if necessary and has a surface that accommodates my brushwork. Strathmore Aquarius II is my preferred paper. Though only 80-lb. (170gsm), it needs no stretching and is very tough. This paper is ideal for simulating a variety of textural effects, from the hard glint of light on a silver bowl to the soft textures of fur or cloth. Its surface is tough enough to allow a great deal of scrubbing and working over, which in turn raises the nap of the paper sufficiently to suggest textures hard to achieve with straight brushwork. It comes in the standard 22" × 30" (56cm × 76cm) sheets.

BRUSHES

Quality brushes are essential, but you don't have to buy Kolinsky sables. Though I use sables almost exclusively (I don't use masking fluid in my work, so I require precise control of edges, and nothing handles better than a high-quality Kolinsky sable), synthetics are fine for most uses. I have many more brushes than I need, though it's awfully nice to be able to reach for just the right one. If I had to choose just a few brushes, I'd select nos. 4, 6 and 12 rounds; and 1- and 2-inch (25mm and 51mm) flats; plus a couple of cheap oil hog filberts for occasional scrubbing out (prevents beating up more-expensive brushes). The 44-14 series Kolinsky sables available from Daniel Smith have a subtle six-sided grip that makes them fit my hand better than any other brushes I've used, and their point, spring and paint-holding capacity are also unsurpassed. The Steve Quiller series brushes available from the Jack Richeson & Co.,Inc are good synthetic substitutes as they have awfully good spring and point for synthetics and are much, much less expensive sables.

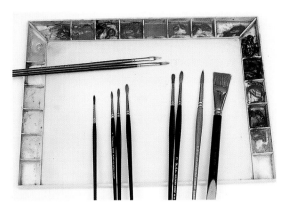

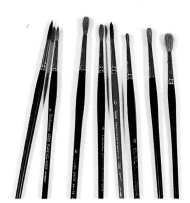

Brush Sizes

I mention specific brush sizes to use in the demonstrations in this book. Keep in mind that sizes vary from brand to brand.

All of the brushes in the image on the top right are no. 6 rounds, but look at the differences. Consider my recommendations on brush sizes as a rough guide. If in doubt, use the largest brush possible to accomplish what you need to do. This will keep you moving without being sloppy.

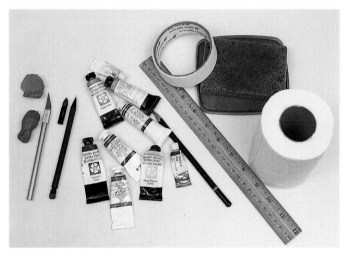

Don't Wipe Off Your Palette

As you paint a subject, your palette gradually acquires lots of different color mixes. Try not to wipe your palette until you're done with the subject, as all of the mixes you'll need are right there. Why try to re-create all the good color mixes you've already found?

Other Helpful Supplies

I like to keep the following supplies on hand as I paint:

Use a kneaded eraser to clean up pencil marks or erase line drawings. A craft knife can come in handy to scrape out small highlights. A no. 2B .5mm mechanical pencil or a no. 4B solid graphite pencil work well for line drawings. A ruler can help with proportions and straight lines. A painting board (at least 16" × 23" [41cm × 58cm] for up to half-sheet watercolors; 23" × 31"[58cm × 79cm] for full sheets) provides a strong, stable surface as you paint. Artist's tape secures your work to your painting board. You can get rid of excess paint on a brush by wiping it off on a damp, synthetic kitchen sponge. Use toilet paper or paper towels—I prefer Kleenex's Viva—to lift off color or to sop up extra water or pigment. Use a hair dryer to dry your paint between washes. Looking at your painting in a hand mirror or cropping it with L-mats will help you determine whether or not your composition works. Spraying your palette with water from a spray bottle keeps your colors juicy, and spraying your painting surface gets the surface ready for a wet-on-wet wash. Two one-quart water containers will hold ample supplies of clean water for your brushes. A sketchbook or blank notebook allow you to keep track of ideas as you go.

Learn What Your Colors Can Do

There are no quick shortcuts to mixing the right color; experience is the best teacher. However, since my goal is mainly to accurately re-create the colors I see in my subject, I'm not too concerned with various color theories—triads, split-complementaries, etc. For successful results, just keep it simple: Arrange a pleasing and harmonious composition, and paint the colors you see. Here are some tips:

When in doubt, figure out what color it is *not*. By deciding a color is not in the family of reds, for instance, you eliminate a huge group of possible colors.

Figure out if the color is warm or cool. When you try to figure out the comparative warmth or coolness of a color, keep in mind that it takes two to tango! That is, warm and cool are relational qualities. It's hard to say for sure that a color is warm or cool without comparing it to another. For instance, if it's a purple, is there more red (warm) or blue (cool) in the mix?

Keep in mind that most subjects, if naturalistically rendered, are not pure primaries or secondaries. The colors usually contain some of their complements; that is, they are grayed out to some degree. If an orange is too bright, add some of its complement, blue. On the color wheel, whatever is directly opposite a hue is its complement.

Temperature is Not Always Clear

Look at the red and green. It's clear that both are warmer than the blue mix of Indian Red and Carbazole Violet, but is the red warmer than the green?

Red is supposed to be warmer than green, but here is a cool red (Indian Red) cooled further with Carbazole Violet. The mix of Phthalo Blue, Gamboge and Quinacridone Gold creates a slightly warm green. Is the red or the green warmer? Personally, I have a hard time saying.

Indian Red/
Carbazole Violet

Phthalo Blue/Gamboge/
Quinacridone Gold

Indian Red/
Carbazole Violet

GRADED WASH

Throughout the demonstrations in this book, I mention the need for a wash that changes color as you move across the surface. I call this type of wash a "graded wash." Here you can see that the upper wash moves gradually from color to color. This allows you to pick out a particular color as you need it, rather than needing another mix. The lower puddle shows these same colors equally mixed. There are certainly uses for such flat washes, but shifts in hue and temperature add appeal to your work.

KEEP A SWATCH DIARY

Mixing your colors in various combinations can teach you a lot, but you won't always remember what combination of pigments was required to get the color you're after. Keeping swatches of mixtures in a small watercolor sketchbook can be a big help. Once you know how you mix your colors, you can decide whether to keep a color in your palette or not.

For instance, all of the earth colors can be easily mixed from purer hues, but some colors can't be made by mixing. For example, you can mix an approximation of a quinacridone color, but you will not be able to achieve the clean, intense hue of pure quinacridone.

WHAT COLOR IS IT?

Can't figure out what that color is? When all else fails, make a little viewer with your fingers or with L-mats. The hole you look through should be only about a ¼-inch (6mm) square. Focus on the area of color that's confusing you and then move the viewer to a color area that's clearly different (preferably a color you do know). The difference between the two areas of color should help you make a more accurate decision.

PURE COLOR
Yellow Ochre

MIXED COLOR
Cadmium Yellow Light, Cadmium Red Light, and just a little Carbazole Violet combine to make a Yellow Ochre hue.

PURE COLOR
Burnt Sienna

MIXED COLOR
Cadmium Yellow Light, Cadmium Red, and a little Ultramarine Blue combine to make a Burnt Sienna hue.

PURE COLOR
Quinacridone Red

MIXED COLOR
Cadmium Red mixed with Gamboge is close to the Quinacridone Red but a little earthier.

PURE COLOR
Quinacridone Violet

MIXED COLOR
Mixing Quinacridone Red with Carbazole Violet doesn't come close to capturing Quinacridone Violet's bright purple.

Find the
Right Light

A still-life setup that holds no interest under normal light becomes radiant when you close the blinds and shine a small lamp on the arrangement.

In order to bring life to your work, you must understand the relationship between light and shadow. An object bathed in light from all sides is nondescript, with poorly defined internal transitions. However, move the main light source to one side and you will create light and shadow planes that are easy to see, and have visual appeal. Even if the light is soft, if it's from one direction, these transitions are still visible.

LIGHTING YOUR STILL LIFE

If you live in a sunny house, you might have so much light coming in that it bounces around from all directions. In these instances, seeing light and shadow planes on your arrangement can be nearly impossible.

Try arranging your still life inside a deep box and lighting it from one side with a small lamp. This won't eliminate all light coming in, but it will at least give you a dominant light source and easier-to-read light and shadows on your subject matter.

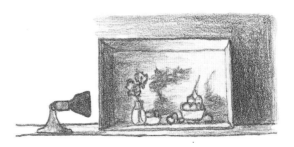

18

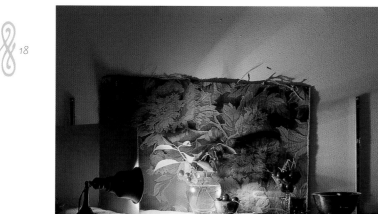

My Lighting Setup
This is a typical arrangement on the shelf where I arrange my subject matter.

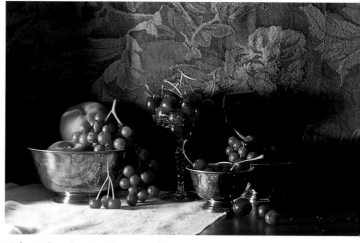

Light Makes the Mood
I blocked the light coming from the left of the arrangement, giving a quieter mood and plenty of interesting lost and found edges. The addition of a brocade cloth adds movement to the large negative shape above the foreground objects, and its green is a nice complement to the reds of the cherries and grapes.

Look at these other areas I have created by directing the light: The light cloth is reflected in the silver bowls, helping them to stand out from the dark background. The reflected cherries and grapes provide a repeat of the larger shapes they echo, as well as abstract interest. The large cluster of grapes is echoed by a smaller one, and the same is true of the cherries. The patterned cloth complements the foreground shapes, especially the stems of the grapes and cherries.

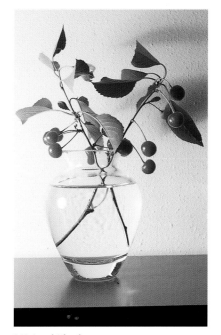

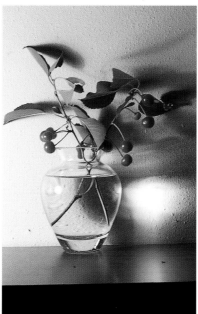

Minimal Shadows
An arrangement with no light and shadow has no character and little definition.

Accentuate the Light and Shadow
Moving the vase closer to the wall creates an interesting pattern of light and shadow.

Add Accents
To accent an edge normally in the light, place a piece of cardboard or mat board in front of your lamp and move it until you see the pattern you're after.

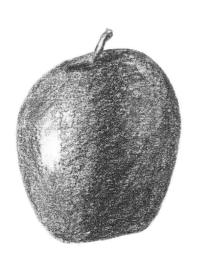

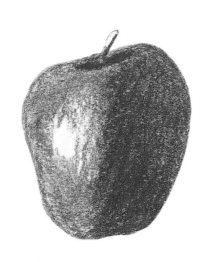

Modeling Three-Dimensional Form
If a value rests on the lighter plane it should be lighter than the values in the shadow. The darkest value on the light side of an object should be lighter than the lightest value on the dark side of the object. Reflected light is sometimes an exception, but this rule applies under most circumstances.

Look at the apple on the left The closeness of these values is confusing, and the apple feels flat. You cannot tell which side is lit and which is in shadow because the light value on the shadow side is the same as that on the lit side. Now, look at the apple on the right. Here the lighter and darker values clearly belong to separate planes, allowing the apple to turn as you move to the shadow side.

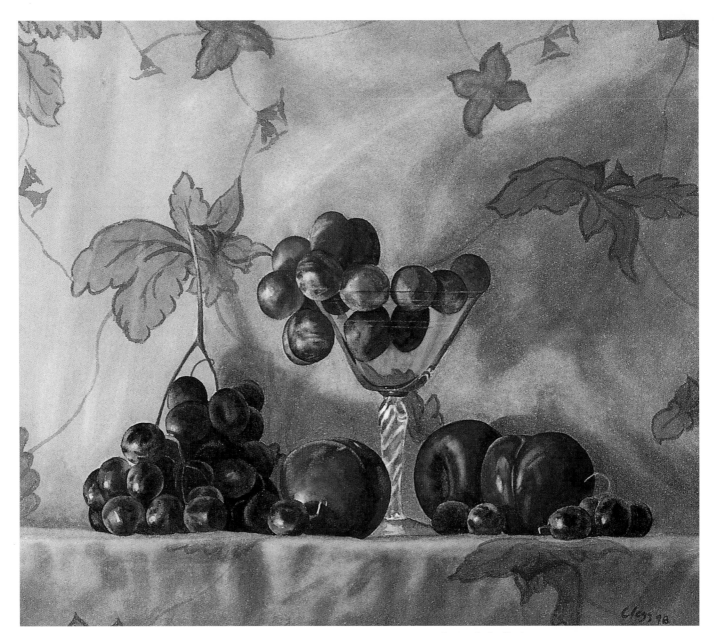

Choose a
Background

There are three basic types of backgrounds as illustrated here (realistic, abstract and "foreground"). As you arrange your composition, try to decide which style best suits the mood you're after. Consider how the foreground and background elements relate and the relative importance of each.

The Realistic Illusion
Occasionally I arrange a background that just begs to be painted as it is. In these cases, the background (the folds of the cloth, for instance) does such a nice job of complementing the foreground that my job is simply to re-create what's before me. Despite the additional work it might require to make the background feel real, this is probably the easiest type of background to paint. If it looks good in front of me and I paint it well, I don't have to worry about anything else!

Arrangement in Black, Ochre and Red
14" × 16" (36cm × 41cm)
Private collection

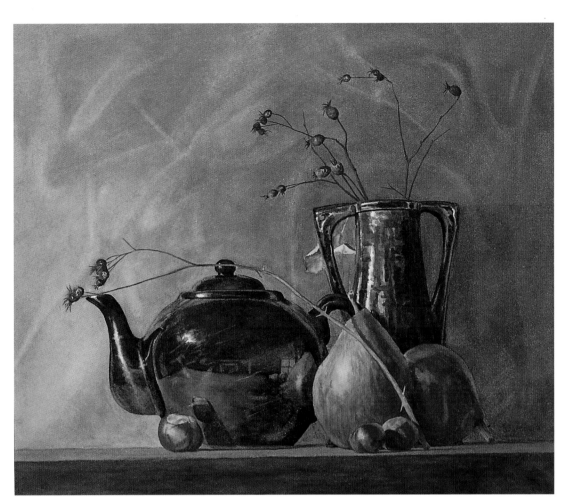

Abstract Imagery

Though I'm a realistic painter, I don't always care if my backgrounds look real. Sometimes it's enough to just think in terms of the abstract design of a background. Cast shadows, for instance, may be placed simply to look good compositionally; in my arrangement they may actually look quite different. A cloth backdrop need not always be clearly defined to be effective.

Arrangement in Blue, Red and Green
15" × 17" (38cm × 43cm)
Private collection

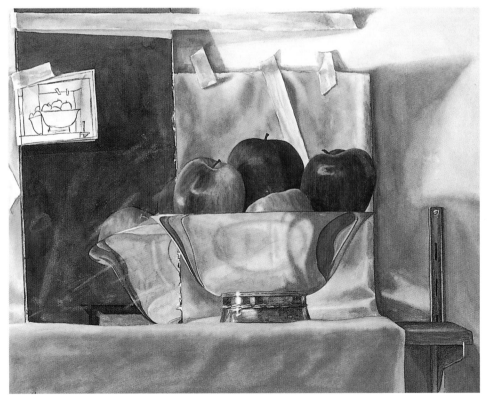

"Foreground" Backgrounds

In this type of background, the ordinary order of things is reversed, and the background is made to be just as important, or more so, than the foreground objects. While there are a variety of ways to achieve this, I most often do so by showing my arrangement as it actually is. For example, if I have a cloth taped to the wall, I include the pieces of tape and the edge of the cloth in the painting. The painting becomes a comment on the process of painting itself, and the background becomes the focus of your attention.

Arranging a Still Life, #3
17" × 22" (43cm × 56cm)
Private collection

Work With
Fabric Backdrops

Cloths, patterned or otherwise, usually serve as only rough guides to use as the needs of my painting dictate. Though I alter my foreground objects as needed, most visitors to my studio wouldn't notice my small departures. They would no doubt observe huge changes, though, from the cloth actually hanging behind or lying under my still-life arrangement and what I've actually painted.

Think of a cloth as something to support your painting, not dominate it—unless, of course, the cloth itself is your real subject. In general, though, there's more there than you need.

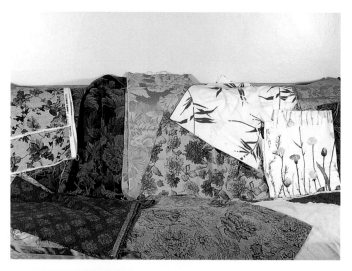

Organic Appeal

Since most of my paintings include a garden theme of some sort, the cloths I favor echo that motif, although some have no pattern at all. The one on the lower left, with its geometric pattern, is somewhat of an anomaly.

When I arranged them on our futon, it was something of a surprise to me to see how "quiet" most of them are. I think this probably shows my preference to complement, not overwhelm, my foreground subjects. I have painted really bright, primary color backdrops, but they've usually felt a bit jarring to me, even when they're effectively handled.

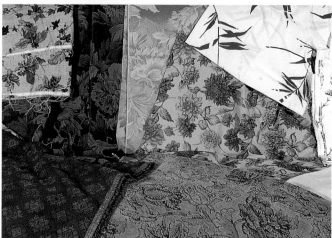

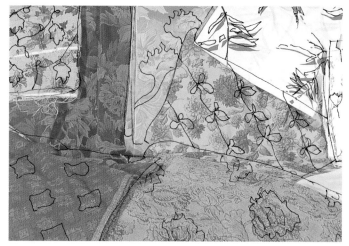

Pick and Choose Your Background Patterns

From this close-up, you can see how dominant the pattern is in most fabric designs, with relatively little "relief" area of blank cloth. There is a variety of ways you can make a pattern work to your benefit. The easiest, I think, is to find an element that you like and use it, leaving out the rest, and place it wherever best suits your composition.

The Disappearing Pattern

Here are some solutions to busy patterns. On the upper left, I took one cluster from the pattern and used it throughout, linked by the branches and leaves. Below that, I ignored the pattern altogether and simplified it into a geometric pattern by spacing the diamonds further apart. The purple bamboo-patterned cloth is one of the few I've actually painted pretty much as is.

Look at these patterns and think of the various rhythms they offer. For instance, the repeating diagonal of branches and leaves near the center has a different feel from the one on the upper left, though the idea is similar.

Many fabrics have several appealing designs within them, so you might consider selecting and using a dominant element for one painting and something else from the same cloth for another. With a little imagination you can get a lot of mileage out of a few cloths!

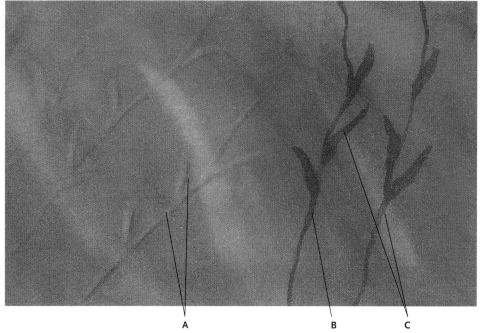

Negative and Positive Approaches

You should also consider which approach, or combination of approaches, best achieves the look you're after. Both adding and lifting color can work equally well.

A Lift the pattern, then add color to the shadow side to make a brocade.

B Paint the pattern over the lighter cloth, and leave it flat.

C Lift paint to make the raised folds. This also lifts color from the pattern, making it "sit down" on the cloth rather than float over the top.

DESIGNING WITH CLOTH

Place it at an angle. Use the exposed edge to repeat other diagonals in the foreground.

Think color. Collect cloths of many hues. You never know when they will be just the right accent for your foreground subject.

Combine cloths. More than one can be used to create an interesting mosaic of color and pattern.

Crumple it. Just drop a cloth on your shelf or table and see if the resulting folds and shadows are interesting enough to support the foreground.

Use your imagination. Maybe just one small portion of the pattern is interesting. Use that as needed, and ignore the rest!

Practice Re-creating a Brocade Pattern

Paint a heavy wash as your foundation, then use a darker color to paint negative shapes around the brocade pattern. Add texture with a wash of clear water, then develop the details in the fabric by lifting the paint and softening color and edges with washes of clear water or light applications of paint.

23

It's Helpful to Think Abstractly

I occasionally like to pay tribute to artists whose work I admire, and here the challenge was to fit the white card (William Paxton's *The Waitress*) into the composition and keep it from sticking out like a sore thumb. I chose other elements to complement the shapes, values and edges of the card. Even though I'm a realist, while I'm painting, my concerns are almost entirely abstract. It didn't occur to me until halfway through the painting that the teacup related to the teapot in any other way than shape!

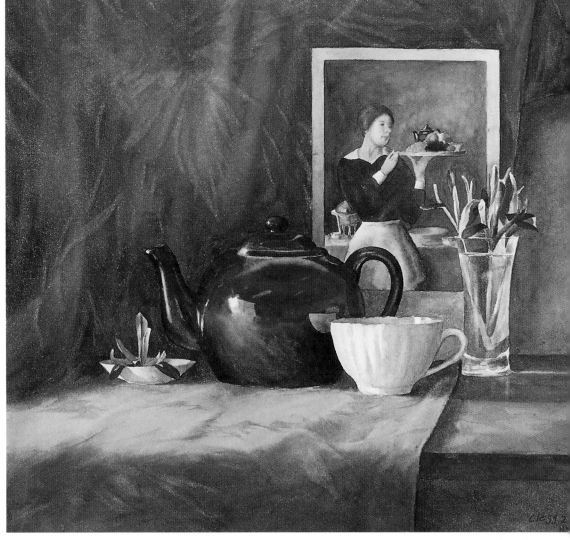

The Waitress
17" × 18" (43cm × 46cm)
Collection of the artist

Composition
Fundamentals of Good Painting

If you study the topic of composition you can find all kinds of rules for designing a painting. Applied slavishly, they seem to me to be the equivalent of giving you a fish rather than teaching you how to fish yourself, so I'm going to avoid them as much as possible. However, if I had to state just one rule, it might go something like this:

Take a look around you, and you'll see this rule applied everywhere. Salad forks are smaller than dinner forks and dinner plates are larger than salad plates. That's unbalanced repetition, and you'll see it everywhere! A word of warning, though, once you start to recognize good design you'll also be more sensitive to bad design. Unfortunately, that's also all around.

Good designs are built upon the unbalanced repetition of well-placed shapes.

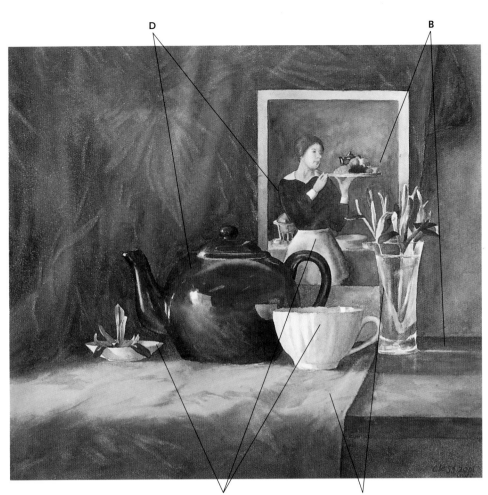

D

B

A

C

Everything in Its Place

Always be on the lookout for ways to complement the dominant shapes in your painting. Your eye is delighted by the repetitions, even if you don't consciously recognize all of them.

A The white apron and cup have similar folds and relate to the small, accenting butter dish.

B The shelf is also a rectangular shape and repeats the brown background behind the figure.

C The green stems repeat the green cloth and also echo the pattern's design, as do the irises.

D Though different colors, the values of the teapot and the waitress's uniform are similar.

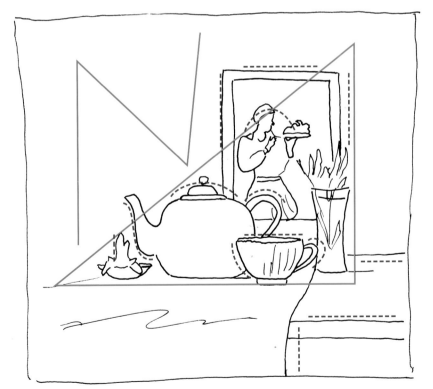

Provide Supporting Elements

The basic structure of the painting is a large right triangle. The negative space of the patterned cloth provides a restful complement to the main mass, but the folds also create echoing triangular shapes. You can see that a large variety of straight lines and curves balance one another—the round top of the teapot repeating the head and shoulders of the young woman, for instance. I think the eye enters at the card, but you can also make an argument for the left edge of the cup, where the hardest edge and darkest value meet. From there, my eye makes a clockwise trip, venturing occasionally into the cloth and out along the shelf. The hard edge of the lower-right side of the cloth is an important "arrow," repeating the card's edge and providing a reason to move into the lower horizontal rectangle of the cloth. More important, though, is the relatively small shape of the butter dish and iris. They provide an important balance to their counterparts on the right.

Composition
Before and After

Something I frequently hear is, "Oh, watercolor is so tough, and you can't make changes." I can't deny the difficulty of the medium (it's worth the trouble to learn though!), but you absolutely can make changes. Many of the approaches I now regularly use came at one time from desperation—trying to fix a bad painting.

At various times I've taken sandpaper, a razor blade or the sharp edge of my brush to paintings. I've put them on the ground and kicked and scuffed 'em with my shoes. I've rubbed the surface with a sponge or paper towel or the palm of my hand. I've even taken paintings outside and turned a garden hose on them!

From all this I know that you *can* make changes. When a good painting goes bad, don't hesitate to do whatever it takes to try and save it. If it's already bad you have nothing to lose, and as time goes by you'll learn the most effective ways to modify it. You may not even need your garden hose!

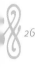

Crop to Fix a Bad Idea
All artists have experienced that sinking feeling when a good design starts looking suspiciously like a stinker. I started this vase as a visual complement to the oak leaves. However, as the painting went along, problems arose in the the most important area of the painting, the seat. These were among the most noticeable: The vertical bands of dark and light were boring—too much the same size and shape; neither of the leaves was dominant, as each fought for attention; the leaves on the vase didn't read right.

I kept looking at a smaller section of the painting, which had some good qualities. Giving up the larger idea made me focus on the real area of interest—the leaves themselves—and crop the irrelevant space. Of course, it's best to avoid this situation altogether, but no one's perfect!

Oak Leaves (Before)

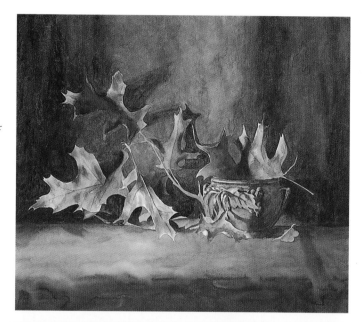

Simple Power
You can see in this final version that I not only cropped the image, but I dramatically altered the background. Dominant and secondary areas of interest are clearly stated. Lost and found edges add an element of mystery and integrate the leaves with the background. When you squint your eyes, the leaf largely disappears—otherwise it would appear to be somewhat awkwardly placed. As it is, I like the challenging element it adds to the design. I decided the light on the leaves, along with their crisp edges, were the qualities I wanted to shine.

Oak Leaves (After)
8" × 10" (20cm × 25cm)
Private collection

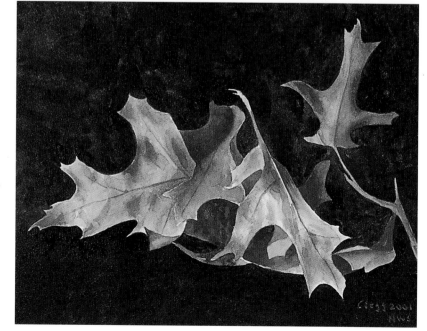

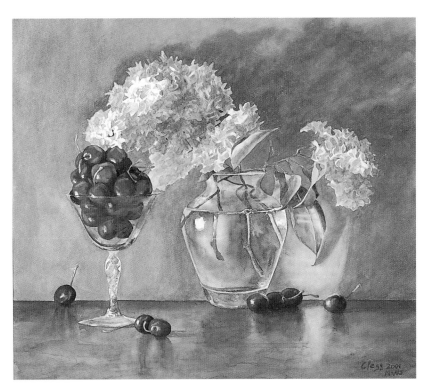

Change Your Plan

When I initially designed this painting, I thought that the activity in the foreground, especially in the clusters of lilac petals, warranted a relatively quiet background. I actually finished the painting that way and sent it for framing. However, when I picked it up, I was no longer sure. Within a few days I decided that the background was just plain boring, and I took it out of the frame to work on it. I began to tackle the big issues: This light area—along the top right, above the lilac's shadows—feels isolated and stands out too much drawing the viewer's eye there more than it should; the values and color temperature throughout the shadow areas are all the same; from top to bottom, the left side of the painting is also too much the same color and value.

White Lilacs & Cherries (Before)

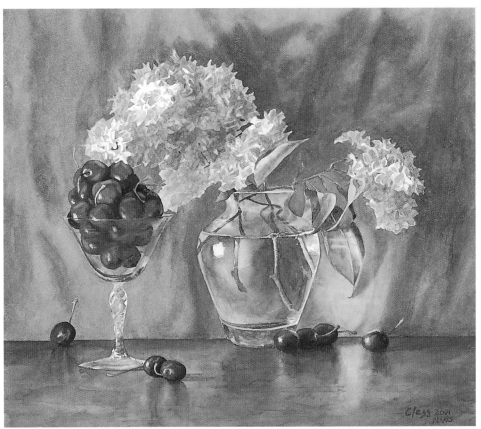

A Good Background Supports the Foreground

My thought process for background changes was primarily abstract. I wanted to simply paint curves and angles that echoed the dominant shapes in the foreground. It was a relatively simple matter to make those areas look like cloth, having painted it so often before.

The area above the shadows—in the top right—now enhances the shadows, and its lighter value relates to the light area to the right of the vase. The fold angles echo the shapes of the glass, the vase, and the triangular light area to the right of the vase. The lighter areas within the shadow now add depth and interest. I made all of the folds repeat the curving shapes of the foreground and provide additional movement through a large, flat expanse. I also added light by lifting color above the shadow area, making the entire painting more dynamic. These changes helped the design immensely.

White Lilacs & Cherries (After)
14" × 16" (36cm × 41cm)
Collection of the artist

Composition
Breaking the Rules

As a general rule, the recommendation against centered objects is a good warning, but it shouldn't prevent you from giving it a try—there are many ways to succeed. These days I don't even worry about arranging designs that "shouldn't" work. I just figure out what will unbalance the composition enough to provide movement away from the center.

One detail in this painting, as it's pictured here, still bothers me. Notice how a few of the patina marks in the center of the bowl make eyes and a mouth? Once I saw that (after the painting had been photographed, unfortunately) I couldn't help looking there. I took the painting out of the frame and, with a few smudges of a wet thumb, wiped out the "face."

Arrangement in Purple, Orange and Ochre
14" × 16" (36cm × 41cm)
Private collection

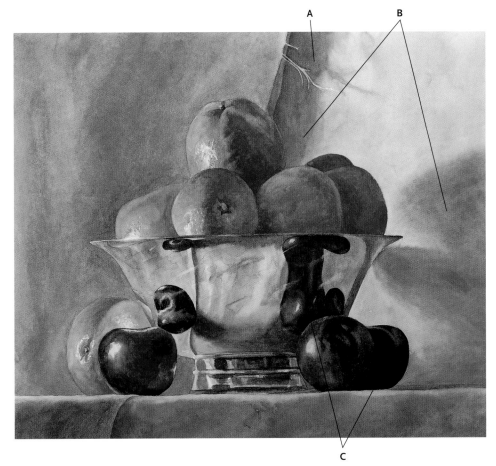

Design Details

Even though you might initially think this design doesn't work, because it's too centered, but take a closer look and I think you'll find that it does work.

A This design is almost literally hanging by a thread. Cover it with your thumb and you'll see what an important directional pointer it is.

B Even though the negative space on either side of the bowl is essentially the same, these shadows break up the right side, creating smaller negative shapes that provide interest.

C Close values and lost edges provide movement from the oranges through the plums, keeping your eye from being stuck inside the bowl.

A Solution in Silver

One of the most appealing things to me about polished silver vessels is the chameleonlike way they take on their surroundings. As you can see, the reflection of the cloth's edge carries the eye through the bowl. Without that element, the breakup of space above and below the bowl would be insufficient; you'd stay trapped in the bowl.

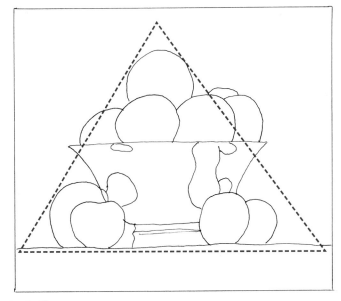

Static Shapes

It's clear here just how important the cloth is. Without it, the shapes form an equilateral triangle, with the orange at the top being smack in the middle. There's virtually no reason to look to either side of the painting, since the negative shapes are identical, and the horizontal rectangle is equally boring—one long, unbroken passage.

Winter offers a chance to look for the appeal in
unusual subjects: dried flowers, silver dollars,
rosehips, even the leftover clamshells from a tasty
cioppino are worth a closer look.

Rev up your spring painting motor with the elusive
look of cherry blossoms, perky pansies or dusky
tulips. Subjects like these teach you to work fast.

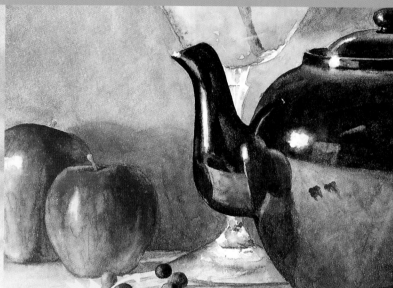

If it's too hot, cool your jets with a cold gazpacho

from your garden. Grill the veggies for extra flavor,

and use plenty of fresh tomatoes and basil. Enjoy

it while studying the sunflowers you'll paint

tomorrow!

There's no season like autumn: picking pumpkins

and squash, canning dilled beans, pickles and green

tomatillo salsa. Autumn provides my favorite

subjects for painting and great meals from the

garden. I wish it'd last forever.

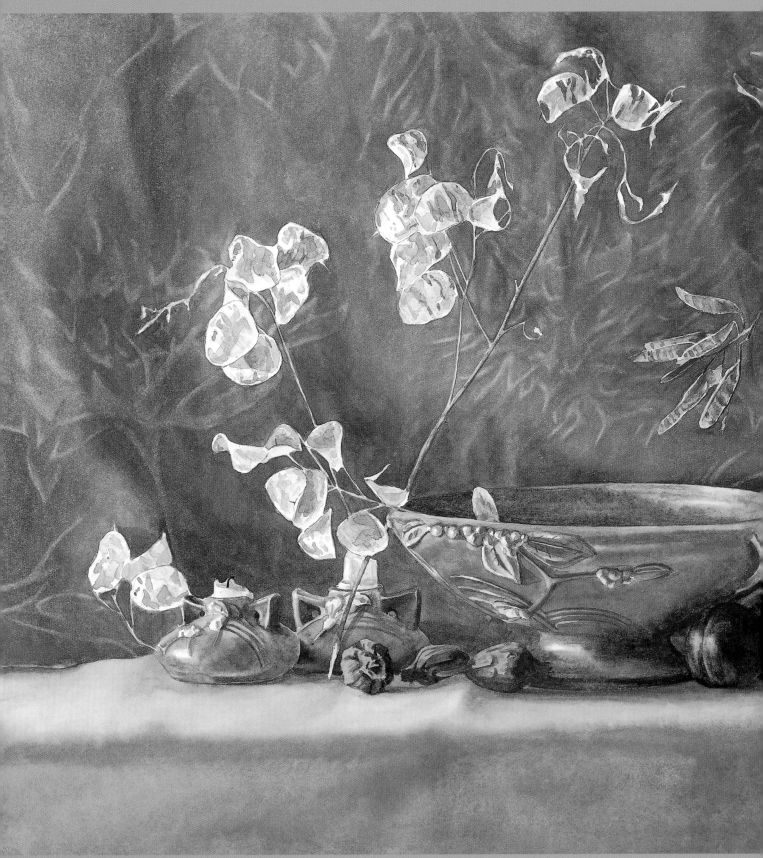

Arrangement in Ochre, Green and Sienna
22" × 30" (56cm × 76cm)
Private collection

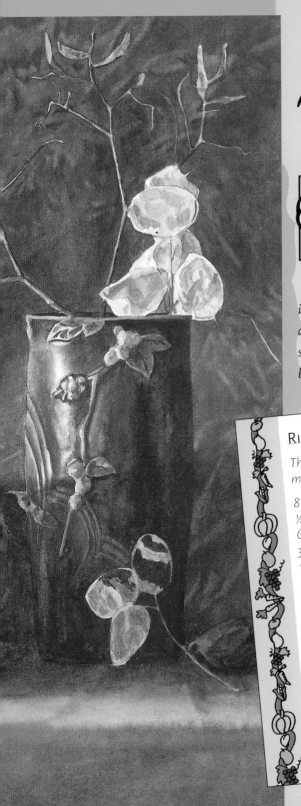

Winter

I've always lived in a four-season territory, and I appreciate the change of pace winter brings, as well as the beauty of the season. True, it's cold going when I grill steaks outside. True, fresh snow gives way to brown slush and ice. True, the days turn dark awfully early. But from a painter's viewpoint it's a pretty good season.

You can take the time to explore your subjects in winter, time that simply isn't there for more transient fare. And as a cook, although I miss the fresh produce from my garden, I like the way a simmering stew smells or the way baking squash warms the kitchen. And nothing smells better than fresh homemade bread!

RISOTTO WITH WILD RICE

This is a perfect winter dish, with the tomatoes bringing in the taste of a summer garden. The wild rice adds contrast and a nutty flavor.

8 dried shiitake mushrooms
½ c. (120ml) sun-dried tomatoes
6 c. (1.4 liters) chicken broth
3 T. (45ml) olive oil
1½ c. (360ml) arborio rice

¼ c. (60ml) wild rice
2 cloves garlic, minced
1 T. (15ml) balsamic vinegar
1 t. (5ml) sweet paprika
salt and pepper, to taste

Cover mushrooms and tomatoes with 2 cups water; soak overnight. Squeeze out water, reserving juices. Boil and simmer along with chicken broth.

Chop mushrooms and tomatoes. Heat 3 tablespoons olive oil in a large pot on medium-high heat. Add rices and garlic; sauté until wild rice grains pop, about 3-4 minutes. Add remaining ingredients, except the stock.

Pour in a cup of stock; stir continuously over medium heat. When bottom of pan starts to show, add more chicken stock, a ½ cup (120ml) at a time. Continue for 25 minutes. Reduce a few minutes if you like it thicker.

Serves six.

Get Cozy with a
Winter Mood

I crunch through the snow on a winter morning, taking stock of changes to our yard that are evident even in this season; the new spruces planted last year actually stand out, even though they are small. I see the ninebark bush residing happily in a corner outside my studio and remember when it was torn out of the ground and lay, roots up, for two months during the winter while my studio was being built.

Without foliage, it's easy to count the many trees and shrubs we've planted over our fifteen years here.

Even in a season that barely seems to move, these signs of change are there—you need only pay attention. In my work, though, I mainly think of stillness and quiet, and the mood reflects this spirit.

A Change of Pace

Winter makes my favorite activities more challenging. As a cook, I prefer the seasons when fresh fare is available only a few paces from my studio. As a gardener, I find that winter's lack of green and growth is kind of depressing. Painting-wise, I miss the profusion of the other seasons.

However, as if in recompense, the season does offer time for sustained study of beautiful objects that may be overlooked the rest of the year. Pottery, silver bowls and cloth backdrops all play a larger role in my work during the winter. It's only during this season that the subject matter of my still lifes really does remain "still."

Collecting for Winter

Although much of the antique pottery I like is out of my price range, I peruse shops every few months, looking for appealing pieces I may be able to afford. Silver-plated bowls—Paul Revere-style bowls are my personal favorite—are a nice, inexpensive addition to your still lifes. I keep some of mine polished, and let others tone down to a nice patina, as both looks are sometimes desirable.

I also tear through fabric shops every now and then. A painter can never have too many backdrops.

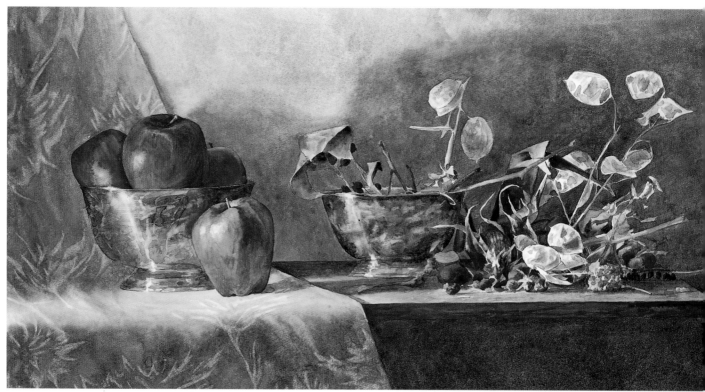

Still Life With Studio Flotsam
15" × 30" (38cm × 76cm)
Private collection

As an artist, one of the main things to take advantage of in your quest for bargains is the fact that you don't have to paint things as they are. While cracks and chips are a curse to many collectors, they're fine to use in a painting! If you can get a chipped vase you like for a cheap price, rather than its five-times higher, original price, go for it!

As you look, keep in mind, too, that design flaws can be selectively ignored. A pot with a nice shape but really strange handles might be ugly, but in your painting you can ignore the handles or change their shape. In a sense, when I go looking for subject matter, I'm visually "painting" as I search.

Finally, don't overlook your friends. People are generally tickled that you like something of theirs enough to want to paint it, and the only potential problems are the length of time you'd like to borrow it or fear of breakage. I recommend letting them know that, while you'll take all due care, you are not responsible if something happens. Not only can it drain your pocketbook, but if something is that precious, I don't even want to chance it (especially with cats as housemates).

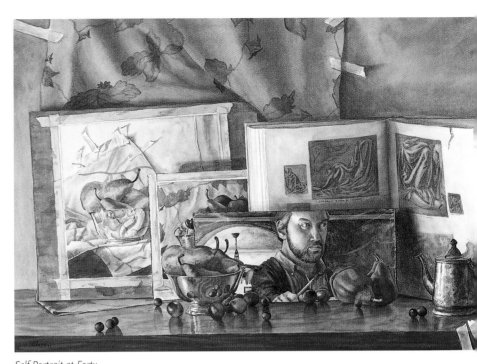

Self Portrait at Forty
16" × 24" (41cm × 61cm)
Collection of the artist

Oyster Stew

I don't do a lot of high fat cooking, but firmly believe that when you do, you might as well really go for it.

16-24 oz. (448g-672g) canned or fresh oysters
2 c. (470ml) milk
2 c. (470ml) whipping cream
6 oz. (168g) bacon, fried, drained, torn small
1 medium sweet onion, finely chopped
½ stick unsalted butter

¼ c. (60ml) cream sherry
1 T. (15ml) dried tarragon
1 T. (15ml) Old Bay Seasoning
½ t. (3ml) Old Bay Seasoning
salt & fresh-cracked pepper, to taste
4-12 dashes Tabasco, to taste

Fry bacon in a large saucepan. In same pan, melt butter, add onion and cover.

Cook over medium, stirring occasionally, about fifteen minutes.

Add cream sherry, stir and reduce for two minutes, then add oyster liquor and all other ingredients, except the oysters.

Bring to a simmer, 10-15 minutes, being careful not to boil. Add oysters and simmer another 2-3 minutes, until oysters are barely firm. Adjust seasonings and serve immediately.

Serves six.

Choose a
Winter Color Palette

When the yard and garden are covered with a blanket of snow, the trees are bare, and there's nary a flower to be seen, it's easy to see the world all in gray—and the connotation is depressing. Winters where I live are often long, and the normally reliable sun seems to have gone on a trip to some warmer clime.

A glance out my studio window seems to confirm this vision. Unless I look closer, I may miss the quiet red-orange of the upper branches of a Linden, or the way a subdued red still brings warmth to the bark of a ponderosa pine.

It would be a mistake to consign all of nature's grays to winter, but it might be the appropriate season for us to take stock of them—maybe with chicken soup simmering on the stove. Tarragon and sage, comforting whiffs of the garden, scent the soup and the air.

WHAT IS GRAY?

To an artist, the word *gray* means something different than the color of a sidewalk. A gray is any color mixed with its complement. For instance, Cadmium Orange and Cobalt Blue are close to pure complements. Add a little Gamboge, though, and you tilt the orange toward yellow, requiring a blue leaning more to purple to complement it. Ultramarine Blue would then be the choice. If you take two perfect complements and mix them until neither color can be detected, you have made a "neutral gray." It's useful to know how to mix neutrals, even though unbalanced grays are more exciting. Once you learn your complements well enough to mix good neutrals, you can then lean them in more desirable directions.

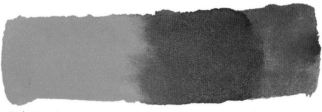

Cadmium Orange Cobalt Blue

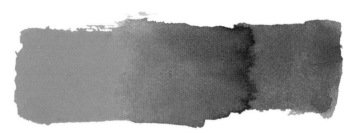

Cadmium Orange Cobalt Blue

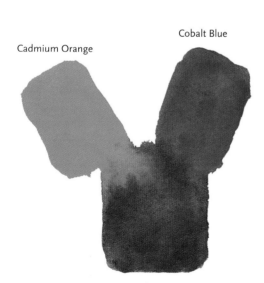

Cadmium Orange

Cobalt Blue

Practice Mixing a Neutral Gray
Cadmium Orange and Cobalt Blue combine to make a nice neutral. Don't worry if your swatches aren't "pretty." Just keep adding blue or orange until neither one seems to dominate the mix.

Practice Mixing Orange-Gray and Blue-Gray
Let the orange dominate one mix, and blue dominate the other. You will create a gray clearly leaning toward either orange or blue.

Cadmium Orange Cobalt Blue

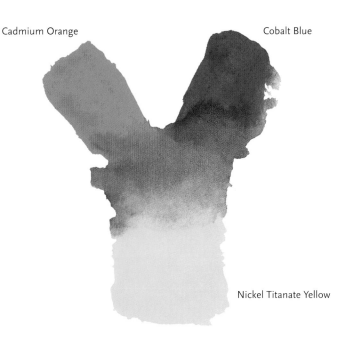

Nickel Titanate Yellow

Cadmium Orange (middle)
Cadmium Orange and Cobalt Blue
(outer)

Cobalt Blue (middle)
Cadmium Orange and Cobalt Blue
(outer)

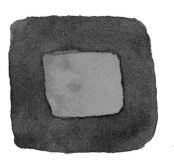

Brighten Your Color With Its Complement

If you place a pure blue with its complementary orange close by, neither dominates and the effect is a bit jarring. However, your orange-gray makes the blue feel brighter, while the blue-gray makes the orange square stand out more. A simple but effective way of making any color appear brighter is to surround it by its grayed complement.

Tone Down Your Gray

Mixing complementary grays is only a start; I often find that such a gray is too dark or the color is stronger than I like. I routinely use Nickel Titanate Yellow to tone down other grays. Since this yellow has a lot of white in it, it helps to further neutralize other colors.

Transitions Between Warm and Cool Grays

Besides learning the fundamentals of good drawing, values and design, few things will more immediately improve your paintings than beginning to appreciate the beauty of warm-to-cool transitions. Most paintings have some passage that is relatively flat and quiet: a distant field, a clear sky, a cloth or wall behind a still life.

 If you simply fill these areas with a flat wash, the eye has no real reason to appreciate the expanse. Even if the transition is subtle, pay attention to how much more interesting it is to follow a movement such as the one shown here, which begins more toward orange (left) and ends more toward blue (right).

Cadmium Orange mixed with Cobalt Blue

Nickel Titanate Yellow mixed with Azo Yellow and Carbazole Violet on the left, moving toward gray on the right mixed from Cadmium Orange, Cobalt Blue and Nickel Titanate Yellow.

Practice Mixing More than One Set of Complements

Don't think that you always have to stay with one set of complements when making a warm-to-cool transition. Sometimes I want something even more neutral, that will still provide interest. In this case, I might start with a gray based on yellow and purple, then transition into one from blue and orange. Here you can see the transition, separating out the colors a bit (top), then mixing them into a wash (bottom). It moves from warm to cool without drawing too much attention—sometimes just what you need.

Nickel Titanate Yellow, Azo Yellow, Carbazole Violet, Cadmium Orange and Cobalt Blue all mixed together.

Snowball
Your Ideas

It's often harder to come up with exciting subjects for your paintings during the winter. For instance, I have a different mind-set toward a teapot, which I can paint any old time, than I do toward wild roses, which might only give me a few days' opportunity once a year. I have no problem getting fired up for that fleeting appearance; the challenge is to bring the same attitude to my winter fare.

This blue teapot, however, is one of my favorite subjects, and I've never tired of painting it. It's like an old friend, and I paint it several times a year. The more I played around with objects, the larger this painting became. The green teapot suggests the green glass, and all the blue called out for a complementary orange. The appeal of all these different shapes and textures was more than enough to keep up my interest.

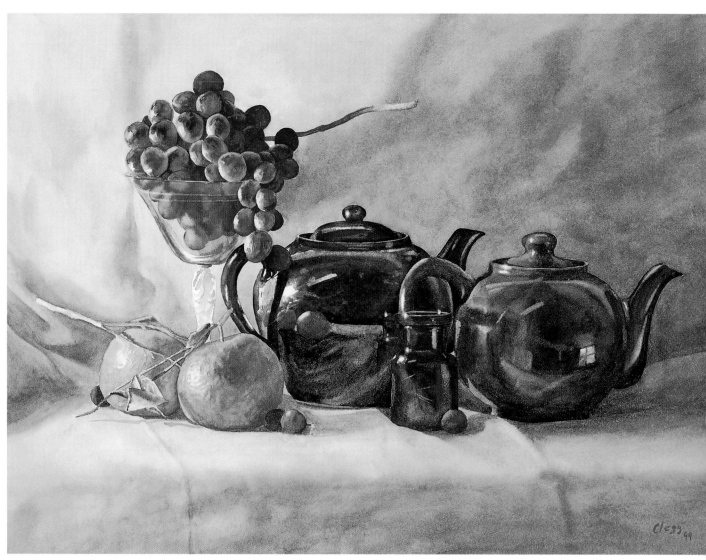

Arrangement in Blue and Green
14" × 20" (36cm × 51cm)
Private collection

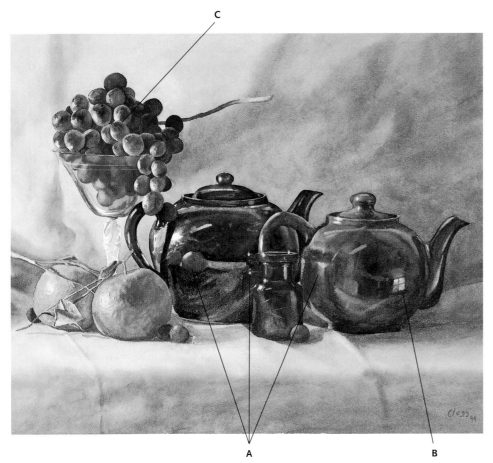

Lost and Found Appeal

Though many of the objects in my painting have clearly defined edges, I try to break up the internal shapes, which provides an alternate mood and movement.

A Although the outer edges of the teapots are well defined, I think the interiors provide a mysterious sweet spot with a lot to explore. The blue ink bottle heightens the appeal, with its own shape almost lost against the adjacent close values. Its reflections, though subtle, enhance the illusion of depth and move the blue across into the green.

B This is interesting not only because it's a "window," but because I needed a light value there to move the eye into that region of the painting. Cover it up and see what happens to the movement.

C Squint your eyes and you'll see that the grapes read more as a large mass than as individual grapes. Defining them any more would have been a mistake, making that area too busy.

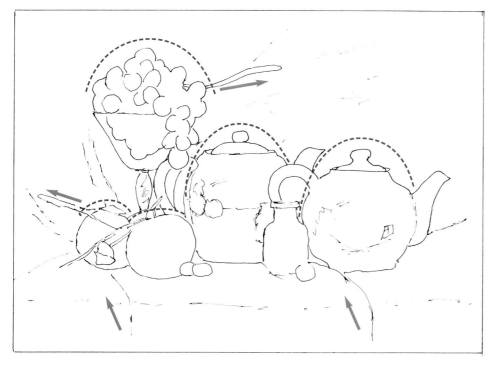

Built on Curves

This painting really shows how the repetition of one or more shapes—using a variety of sizes—can anchor a design. The grapes are a dark value and the only shape placed in the upper negative space; my eye enters there. The stem is a directional arrow further breaking up the negative space and leading the eye across that relief area. Then the eye begins to encounter the pleasing repeated curves of the teapots, eventually moving to the further echo the curves provided by the tangerines. Even the folds are important, moving the viewer from the cloth back into the focal area. The stem to the lower left is perhaps placed at a bit of a risky angle, but I didn't want to be too obvious with another "pointer."

ADD A BURST OF COLOR WITH CHINESE LANTERNS

Materials List

PAPER | 80-lb. (170gsm)
cold-pressed paper

PAINT | Cadmium Orange
Cadmium Red Light
Carbazole Violet
Cerulean Blue · Nickel
Titanate Yellow
Quinacridone Gold

BRUSHES | nos. 4, 5
and 6 rounds

I've always liked Chinese lanterns but until recently I never had any around to paint.

When my wife and I visit Seattle we rarely miss the fabulous Pike Place Market. If I lived in Seattle I could probably focus my career on painting there! It's a treasure trove of seafood, ethnic foods of all kinds, terrific produce from market farmers, tons of flowers—and on our last visit I picked up some Chinese lanterns.

A cautionary note: I put them in a vase by a sunny window and noticed some fading within a couple of months. It's probably best to keep them away from light if you want to preserve that intense orange.

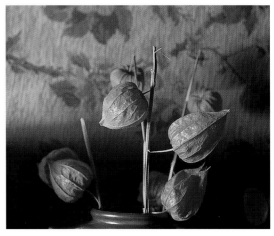

Reference Photo

1 Establish a Base Wash

Mix a graded wash of Nickel Titanate Yellow and Cadmium Orange. Apply it lightly over the lanterns with the largest brush you're comfortable with. Start the shadows with more orange wet-on-wet. Mix a little Nickel Titanate Yellow, Quinacridone Gold and a little Cerulean Blue to start the stem.

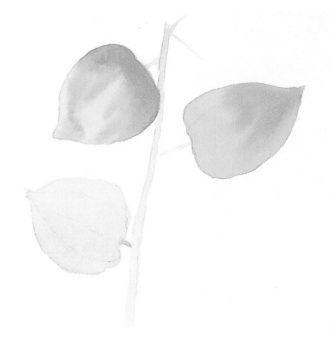

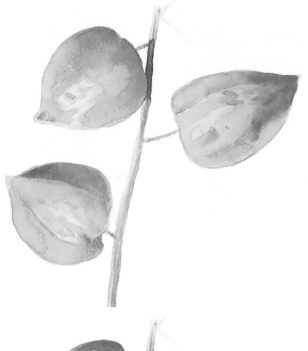

2 Develop Values

Add a mix of Cadmium Red Light and Carbazole Violet to one side of your mix to use for the darker values. Use a dominantly orange mix to model form, working wet-on-dry, and painting around highlights and the light edges of the ribs. While the paint is still wet, apply more of the darks to the shadows, building them up. Dry this, then paint on smaller details. Refine the stem with the same mix from step 1, plus a bit of your lighter lantern mix from step 1, and the darker mix when you reach the shadow near the top.

3 Finish Up

Working wet-on-dry, and softening edges where needed, paint the smaller details. Pay special attention to the shadow side of the ribs. Besides their color, the ribs of Chinese lanterns are their key defining feature. Add the final darks to the shadows. Finally, run a light orange wash over the lantern on the right and all but the lightest highlights of the lower-left one. This breaks up the equality of values, giving slight prominence to the upper-left lantern.

demonstration
ADD DEPTH WITH A REFLECTIVE TEAPOT

Materials List

PAPER | 80-lb. (170gsm) cold-pressed paper

PAINT | Burnt Sienna Carbazole Violet • Mars Violet • Nickel Titanate Yellow • Quinacridone Gold • Raw Sienna Ultramarine Blue Yellow Ochre

BRUSHES | nos. 4 and 6 rounds • 1-inch (25mm) flat

This teapot has an intense, deep blue and a friendly, welcoming shape. Particularly nice, though, is the wonderful depth of all the reflections that it picks up from the surface it rests on and from the surrounding objects and space. Contrasting its main feature—shininess—with a different texture gives interest to the eye. The Chinese lanterns provide this different texture, and they are a nice complement to the teapot's blue.

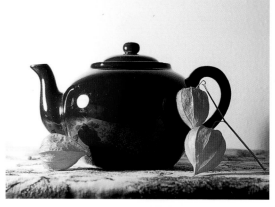

Reference Photo

1 Establish Base Color

Even though the teapot is blue, it reflects color from both the ceiling above and the cloth below, so it won't hurt to first run a wash of a different color over the whole sheet. Mix a light wash of Nickel Titanate Yellow and Carbazole Violet. Apply it over the paper, carefully working around the highlights with a smaller brush, then switching to your 1-inch (25mm) flat when you can. See pages 40-41 for how to paint the Chinese lanterns and paint these now to about 75 percent complete, waiting for the teapot's completion to determine their final value.

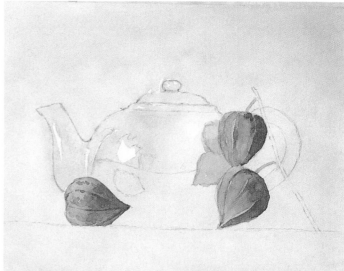

2 Add Reflected Color

Mix a warm gray from Nickel Titanate Yellow, Carbazole Violet, Ultramarine Blue and Raw Sienna. The sienna should dominate one half; the blue the other. Apply the mixes wet-on-dry with a no. 4 or no. 6 round to the upper part of the teapot, where the ceiling color is reflected. Soften the edges as you go. Do the same to the lower half, adding more of the blue-dominant mix in the lower right area. Dry this, then add Nickel Titanate Yellow and Yellow Ochre to your lighter mix and wash it over the cloth area. Use your darker mix wet-on-wet to start the darker portion of the cloth, lifting color if it bleeds into the lights.

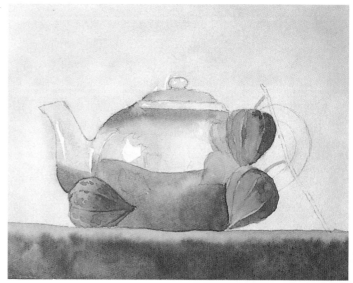

42

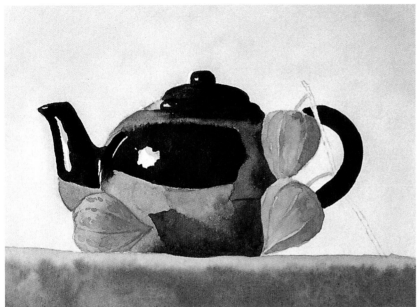

3 Establish the Darks

Mix a very dark wash of Ultramarine Blue, Carbazole Violet and Mars Violet. Make it as saturated as possible, yet, still transparent. Working in sections, paint the darks on the teapot, leaving the highlights pure white. Don't worry if you paint over the lantern's stem as you paint the handle. The teapot's overall blue is a dark enough value that it's an ideal candidate for lifting. For now, just put it down as dark as you can. Soften edges where you meet lighter values. Add some Raw Sienna and Yellow Ochre to the mix and establish the darker values of the cloth's reflection. Add some of your Chinese lantern colors to the mix to develop their reflections.

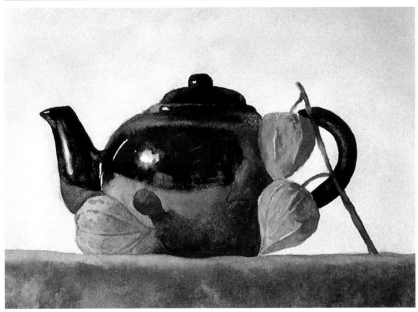

4 The Last 10 percent

Paying attention to these final touches makes all the difference. Mix Quinacridone Gold, Burnt Sienna and Ultramarine Blue to paint the stem, lifting the section that was painted over. Add a little of the dark reflection mix to refine the darks of the Chinese lanterns and better integrate them with the teapot. At the same time, paint the last reflected lantern.

Use your dark cloth mix with a little additional Ultramarine Blue and darken the reflected cloth a bit more, softening the edge as it meets the blue. Make sure to establish the cast shadow of the reflected lantern. Paint the edges of the highlights with clear water—just enough to barely moisten—and blot with a paper towel to soften edges. Lift all the little details; these are reflections from any surrounding objects, and even if they don't seem to mean anything, they actually play a huge role in giving dimension to the teapot.

Finally, the cloth seems a bit stark, so mix a muddy orange with existing color on you palette and tone it down a bit.

NECESSARY DETAILS

A little chopped cilantro garnishing a dish you're about to serve can matter as much as everything else that went into the dish's making. Like cooking well, painting well requires the ability to discern the "telling touch."

Once you've finished your teapot, look at it from a few feet away. You'll probably be surprised at how shiny it looks. Now, do something hard: go back in with your darkest blue mix, paint over those little lifted touches and reestablish the hard edges around the highlights. Look at it again from the same distance and you'll see that it's flat and lifeless. Bring back the highlights and other little details once more, and voila! Three hours of work can sometimes become four times more effective with five telling minutes at the end.

GRAPES ARE COMPOSITIONALLY FLEXIBLE

Materials List

PAPER | 80-lb. (170gsm)
cold-pressed paper

PAINT | Burnt Sienna
Cadmium Orange
Cadmium Red Light
Carbazole Violet
Cerulean Blue
Gamboge · Mars Violet
Nickel Titanate Yellow
Quinacridone Burnt
Orange · Quinacridone
Red · Raw Sienna
Ultramarine Blue
Yellow Ochre

BRUSHES | nos. 4, 6 and 10
rounds · 1-inch (25mm) flat

Like most varieties, these large Red Globe grapes are available in just about any season. I usually paint grapes during the winter, along with pears and tangerines, or in autumn, if my young homegrown vine grapes mature. Grapes are compositionally flexible: The clusters can be bent in interesting ways, with single grapes placed as accents. They're also great for showing off light, as the same grapes can appear reddish with light shining on them or black in the shadows. Notice here that I've changed the design a bit from the reference photo to create a more interesting arrangement.

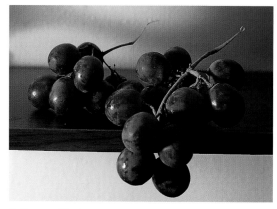

Reference Photo

1 Lose the White

Many painters are afraid of wrecking the white of their paper, but if there are no pure whites, why not get a jump on the painting by toning the paper? Doing so can establish a simple background in a few strokes and can be a good icebreaker to get you going. Mix one light yellow wash with Nickel Titanate Yellow, Raw Sienna and a little Cadmium Orange. Mix a purplish wash with Cerulean Blue and Carbazole Violet, adding a little Burnt Sienna to part of it. Start on the left side with the yellow mix and your 1-inch (25mm) flat, then add the other mixes as you move across and down.

Looking at the dominant temperature of each grape, paint the grapes with either a light wash of Nickel Titanate Yellow and a little Cadmium Red Light or a wash of Cerulean Blue and Carbazole Violet. Drop in a little clear water if you need to re-establish highlights.

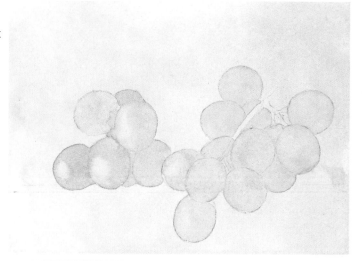

2 Develop the Grapes

For the redder grapes, mix up puddles of Nickel Titanate Yellow, Cadmium Orange, Cadmium Red Light and Quinacridone Red, making sure to keep some of each color separate. Add Carbazole Violet and Cadmium Red to the mix for the darker grapes, and mix a little Cerulean Blue into a portion of the red and orange, but not the yellow. This will give you all the color you need to paint the grapes. Since grapes are one of those subjects best painted wet-on-wet, you should have all your washes at the ready. Don't try to find the right color while the paper's drying! Use either a no. 4 or no. 6 round brush and work from grape to grape, drying in between as needed. Start with a light orange or violet, working around the highlights if they stand out, adding more color wet-on-wet to finish them. Where no edges stand out, the grapes can just blend together, like the top two do here.

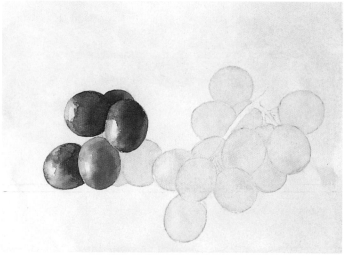

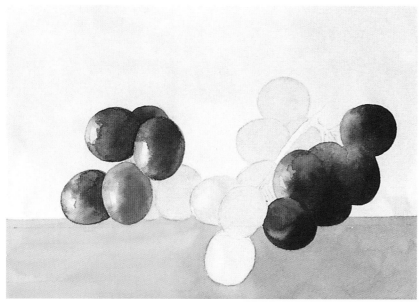

3 Establish a Good Mass

Getting the overall shape and value of the grapes is more important than defining each one separately. If, when you're looking at your arrangement, the edges disappear, don't worry about painting them. Use your previous mixes to continue the grapes, making sure to lift the highlight on the lower grape where a little light shines through.

Start the shelf with a mix of Gamboge and a little Quinacridone Burnt Orange.

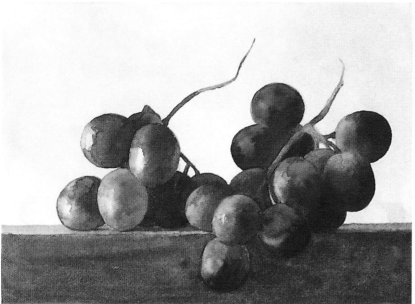

4 Complete the Movement

Think of the grape stems as vehicles to move the eye, and don't paint them the way they are if that won't help the painting! First, paint the stems with a light mix of Yellow Ochre and Nickel Titanate Yellow, then add wet-on-wet a mix of Burnt Sienna and Ultramarine Blue for the darks. Continue to use the no. 4 and no. 6 round brushes.

Add some Mars Violet and Ultramarine Blue to this mix, and combine it with your previous shelf mix to paint the shelf and the grapes' shadows.

If some of the edges of your grapes stand out too much, use your no. 10 round brush loaded with a little clear water, and lightly brush over adjacent edges to soften them a bit and drag a little additional color to the light areas a stroke at a time. Dry and repeat, if needed. Apply more paint to any negative shapes that will help define individual grapes, and don't forget to paint the cast shadow from the stem onto the adjacent grape. Lift a few edges to slightly define individual grapes. Don't worry if the grapes don't all stand out; it'll feel more natural if they don't!

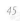

TANTALIZE THE SENSES WITH TANGERINES

Materials List

PAPER | 80-lb. (170gsm) cold-pressed paper

PAINT | Azo Yellow · Cadmium Orange Cadmium Yellow Light · Carbazole Violet · Cerulean Blue · Indian Red Nickel Titanate Yellow · Phthalo Blue Ultramarine Blue · Yellow Ochre

BRUSHES | nos. 4 and 6 rounds 1-inch (25mm) flat

The Fairchild tangerines that show up in our grocery store aisles in December are an exception to my usual homegrown subject matter. However, the interplay of green leaves and orange fruit makes for a lively combination that's fun to paint. You don't necessarily need to paint the objects as they're actually arranged; these leaves seemed unnecessarily busy to me.

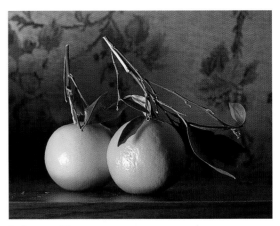

Reference Photo

1 Establish the Rhythm

Mix a light wash of Nickel Titanate Yellow and Azo Yellow and apply it over the tangerines, leaves and stems; use a no. 6 round brush where you can and switch to a no. 4 round as you need to for control. Soften the edge underneath the tangerines as you paint that area. Next, use a no. 4 round brush with a good edge to paint a light wash of Cerulean Blue over a few of the leaves and stems, working around the lights. Then add a little more Azo Yellow and Cadmium Orange to your yellow wash and apply it to the tangerines, working around the highlights. Pay attention to how the leaves create a movement that helps to offset the tangerines.

2 Give Dimension

Mix a big wash of Cadmium Orange and Carbazole Violet, and add Cadmium Yellow Light, Azo Yellow, Nickel Titanate Yellow, Cerulean Blue and Phthalo Blue to it. Keep some of each color unmixed. This will provide a base of colors for further development. Use this mix to paint the tangerines, adding more pigment if needed. First, wash on the lightest values wet-on-dry. Then, build more darks with wet-on-wet washes. Since the shadows of the leaves pick up a bit of reflected color, add a little of the green from the partially unmixed colors listed above. Next, mix a green from Azo Yellow and Phthalo Blue, and add some of your dark orange mix to part of it to subdue it a bit. Use that wet-on-dry to model the leaves, softening edges as needed. Use the no. 4 and no. 6 round as necessary.

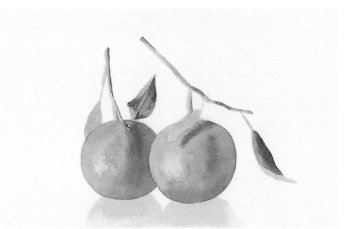

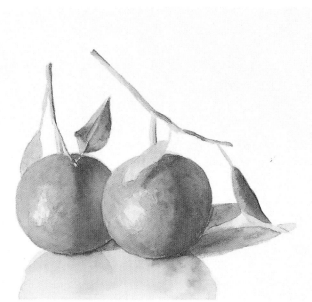

3 Refine Character

Repeat what was done in step 2, but use darker values to complete the tangerines. As you lay in color wet-on-wet, the paper will dry out slightly if you don't use too much water. Keep adding smaller touches of darker values to indicate the texture of the tangerines. Add Ultramarine Blue to your dark orange mix and use it to paint the tangerines' anchoring shadows, softening the edges. Add Cerulean Blue to that mix and paint the cast shadows, also softening the edges as you go.

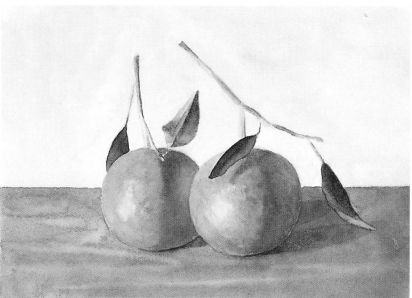

4 Change the Design

If you paint a simple study with the goal of just learning about that particular subject, it might look good enough to deserve a bit more finish. Or you might want to change the design. Looking at how hard it is to move from the circular shapes of the tangerines, you might consider a simple foreground to help the movement.

Mix a wash of Yellow Ochre and Indian Red and paint a simple foreground, adding more Indian Red as you move to the right. Create a little more interest by adding a few strokes of clear water over the wash.

Finish the darks of the leaves, adding more pigment as necessary.

Now that the study has a foreground, you might also consider toning down the background. Apply a light wash of Nickel Titanate Yellow, adding a little Carbazole Violet as you move to the right, and you're done. Use a 1-inch (25mm) flat.

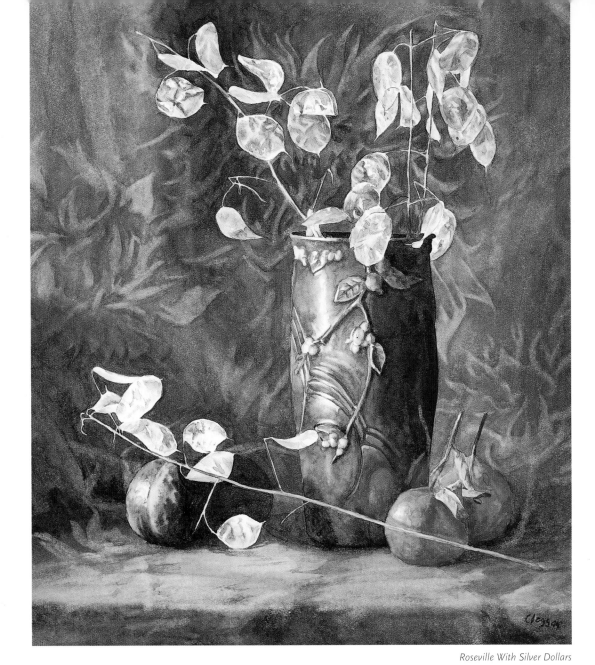

Roseville With Silver Dollars
18" × 16" (46cm × 41cm)
Collection of the artist

Simplicity Can be
Elegant

Occasionally you just get lucky and a painting presents itself as if by magic. This Roseville Snowberry vase actually has strange projecting handles and a weird flying saucer-like flange, but one day I happened to visualize it without those projections and it was gorgeous. I had just picked some silver dollars and was excited to paint them for the first time. Finally, the cloth was a new one I'd just found, with a wonderful brocade. How could I miss? This is one of my very favorite paintings.

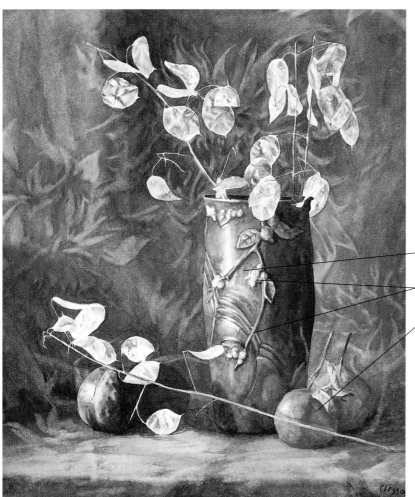

A Perfect Pattern

Occasionally, your subject matter can so naturally complement each element that the painting practically falls into your lap. This offsets all the times you have to struggle.

A The complementary reddish and green glazes of the vase make it an exciting focal point.

B The snowberries and twigs nicely echo the silver dollars and their stems.

C Without the tangerines balancing the warm glaze of the vase you'd spend too much time there. The leaves also carry through the green of the vase, and the stems provide an important entry into the negative space above.

A

B

C

Active Simplicity

While the silver dollars, vase and patterned cloth certainly make for a lot going on, the structure of this painting is simple. The vase provides a solid vertical rectangle and the various stems of the silver dollars and raised twigs of the pottery move your eye pretty directly. Complementing that area are the three main flower clusters of the background cloth, all breaking up the negative space in good areas, and echoing the foreground shapes as well. The long, diagonal stem of the lower silver dollars is a bit risky, but I like the edge it gives to an otherwise almost totally classical arrangement.

MIMIC THE GLAZED SURFACE OF POTTERY

Materials List

PAPER | 80-lb. (170gsm) cold-pressed paper

PAINT | Azo Yellow Cadmium Orange Carbazole Violet Cerulean Blue Gamboge • Indian Red Mars Violet • Naples Yellow • Nickel Titanate Yellow • Phthalo Blue Ultramarine Blue

BRUSHES | nos. 4 and 6 rounds • 1-inch (25mm) flat

Pottery is a nice departure from clear vases or silver bowls. The surface glazes vary from piece to piece, and the raised patterns of many also present a different challenge. Although this demonstration is handled in a straightforward manner, remember that you can definitely take liberties—leaving off awkward handles, changing the placement of the pattern or even the color of the glaze.

It's useful to place a silver bowl by a piece of pottery and compare the intensity of light striking the objects. Unless the pottery has a much glossier glaze than usual, you'll see that the highlights are much softer and more diffused than those striking the silver. Understanding this will aid you in mimicking the surface of the pottery.

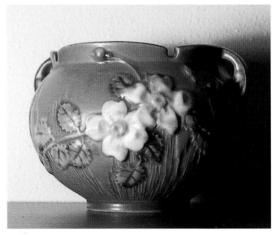

Reference Photo

50

1 Tone it Down

If you were to study this pot while squinting your eyes, you wouldn't see any pure whites, so it makes sense to get rid of the white of the paper right away. Mix a diluted wash with Nickel Titanate Yellow and a little Gamboge and Carbazole Violet. Use your 1-inch (25mm) flat to paint this wash over all of your paper. Dry this, then mix two separate puddles: Indian Red/Nickel Titanate Yellow and Nickel Titanate Yellow/Carbazole Violet. Using your no. 4 round, apply the second mix wet-on-dry to the roses, working around highlights. Then, using a no. 6 round, apply the first mix to the rest of the pot, working around leaves and flowers.

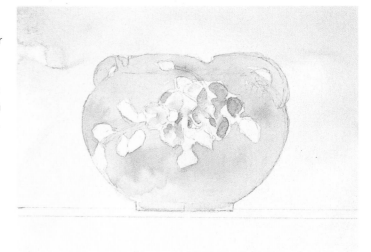

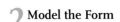

2 Model the Form

Mix two separate greens: one from Nickel Titanate Yellow, Azo Yellow and Cerulean Blue, and the other from Gamboge, Naples Yellow, Phthalo Blue and a little Cerulean Blue.

Use a no. 4 round to apply the first wash lightly over all of the leaves. Dry this. Add a little Phthalo Blue to the mix, then begin modeling the leaves, working around any highlights.

Begin modeling the pot with the second green mix, softening edges with an Indian Red/Naples Yellow mix.

Start the shelf with a wash of Indian Red and Naples Yellow applied with your 1-inch (25mm) flat.

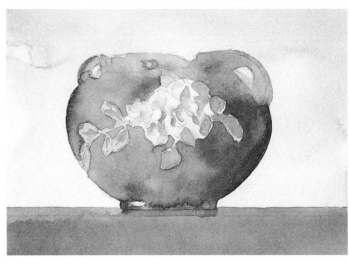

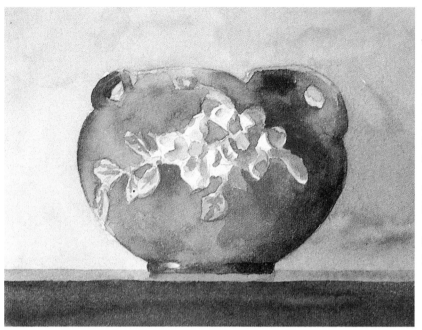

3 Develop the Darks

Continue to model the pattern with your previous mixes, adding Cadmium Orange and Ultramarine Blue to your flower mix to paint their darkest values. Start the centers of the flowers with Azo Yellow. Use the same mixes as before to continue modeling the pot, adding a little more Indian Red to deeper values and Ultramarine Blue to both mixes to model the shadow side.

Mix Cadmium Orange, Ultramarine Blue and Nickel Titanate Yellow, and apply a graded wash from light to dark across the background using your 1-inch (25mm) flat. Darken the vertical side of the shelf with a mix of Gamboge, Indian Red and Mars Violet using your 1-inch (25mm) flat.

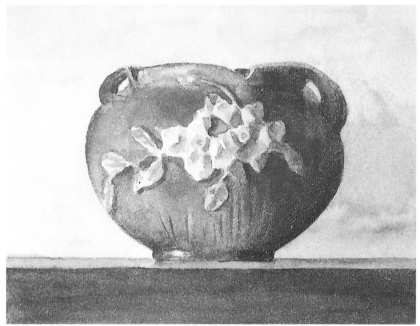

4 Pay Attention to Detail

By now you should have a nice melange of color on your palette, ranging from light yellow-red to dark, dirty greens and reds. Use the appropriate colors to continue refining darks, making sure to tone down the pattern in shadow. Make sure you paint the cast shadows that the pattern casts onto the pot; this will help the pattern pop out. Refine the darks of the handles and top of the pot, paying careful attention to edges.

As the pot approaches completion, the flowers might feel too white. Tone them down slightly with your flower mix. The one on the right is more in shadow; it should be slightly darker.

Lift hints of the striated pattern toward the bottom of the pot, and apply darker touches to the recessed shadows on the left edge of each.

Finally, use your shelf mix, with the addition of more Gamboge, to refine the top edge of the shelf. If you've inadvertently covered up any subtle highlights on the pot or pattern, lift them out.

51

LEARN ABOUT LIGHT WITH SILVER DOLLARS

Silver dollars go into a class of subjects that are interesting, but not classically beautiful. However, one of the nice things about art is that humble fare, such as silver dollars, can be portrayed so that it becomes beautiful.

Silver dollars are so thin that light passes through them, and they glow when properly lit. They make great accents in a painting, and can even be a nice focal point. If you have other whites or circular shapes of some kind in the composition, silver dollars are nice complements.

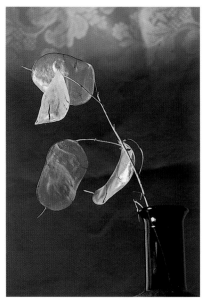

Reference Photo

1 Start With Shades of Gray

Like anything, silver dollars are influenced by the temperature of the light striking them. Sometimes they're a little warmer or a little cooler. To accommodate both, mix one neutral gray from Cadmium Orange and Ultramarine Blue and another from Nickel Titanate Yellow and Carbazole Violet. Then lean both mixes toward warm and cool, giving you four basic batches to dip into. Try for some variation even within these mixes, and you'll have all the colors you need.

Use the largest brush you're comfortable with, and apply small touches of pigment to dry paper, working around the lights. Silver dollars are weird abstract shapes, and only by paying close attention to their edge quality you can capture their dry, crackly character. If some of the edges meet, let the paint just flow together.

2 Add Detail

Use those same mixes to overlay more strokes wet-on-dry working from silver dollar to silver dollar. You're deepening values and creating the crisp character of their surface. Don't worry about softening any edges right now. If it happens, fine, but don't worry about it. Dry this before proceeding to the next step.

3 Add a Softening Wash

The white of the silver dollars isn't a pure white. Mix a very light wash of Nickel Titanate Yellow, Naples Yellow and a dab of Carbazole Violet. Using your 1-inch (25mm) flat, paint over all the silver dollars, stopping just short of the edges of the paper, since this is a vignette of sorts. This wash will tone the silver dollars down and soften the hard edges all at once. Dry this, and add details like you did in the first two steps.

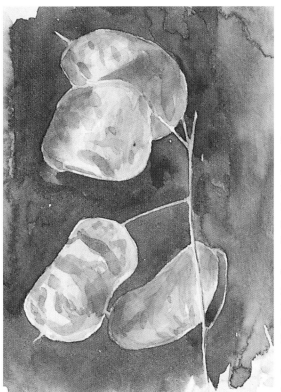

4 Bring the Dark Into the Light

Up until now, the silver dollars have been darks against a light background. By painting a darker value next to them, they'll turn "white." Mix a fairly strong wash with Gamboge, Ultramarine Blue and a little Carbazole Violet (it's okay to leave the colors slightly unblended). Work carefully around the silver dollars and stems, letting the colors run together as they meet.

Now, what looked dark is too light. Add a little Quinacridone Gold to the wash to tone down the stems. Use a little additional Carbazole Violet to paint their shadow side. Finally, use your silver dollar mix with the addition of a little Quinacridone Gold to finish toning them down to their final values.

A word of warning: Silver dollars spread, well, like weeds. Don't be surprised if they grow everywhere, even if you only plant a small area.

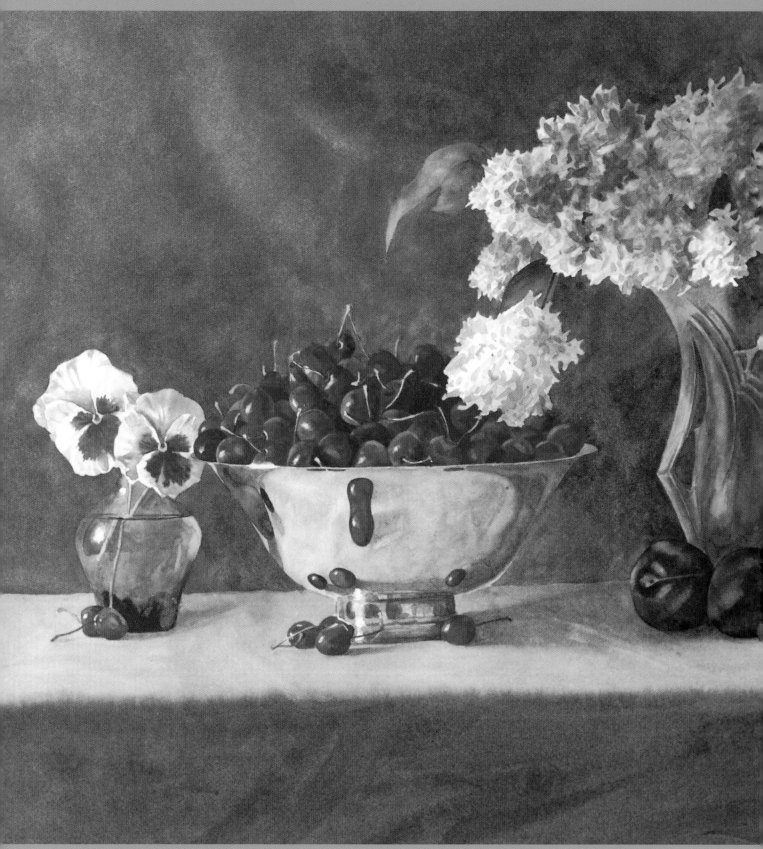

Arrangement in Red, White and Green
22" × 30" (56cm × 76cm)
Private collection

Spring

My wife always said that in the place where she grew up, spring is the two nice days between winter and summer. We have it a bit better where we live now, thankfully. It's always a delight to see the trees and shrubs bud and then to watch the explosion of green that seems to come all at once. As the days get longer, I can cook outside without earmuffs, and my paintings fill with spring flowers.

If you work from life, almost every day brings something new to paint. It might seem discouraging to know that if you miss something you'll have to wait a year before it comes again, but this keeps you fresh. Subjects that are here and gone have a bit of magical quality to them, as does spring itself.

CINCO DE MAYO SCRAMBLE

This recipe shows that radishes can go beyond their "party tray" reputation. You'll also learn that you can make a good scramble without eggs. The colors are festive, and the flavors perfect for Cinco de Mayo.

1 tube (12 oz.[336g]) country-style pork sausage
1 large sweet onion, sliced thin and roughly torn
1 large Anaheim pepper, cut into ¼-inch (6mm) strips, 1- to 2-inches (3cm to 5cm) long
8 large radishes, thinly sliced
1 minced fire-roasted jalapeno*
4 T. (60ml) roasted pepper dip*
2 handfuls spinach leaves, large ones roughly torn

Place sausage in a large skillet and cook over medium heat until done . Break it up into small pieces as you stir.

Add all remaining ingredients except spinach and turn with a flat wooden spoon, bringing up any sausage bits from bottom of skillet. Sauté until onion and radish just start to turn transparent.

Add spinach and stir until it starts to wilt. Serve right away.

Serves four.

*AVAILABLE FROM SPECIALTY STORES. IF NEEDED, SUBSTITUTE A CHIPOTLE IN ADOBO SAUCE AND YOUR FAVORITE SALSA.

Renew Your Paintings with a
Spring Mood

In our yard, spring first announces itself in the emerging snowdrops and aconite, closely followed by crocuses. Though late snows may cover them for a day or two, they seem none the worse for the wear, confident that their time has come and that winter is now only bluffing.

Walking around the yard, looking at all the budding trees and shrubs, makes me anxious for blossoms I can paint. If you need to do a little pruning, cut some branches and put them in vases to force their buds. You'll have fresh blossoms in no time.

While you wait for spring's showier offerings, take advantage of the smaller flowers that first arrive. If you're painting short-stemmed flowers, such as pansies, put coins in the bottom of the vase to prop them up.

FRESH FARE
These first flowers are welcome, but my real interest is in my veggie garden. Might there still be some overwintered carrots? Some hardy greens? I stick a soil thermometer in a bed and squeeze a handful of soil, checking to see whether I can work yet.

ACTIVITY IS EVERYWHERE
My approach to painting changes with the seasons. After the formality of my winter compositions, I generally take a more impromptu approach to my spring designs. Once again, my subject matter won't stay still! Tulips are particularly problematic

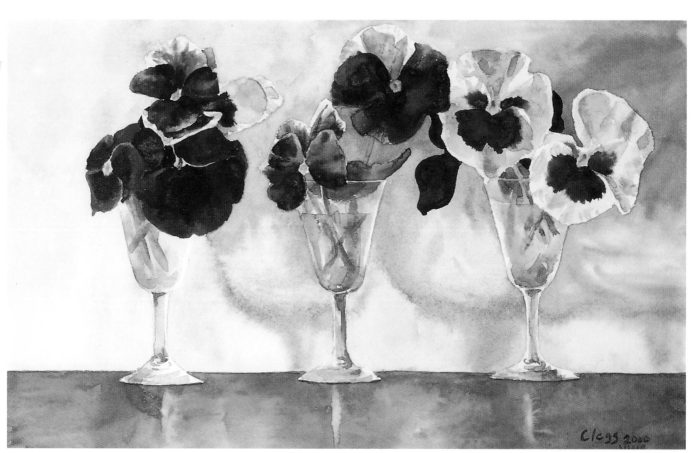

Pansies in a Row
7½" × 12½" (19cm × 32cm)
Private collection

for from-life work, but I've learned ways of putting together a painting even as my subject matter changes.

If you're working with changeable fare, plan with an eye toward the overall placement of objects and forget about doing a complete drawing. If you're painting flowers in a vase, just make a few rough (but accurate) marks to indicate placement and size, and then pick one flower you like and start there. Don't worry about drawing the vase until you're done with the flowers, but do draw the stems—at least the most important ones.

The short duration in which I often have to finish something before it completely changes really gets me going, and I work like a fiend. The benefit is twofold: I usually finish paintings faster, and the concentration involved in working like this often results in fresher work that really does capture a moment in time. Spring makes everything more active and my work reflects this mood.

PAINTERLY COOKING

You know that good design, values and color are likely to make a good painting. Bring all that to your cooking! Think of the size, shape and texture of your ingredients as the design element. Unless there's a reason for uniformity, vary them, just as you would shapes in a composition. Sweet and sour flavors are the color of your cooking, working like complements. And the array of spices you use is your value range. It can be high-key, low-key, or full range. Think like a painter when you cook and you'll turn out works of art in the kitchen!

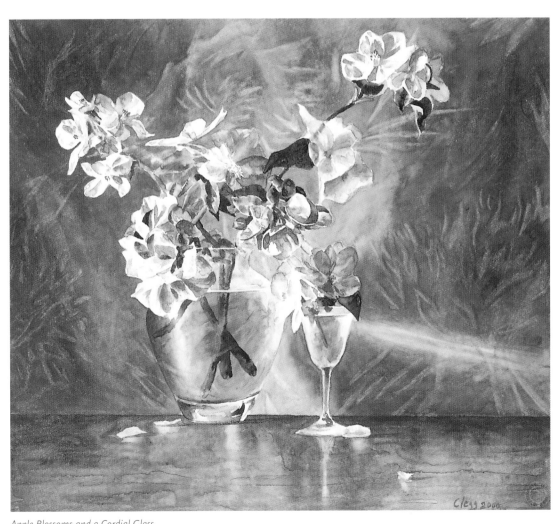

Apple Blossoms and a Cordial Glass
16½" × 18½" (42cm × 47cm)
Private collection

Choose the Appropriate
Spring Color Palette

As I write this, spring really is busting out all over. Several unseasonably warm days have fostered an explosion of green. Though Robert Frost insists that, "Nature's first green is gold, her hardest hue to hold," I'll argue for that first blush of pale yellow-green that presages the fuller leaves to follow. What better time to take a look at the dominant color of the season?

Two Chalky Greens
This time of year offers a bewildering variety of greens, far beyond the reach of a few tube greens. It's better to learn to mix your own! Both Cobalt Blue and Ultramarine Blue pair with Azo Yellow to make serviceable dull greens that are suitable for some needs, but you'll need more than these two blues for intense, pure greens.

Cobalt Blue Azo Yellow Ultramarine Blue Azo Yellow

Two Clean Greens
Cerulean Blue and Azo Yellow mix into a nice pale green that's particularly good for spring's first budding leaves, but its light value will never allow for mixing a very dark-valued green.

With the introduction of Phthalo Blue, yellow finds its perfect partner, and when that yellow is Azo Yellow, you mix a clean, intense green.

Cerulean Blue Azo Yellow Phthalo Blue Azo Yellow

USE PHTHALO BLUE WITH CAUTION!

It's a good idea to get into the habit of using an old brush (so you don't wear out the tips of your good brushes) to draw paint from your wells, rinsing in between colors. It might not matter much if you get some of your reds mixed together, but when working with Phthalo Blue you absolutely have to be careful. It has one of the highest tinting strengths of any color. Just the teeniest amount touched into a well of yellow, for example, will spoil a huge amount of pigment. Keep your brushes clean and get new water frequently when using Phthalo Blue or it'll muddy all your colors in a hurry.

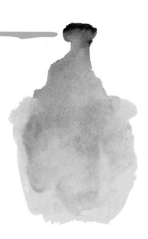

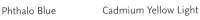
Phthalo Blue Cadmium Yellow Light

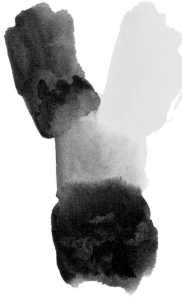

Quinacridone Burnt Orange

Quinacridone Gold

Phthalo Blue

Every Value You Need

You can see that Phthalo Blue's very dark value—Phthalo Blue is just about tied with Carbazole Violet as the darkest pigment on my palette—allows for a huge range of greens. From pale tints to the blinding green of a mallard, it's your best blue for mixing greens.

Earthy Greens

You won't always want intense pure greens, and at those times you'll need something other than simple yellow/blue mixtures. In these instances, you need a partner with some red in it. On the left, you can see that Quinacridone Burnt Orange combines with Phthalo Blue to make a nice dark green, but if the proportions aren't right, you just end up with brown. Quinacridone Gold, on the right, and Phthalo Blue combine to mix a huge variety of olive greens.

PLANTING TIME?

Though various almanacs, folk tales and plain old family traditions guide many gardeners in their spring plantings, soil temperature is a much better indicator. In a benign year, paying attention to it may mean we're eating our first greens by the end of March, rather than planting them then. If you know the optimum soil temperatures for your crops—as well as your local frost-free date for nonhardy peppers and such—you're well on your way to an extended crop.

Lettuces, for instance, will germinate at soil temperatures as low as 30°F (2°C), but I like to wait for about 45°F (7°C), which speeds it up. At 55°F (13°C) it's time for potatoes. Make sure to dig your trenches well ahead to speed soil warming!

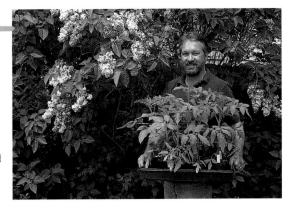

Set the
Stage

When a friend of mine called me saying that her apricot blossoms were ready, I went right over. The branches were large and the blossoms were beautiful, so I decided to do a full-sheet watercolor. Taking on a subject of this complexity is difficult enough, and when you factor in the short life of the blos-

soms, time is of the essence. I couldn't waste time fiddling with the composition too much, since a good deal of my designing had to be the fly, so I chose which blossoms to paint and where to place them for the best effect. As soon as I placed the smaller vase by the larger, I knew I had the basis for a good painting—solid anchoring shapes to play against the blossoms and backdrop.

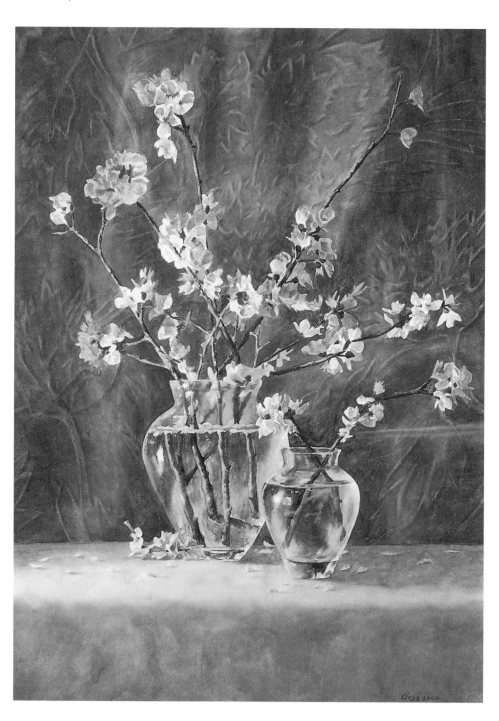

Orchard Apricots
30" × 22" (76cm × 56cm)
Private collection

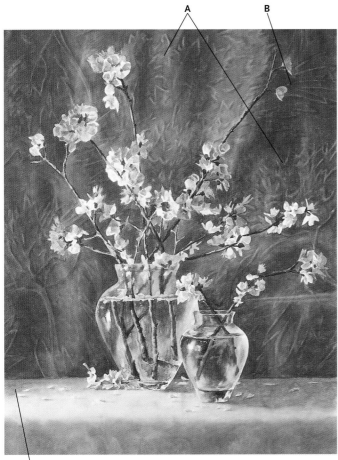

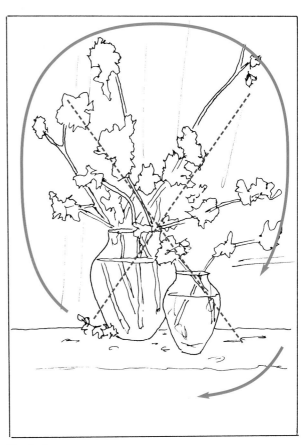

Tying it Together

The structure and edge quality of your foreground shapes often suggests the type of treatment you might give to the background and smaller details, such as the fallen blossoms here.

A Even though the design of the fabric's pattern is different, it still has many of the same edge qualities as the blossoms.

B The upper right of the painting would be too empty without interjecting this branch and blossoms.

C I think the fallen blossoms add an interesting circular movement to the tabletop, as well as an air of casualness.

Simple Structure

Though there's quite a lot going on in this piece, the design is a simple one. The **X** of the branches and blossoms creates the dominant movement. It was quite important that the diagonal extending from the smaller vase through to the upper left crossed the **X** away from the center. That placement, along with the overlapping of the two vases, nicely offsets the centered one. The pattern provides a supporting circular movement that moves the eye through negative space. All this activity needs a quiet relief area, so the background and foreground were left understated.

ADD A DELICATE AIR WITH BLOSSOMS

Materials List

PAPER | 80-lb. (170gsm) cold-pressed paper

PAINT | Cadmium Orange · Cadmium Yellow Light · Carbazole Violet · Gamboge · Nickel Titanate Yellow · Phthalo Blue · Quinacridone Burnt Orange · Quinacridone Gold · Quinacridone Red · Ultramarine Blue

BRUSHES | no. 4 round

Blossoms are among the most delicate— and ephemeral—subjects imaginable. If they're white and in the light they can be painted with only a few touches. Pink blossoms, like these quince blossoms, require more pigment, but the shapes are still small and need to be carefully drawn.

When painting small studies like this, you don't have to paint "what's there." Move and place objects for good design to get the shapes you like.

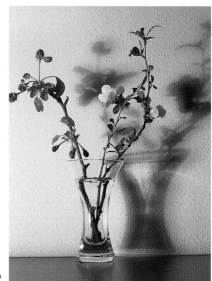

Reference Photo

1 Establish Pale Tints

Complete a drawing of the blossoms. I darkened my pencil drawing here to show the overall placement of shapes, but I erased it before going further. In a study like this, the pencil marks would destroy its delicate quality.

Mix separate puddles of Nickel Titanate Yellow and Cadmium Yellow Light; Nickel Titanate Yellow and Gamboge; Nickel Titanate Yellow and Carbazole Violet; Quinacridone Red, Nickel Titanate Yellow and Carbazole Violet; Quinacridone Red and Nickel Titanate Yellow; and Ultramarine Blue, Nickel Titanate Yellow and Cadmium Orange. Begin the blossoms with light washes of your mixed puddles of paint ranging from pink to blue-gray.

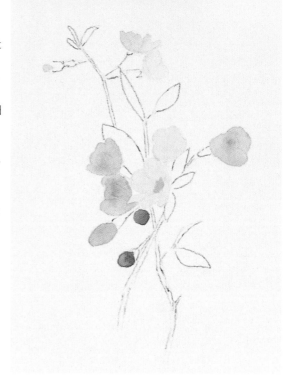

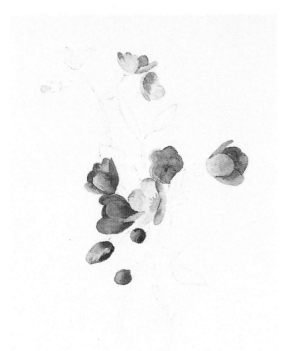

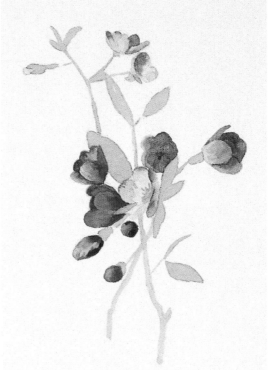

2 Complete the Blossoms

Finish the blossoms wet-on-dry with darker versions of the previous washes, softening edges where needed. Pay attention to where hard edges define the petals and where soft ones let them merge; you don't need to paint every petal individually. Use Gamboge, Cadmium Yellow Light and Phthalo Blue to paint the yellow and green centers of the open petals. Paint the centers wet-on-wet as you paint the petals. Define a few edges wet-on-dry if needed.

3 Extend the Study

Use the previous mix of Gamboge, Cadmium Yellow Light and Phthalo Blue to begin the branches and leaves. These are thin strokes! Notice, even in a vignette, how the various overlapping shapes move some objects forward and other objects back.

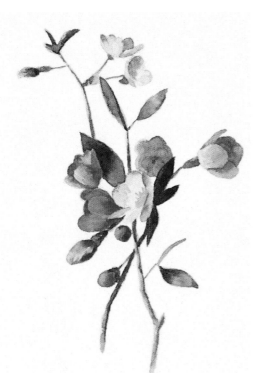

4 Finish the Darks

Add Carbazole Violet and Quinacridone Burnt Orange to your yellow-orange mixes and paint the darks of the branches. Use more Gamboge, Quinacridone Gold, Cadmium Yellow Light and Phthalo Blue for the dark greens. Apply clear water to the branches, and paint the shadow side with the first mix. Vary the edges as you go so your eye moves through the painting at different speeds. Use your green mix to paint the leaves wet-on-wet, setting off the blossoms.

Stand back and take a look at your work. I think that studies like this really show off the delicate side of watercolor.

ADD A DASH OF COLOR WITH CROCUSES

Materials List

PAPER | 80-lb. (170gsm) cold-pressed paper

PAINT | Cadmium Orange · Carbazole Violet · Cerulean Blue · Gamboge Nickel Titanate Yellow · Phthalo Blue Quinacridone Red · Quinacridone Violet · Ultramarine Blue

BRUSHES | nos. 4 and 6 rounds 1-inch (25mm) flat

After winter's lack of color, it's always fun to see the bright clusters of crocuses appear, sometimes even when there's still snow on the ground. Crocuses are good painting partners, holding their shapes well, unlike those uncooperative tulips. My wife thinks one of our varieties is a saffron crocus. If I ever find out for sure, it'll be fun to harvest our own saffron threads—and probably gain an appreciation for the amount of work involved.

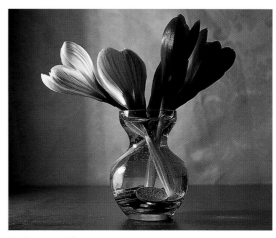

Reference Photo

1 Establish a Base

These crocuses aren't pure white, so use your 1-inch (25mm) flat brush to tone the paper down with a light wash of Gamboge and Nickel Titanate Yellow, adding a little Carbazole Violet as you move to the right.

Let dry. Apply a wash of Nickel Titanate Yellow, then Cerulean Blue, then Carbazole Violet to the blooms, changing colors as you move to the right. The slight yellow cast of the left-most crocus will be a subtle complement to all the purple.

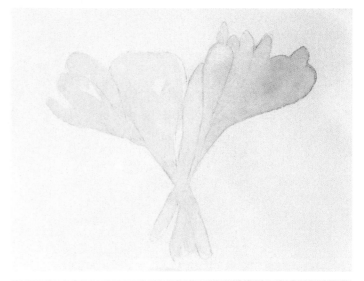

2 Begin to Suggest Form

Mix up several washes, keeping them separate: a gray from Cadmium Orange, Ultramarine Blue, Carbazole Violet and a little Nickel Titanate Yellow; a red-violet from Cadmium Orange, Quinacridone Red and Carbazole Violet; a purple from Cerulean Blue and Quinacridone Red; and a light green from Nickel Titanate Yellow and Cerulean Blue.

Start with a little Nickel Titanate Yellow, then work across the flowers, switching to the gray, red-violet and purple as you go, adding the light green for the stems. Use your no. 6 round when you can, switching to a no. 4 if need be.

Drop a little clear water, followed by Cerulean Blue, to regain the lighter areas you first painted over. Be especially careful not to work over the little negative shape in the middle of the blossoms, as it's an important indicator of form.

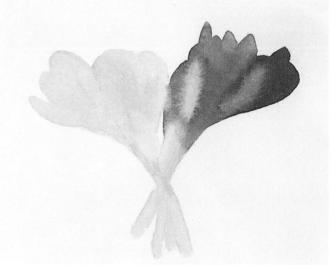

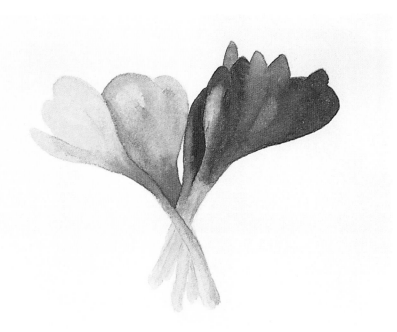

3 Separate the Flowers

Starting with your gray mix and adding more purple as you go, begin modeling each flower. Add a bit of green to the upper section of the stems and blend the red-violet into it, softening edges as needed. If you need to, add more red, violet or blue to your mixes, depending on the predominant color.

Add a little Gamboge to your green, and begin to define the stems, making them into separate shapes.

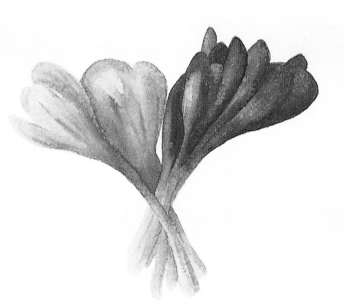

4 Small But Important

Though the third step almost finished the flowers, the characteristic veins of color that make crocuses so pretty are still missing. Go back in, wetting the petals with clear water, then add the veins of color wet-on-wet with Quinacridone Red and a little Quinacridone Violet. Darken values as you go if they aren't quite intense enough.

Add more Gamboge and Phthalo Blue to the green to finish the stems.

If you think any lighter areas on your crocuses are too dark, paint them with clear water and lift some color.

MASTER THE ILLUSION OF WATER IN A VASE

PAPER | 80-lb. (170gsm) cold-pressed paper

PAINT | Cadmium Yellow Light · Carbazole Violet Cerulean Blue Gamboge · Indian Red Mars Violet · Nickel Titanate Yellow Phthalo Blue Quinacridone Red Quinacridone Violet Yellow Ochre

BRUSHES | nos. 4 and 6 rounds · 1-inch (25mm) flat

I often hear comments regarding the difficulty of painting a clear vase full of water. It's really not that hard if you pay attention to some key areas. Highlights are critical, so work around them carefully. The edge plane of the water is also important, as are the resulting distortions of stems and branches. Beyond that, the water is simply a melange of the colors around it. One of the most fun things about painting water is that any little drips and runs of paint that might ordinarily look odd work perfectly to capture the distortions created by the water.

In this demonstration we'll put the crocuses from pages 64-65 into a vase of water.

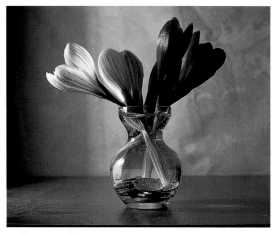

Reference Photo

1 Establish the Highlights

Mix a light wash of Nickel Titanate Yellow, Cadmium Yellow Light, Phthalo Blue and a touch of Carbazole Violet and start the stems, working around highlights and the surface of the water using your 1-inch (25mm) flat. Add a little Quinacridone Violet to the upper part of the stems while they're still wet.

Next, mix one wash of Yellow Ochre, Nickel Titanate Yellow and Quinacridone Red and another wash of Quinacridone Violet and Cerulean Blue. Apply these washes to the interior of the vase, working around all the highlights. Use your no. 6 round where you can, but if you don't have enough control, switch to a no. 4 round.

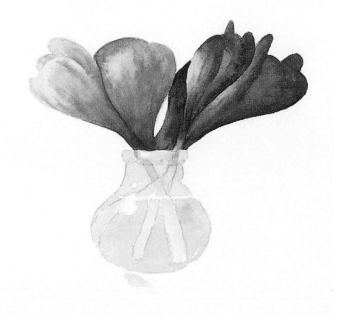

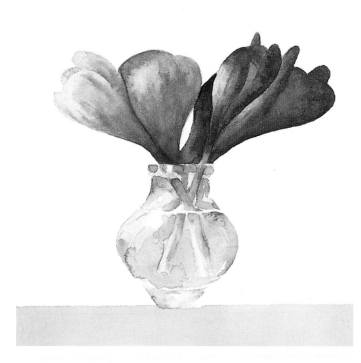

2 Let it Run

Use your green wash to continue the stems. Mix Carbazole Violet and Cerulean Blue into the other washes, making warm grays. Use these grays to further darken values, letting the colors run into each other haphazardly. You'll probably want to use your no. 4 round from here on out for the vase since the patches of color are getting smaller. All of the colors running into each other will help achieve the look of glass and water. Start the shelf with a light wash of Gamboge with a stroke of your 1-inch (25mm) flat.

3 Paint the Darkest Values

Use the previous mixes to establish the darkest values, working wet-on-dry, then letting the strokes overlap and run together. From the colors already on your palette, paint the anchoring shadow under the vase with a maroon-brown.

4 Lift for a Great Look

Moving from warm to cool, place a stroke of Gamboge, Indian Red and a little Mars Violet across the bottom of the shelf to finish it.

Now to bring the vase to life. Soften the edges of the highlight on the top lip of the vase, lifting a little color above it to create the illusion of a glinting highlight. Then use a clean, damp brush and place little strokes of water and lift color to create the illusion of light on the vase's surface. Finally, place a few random, light ochre-violet strokes wet-on-dry to finish the look of glass. See, you can do it!

Vegetables
Vary Your Painting Repertoire

This is a strange little painting, more abstract than most of my work. The fact is, though, that everything is an abstract collection of colors, edges and values. Some of these items you may consider "beautiful," others you may not. Many orchids, for instance, are made up of weird, ugly shapes, as far as I am concerned. You need to have an affinity for your subject matter in order to bring out its best qualities. Apparently, at least right now, I prefer eating lettuce to painting it.

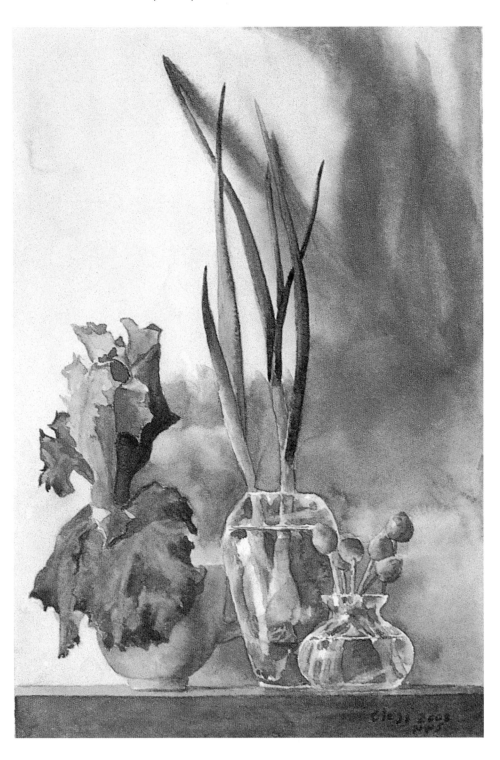

Scallions, Chives and Lettuce
9½" × 6½" (24cm × 17cm)
Collection of the artist

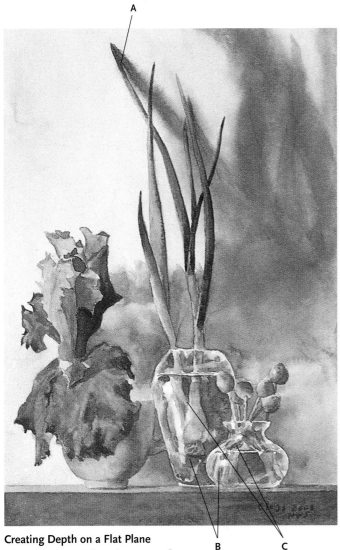

Creating Depth on a Flat Plane

It's an easy trap to allow shapes on a flat plane to remain static and separated. Try to use interesting shadows and overlapping shapes to prevent this.

A This shadow anchors the scallion to the wall, providing more depth than if it were missing.

B Overlap shapes on eye-level compositions to show what's in front and what's behind.

C To get objects in clear vases to look right, pay attention to how glass and water distort their forms.

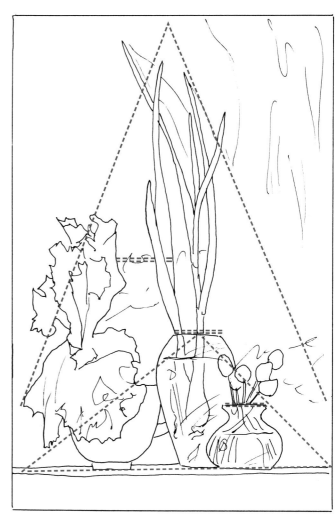

Double Triangles

The vertical shapes of the lettuce and scallions, connected to the shelf, make a dominant triangle that is then echoed by the smaller cluster of the cup and vases. You can see that the upper thrust of the scallions would stick the eye right in the middle of the painting without the directional movement provided by the cast shadows. Notice, too, that the shadows from the lettuce, as well as the top edges of the vases, provide horizontals that help to break up the overall vertical thrust of the design.

INVESTIGATE THE PATTERNS OF SPRING GARLIC

Materials List

PAPER | 80-lb. (170gsm) cold-pressed paper

PAINT | Cadmium Orange
Cadmium Yellow Light
Carbazole Violet
Cerulean Blue
Gamboge · Indian Red
Mars Violet · Nickel
Titanate Yellow
Phthalo Blue
Quinacridone Gold
Quinacridone Red
Raw Sienna
Ultramarine Blue
Yellow Ochre

BRUSHES | nos. 4
and 6 rounds · 1-inch
(25mm) flat

When I say that life without garlic would be meaningless, I'm joking, but not very much. Cooking without garlic would be like painting without red. You can do it, but would you really want to? My garden always has plenty of garlic, from the young, first-year greens to the maturing, second-year stalks that will be ready for harvest by late summer. While not exactly "pretty," the flat greens array themselves in interesting patterns.

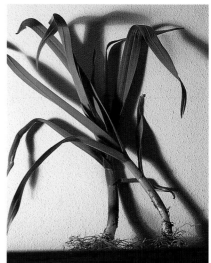

Reference Photo

1 Tone the Paper

When the color of your subject allows, it's a good idea to tone the paper as a first step. If you don't need any pure whites, this wash darkens the paper to its new lightest value and establishes a simple background. Use your 1-inch (25mm) flat to cover the paper with a light wash from a mixture of Nickel Titanate Yellow and a little Gamboge.

Add Cerulean Blue and Cadmium Yellow Light to the mix to start the green areas. Mix Quinacridone Red and Yellow Ochre for the red of the stalks, and a light mix of Nickel Titanate Yellow and Carbazole Violet for the white ends. Using your no. 4 and no. 6 rounds, start from the bottom wet-on-dry with the yellow-violet mix, switching to the red, then green as you go, painting the shapes of the garlic.

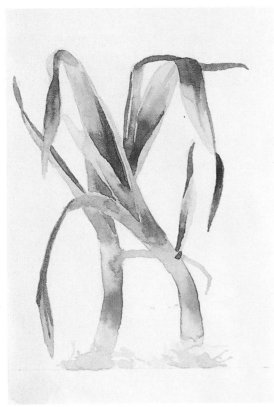

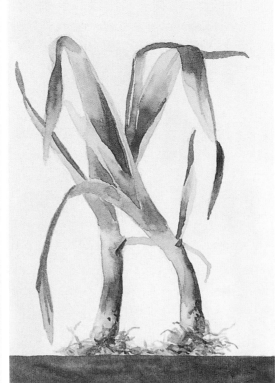

2 Define Edges

Add Phthalo Blue, Gamboge, Yellow Ochre and a little Quinacridone Gold to the previous green wash. Start to refine the edges of the garlic greens, drying the paper as needed to prevent the paint from bleeding into adjacent areas. Use your no. 4 round just to be safe, given the sharpness of many of the edges.

3 Give It Roots

Apply your previous mixes in darker washes to refine the lower portion of the stem. Add a mix of Ultramarine Blue and Raw Sienna for the darks of the roots and attached soil. Think of the roots as a large mass with a few negative shapes that stand out—you don't need to define every strand. Paint them wet-on-dry, then add more color wet-on-wet. Dry, and add a few more defining edges, if needed.

Use a mix of Gamboge, Indian Red, Mars Violet and a little Ultramarine Blue to paint the shelf, using the warmer colors to the left and adding more of the violet and blue as you go.

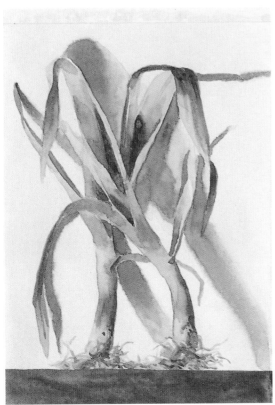

4 Anchor the Shadows

Mix a dark gray from Cadmium Orange, Ultramarine Blue and a little Carbazole Violet. Mix a little of your green wash into it as well. Paint the shadows wet-on-dry, softening the edges with clear water. Pay attention to how their values and edges lighten and soften as they move away from the objects. Use your darkest green mix to establish the final dark shadows in the greens.

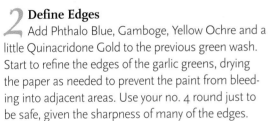

LETTUCE IN A CUP HOLDS MANY TEXTURE LESSONS

Materials List

PAPER | 80-lb. (170gsm) cold-pressed paper

PAINT | Burnt Sienna
Cadmium Orange
Cadmium Red
Cadmium Red Light
Cadmium Yellow Light
Carbazole Violet
Cerulean Blue · Naples
Yellow · Nickel Titanate
Yellow · Quinacridone
Burnt Orange
Quinacridone Gold

BRUSHES | nos. 4 and
6 rounds · 1-inch
(25mm) flat

Even though I've always kind of liked the overall shapes, colors and textures in a bed of mesclun, I hadn't ever considered it for painting. For eating, yes, definitely, with a nice vinaigrette and additional pluckings from the garden—maybe scallions, radishes, chive blossoms, baby dill and a bit of sorrel.

With its crinkly shapes and edges, this lettuce is definitely a lesson in "painting what you see." You can't make up the weird shapes of subjects like this, so the best thing to do is just closely follow what's there in front of you. Trust that, as a side result of good attention to drawing, color, value and edges, it will in fact look like a lettuce when you're done!

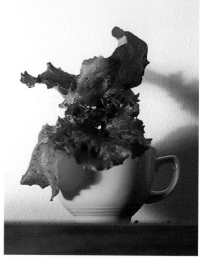

Reference Photo

1 Establish the Shapes

Get a start on both the cup and lettuce—neither have bright highlights—by toning down the paper. Mix a light wash of Nickel Titanate Yellow and Naples Yellow, and use a 1-inch (25mm) flat brush to tone down your paper. Pick up a little Burnt Sienna and float it onto the right side to add a little movement.

Mix Cadmium Orange, Quinacridone Burnt Orange, Nickel Titanate Yellow and a little Cerulean Blue. Apply a graded wash to the lettuce wet-on-dry with your no. 4 and no. 6 round brushes. Add a little Quinacridone Gold and Cadmium Red Light wet-on-wet to the shadow areas. Next, mix Naples Yellow and Cadmium Yellow Light and paint over cup and shelf, working carefully around the highlights on the left edge of the lettuce.

VINAIGRETTE HERESY

I love fresh vinaigrettes—easy to make and good for marinating, as well as topping a salad. However, the typical ratio of ingredients seems to be heavily weighted toward oil! Right now we have plenty of fresh chives and parsley, so they're my additions for this one.

1 T. (15ml) balsamic vinegar
2 T. (30ml) red wine vinegar
3 T. (45ml) extra virgin olive oil
1 t. (5ml) parsley, finely minced

1 T. (15ml) chives, finely minced
1 t. (15ml) Dijon mustard
1 t. (15ml) sugar
Salt and fresh cracked pepper

In a small mixing bowl, add vinegars and olive oil. Add parsley and chives. Plunk in Dijon mustard and sugar. Add salt and pepper to taste. Whisk vigorously with a whip and toss into a salad just before serving.

Serves four.

2 Develop the Lettuce and Cup

Mix mostly separate puddles of Quinacridone Burnt Orange, Quinacridone Gold, Cadmium Red Light, Cadmium Red, Cadmium Yellow Light and Carbazole Violet. Brush clear water over the leaf on the right and paint wet-on-wet, blotting and lifting if any colors run into the light areas. Dry and repeat for the leaf on the left, working carefully around the highlights at the edge of the leaf on the right. Alternate between a no. 4 and no. 6 round as necessary.

Add Cadmium Yellow Light and Naples Yellow to the above mixes and develop the cup, first wet-on-dry, then wet-on-wet. The reflected color from the lettuce changes the color of the yellow cup a great deal.

Next, apply your lettuce mix to the shelf with your 1-inch (25mm) flat.

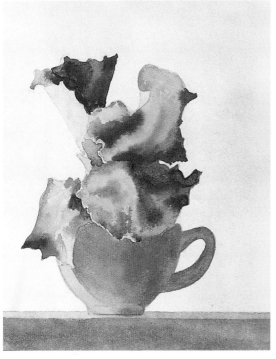

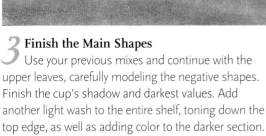

3 Finish the Main Shapes

Use your previous mixes and continue with the upper leaves, carefully modeling the negative shapes. Finish the cup's shadow and darkest values. Add another light wash to the entire shelf, toning down the top edge, as well as adding color to the darker section.

4 Add Small Touches to Finish

Using colors from the previous mixes, add small wet-on-dry details with your no. 4 round to finish the leaves.

Warm up lighter areas with the no. 6 round brush or the 1-inch (25mm) flat, laying in a few strokes of diluted Cadmium Red Light.

Use the no. 4 round brush to lift a few lights that may have been lost.

Finally, use your shelf mix to add the shadow under the cup and apply a last wash to the bottom of the shelf to complete it.

Capture
Elusive Appeal

During this tulip study, the left-most flower opened so much while I was painting the others that I had to paint it from memory, even though it was right in front of me. Because of the strong movements of some flowers, you may need to rework your arrangement, picking and choosing the flowers that work best compositionally. Here, the pansies engage the viewer's attention, looking right at the viewer, while the tulips are a bit more aloof.

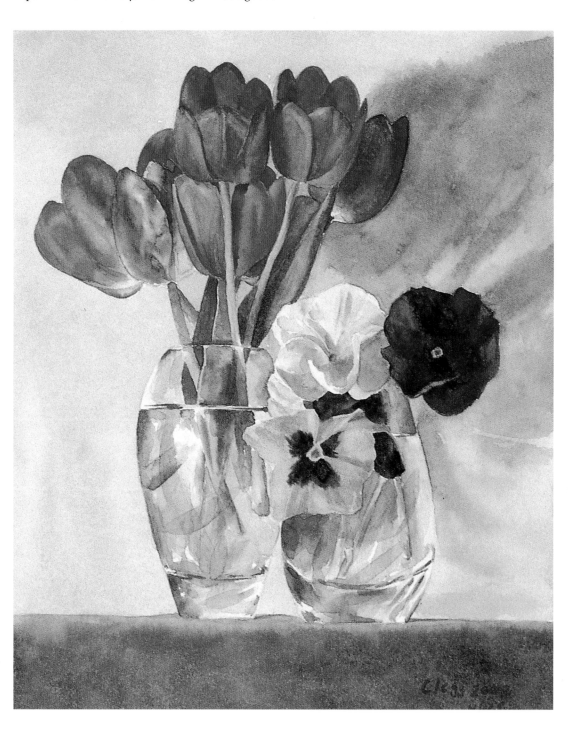

Spring Smiles
10½" × 8" (27cm × 20cm)
Collection of the artist

74

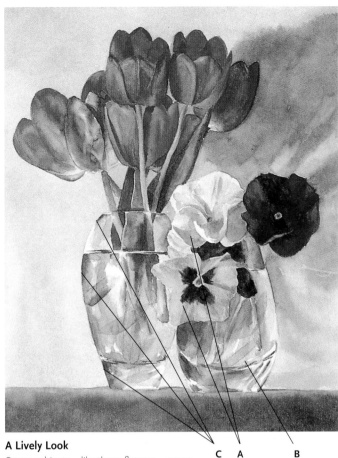

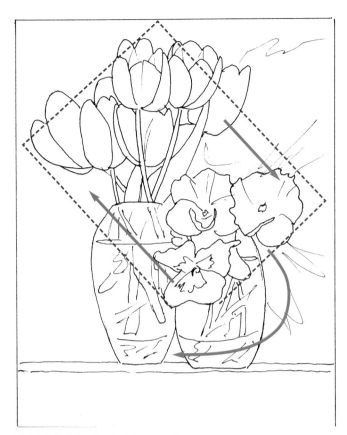

C A B

A Lively Look

Some subjects—like these flowers—are so
naturally dynamic you don't need to search
for ways to "punch it up." Just paint what
you see!

A A variety of pansies is more fun to look at
than one single type since each has its
own appeal—some solid, some with
faces.

B A number of small, wet-on-dry strokes
enhance the surface of the vases, as well
as creating an interesting abstract rhythm
and movement.

C Accenting a few key edges pops the vase
out; otherwise, it's nearly invisible against
the background.

Multiple Entries Create Movement

This composition has a playful movement that's hard to nail down exactly.
The eye can enter the painting at the tulips or the pansies, either the yellow
or dark purple pansy. Basically, the entire mass of flowers makes up a large
rectangle, and the eye moves back and forth within it, rotating in a circle or a
figure eight. Then, occasionally, it zips out of there, exploring the vases
before going back in. The movement actually reminds me of a bee in flight!

TULIPS, THE PERFECT FLOWERS FOR WATERCOLOR

Materials List

PAPER | 80-lb. (170gsm)
cold-pressed paper

PAINT | Azo Yellow · Cadmium Orange
Cadmium Red Light · Carbazole Violet
Cerulean Blue · Gamboge · Nickel
Titanate Yellow · Phthalo Blue
Quinacridone Gold · Quinacridone Red
Quinacridone Violet · Raw Sienna

BRUSHES | nos. 4, 6 and 10 rounds
1-inch (25mm) flat

If ever there was a flower made for watercolor, it's the tulip. The textures and delicate veins are perfectly suited for wet-on-wet painting, and if all goes well, the flowers appear with very little work. Tulips do have their downside, though: Put them in a vase, arrange them the way you like, then watch them quickly change before your eyes!

Reference Photo

1 Establish a Warm/Cool Transition

Mix a wash from Cadmium Orange and Nickel Titanate Yellow, and apply it with your 1-inch (25mm) flat, adding Cerulean Blue to the right side as you go. This will not only make a simple background, but establish a change in temperature for the lightest lights of the tulips, as well.

Next, mix a light reddish wash from Quinacridone Red and Cerulean Blue; a light yellow wash from Gamboge and Azo Yellow; and a light green wash from Azo Yellow, Phthalo Blue and Cerulean Blue. Use the reddish mixture to tone down the tulips, the yellow for the pitcher, and the green for the leaves. Use a no. 10 round brush, working wet-on-dry.

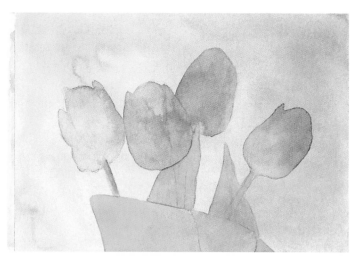

2 Paint Through the Shapes

Mix Quinacridone Gold and Phthalo Blue to paint the stems of the left and right tulips. Then, use the green from step 1 along with this mix to paint the leaves wet-on-wet. Lift color with a clean brush if it flows too much. Since the center stems will be darker than the leaves, you can save time by painting right through them. Use your no. 10 round, switching to your no. 4 round for fine edges.

Use a mix of Gamboge and Raw Sienna to paint the lip of the pitcher and darken the pitcher a bit, especially to the right of the leaves using your no. 6 round.

Where the tulip bottoms are exposed there's a bit of temperature change, so apply a little Nickel Titanate Yellow and Carbazole Violet to these spots using a no. 4 round.

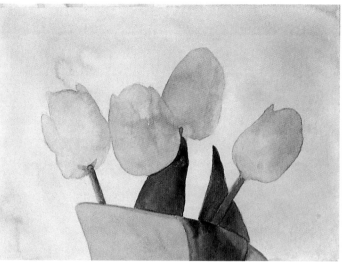

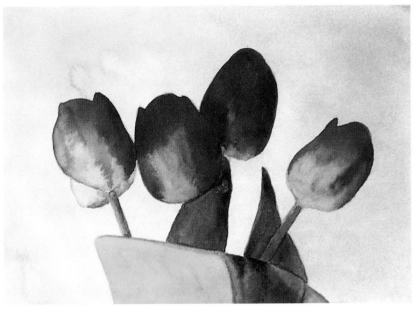

3 Making Tulips, Fast!

Mix a concentrated graded wash (see page 16) from Carbazole Violet, Cerulean Blue, Quinacridone Violet, Quinacridone Red, Cadmium Red Light, Gamboge and Nickel Titanate Yellow, making sure to leave each color partly unmixed. Use a lot of pigment—you don't want to run out halfway through. Paint the tulips wet-on-wet, working around the hard edge of the tulip on the left. Lift color if it bleeds into the highlights, and reapply more darks if your first strokes weren't intense enough. A single wet-on-wet passage can get you tulips that are already 90 percent done—but only if you're bold placing those dark values! Use your no. 10 round as much as you can, switching to smaller brushes as needed.

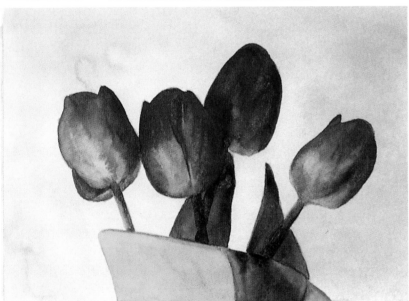

4 Establish Crucial Edges

Use the dark green mix from step 2 to paint the dark stems of the middle tulips and refine the others if they need it.

Use your tulip mixes to paint the opened petal on the left and define the darker petals.

To add the tulips' characteristic texture, lightly draw the shapes you want to lift with a clean, damp brush, and lift using a paper towel. The lit edges of the second tulip from the left are particularly important. Look at the tulip before and after you lift those two thin edges. You'll be surprised by the change! Use your best no. 4 round for this kind of work.

PAINT THE FACES OF PANSIES

Materials List

PAPER | 80-lb. (170gsm) cold-pressed paper

PAINT | Cadmium Orange · Cadmium Red · Cadmium Yellow Light Carbazole Violet · Gamboge · Mars Violet · Nickel Titanate Yellow Quinacridone Burnt Orange · Raw Sienna · Ultramarine Blue

BRUSHES | nos. 4, 6 and 10 rounds · 1-inch (25mm) flat

Despite their delicate appearance, pansies are hardy plants. Some years ago a really nasty hailstorm pretty much wiped out my garden. In ten minutes it just pulverized everything. But before too long, pansies were in bloom again!

With their terrific colors, I find them irresistible to paint. The kinds that have a "face" are particularly personable, but I haven't met a pansy I haven't liked! They do change pretty quickly though, so like tulips, you should paint them as fast as you can.

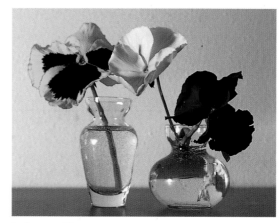

Reference Photo

1 Set the Shapes

If you make a pencil drawing, make sure it's light or erase all but a faint outline. Otherwise, it'll show through the light edges of the first two pansies.

Using a large round, paint the leftmost flower with Nickel Titanate Yellow. Paint the center flower with Nickel Titanate Yellow and a little Carbazole Violet.

2 Model the Form

Finish the center pansy by working from petal to petal with a mixture of Nickel Titanate Yellow and Carbazole Violet and another mixture of Ultramarine Blue and Cadmium Orange. Add Gamboge and Raw Sienna for the center. Work wet-on-dry then wet-on-wet, making sure to dry between each petal so the colors don't bleed.

Paint the left pansy with Cadmium Yellow Light. Dry, then go back in, working from petal to petal with a mix of Nickel Titanate Yellow, Cadmium Yellow Light and Carbazole Violet. As you go, paint the "face" wet-on-wet with a very saturated mix of Quinacridone Burnt Orange, Cadmium Red, Carbazole Violet and Mars Violet using your no. 4 round.

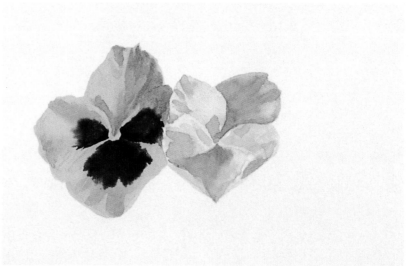

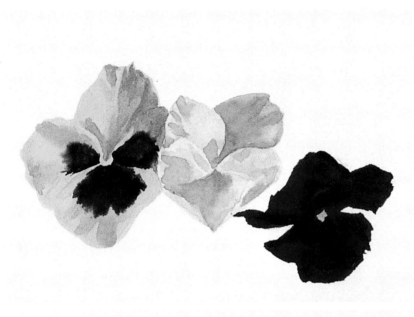

3 Get Dark

Paint the center of the pansy on the right with a mix of Cadmium Yellow Light, Nickel Titanate Yellow and Carbazole Violet. This small stroke completely defines the form of the flower. If you were to cover it the flower would lose its structure, so work carefully around it.

Add more Cadmium Red to the dark mix used to paint the face of the pansy on the left, and apply this mix wet-on-dry to the entire flower. Add more Carbazole Violet for the darkest areas and more Cadmium Red for the lightest. Don't worry about separating the petals. I would suggest using a no. 4 round for the complicated edges of the pansies. If you like, switch to a larger brush for the middle areas.

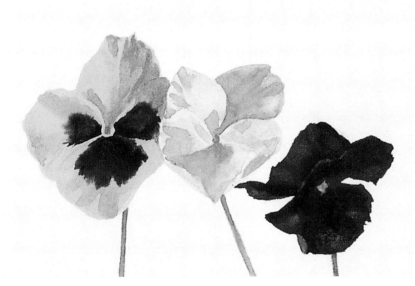

4 Take Away Paint

Anything as dark as the pansy on the right is ideal for lifting, and you'll need surprisingly little to turn this flat shape into a lively pansy! Use a no. 4 round brush—with a very good edge—to draw the narrow strokes that define the petal's edge above the center with clear water. Then, lift the color with a paper towel. Do the same with the other lighter areas. You don't want to lift too much, so just barely dampen your brush. It's easier to take two or three tries to lift enough color than to have to reapply paint.

Use a light mix of Gamboge, Nickel Titanate Yellow and a little Carbazole Violet for the stems. If you need to, go back in with your previous yellow mixes to darken the centers of the flowers.

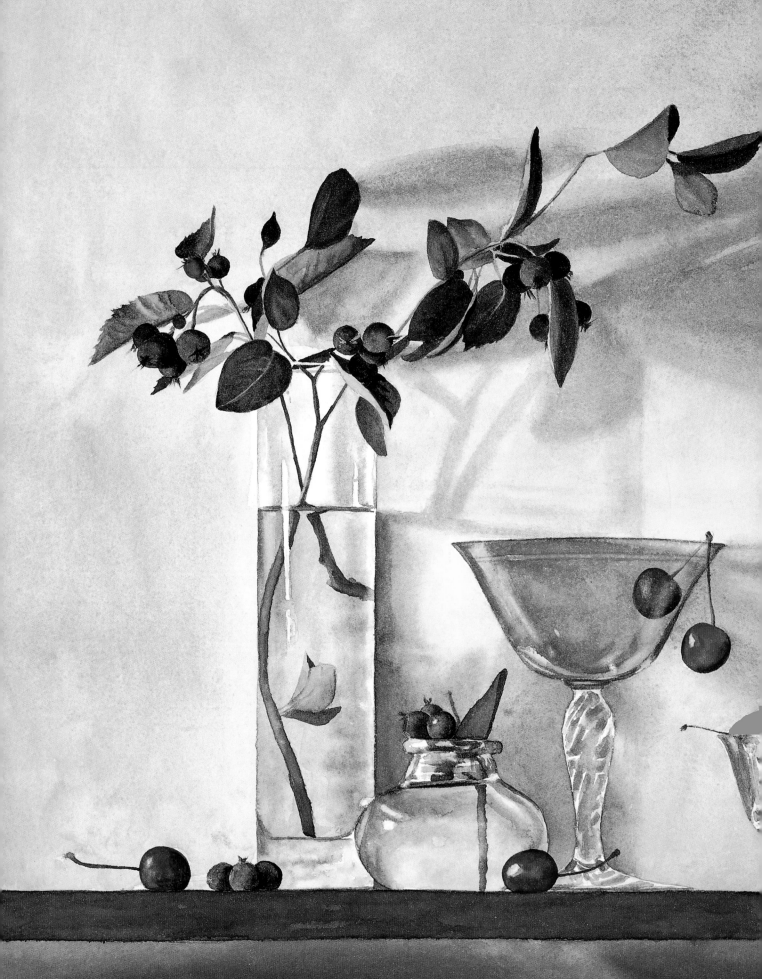

Summer 4

Get into summer and see if you can find something new in things that you've always taken for granted. If you've always just looked at your produce as "food," you're in for a different kind of treat when you paint it, too.

 Make sure to take advantage of the subject matter unique to your region. Washington, for instance, is well known for its apples. You might not know that it also produces much of the nation's cherries, lentils and about as many potatoes as Idaho—though I don't consider lentil and 'taters very exciting subject matter. The point is, take time and look around at your surroundings with a new perspective. You might be amazed at what is waiting for you right under your nose. Enjoy the season!

EGGPLANT TAPENADE

This is best made during the summer, when you can get ripe eggplants and peppers from the garden.

8 Japanese eggplants, 1½ lbs. (681g)
1 large yellow pepper, chopped small
¼ c. (60ml) pitted kalamata olives
½ c. (120ml) fresh cilantro
1 clove garlic

3 T. (45ml) good olive oil
2-3 T. (30ml-45ml) balsamic vinegar
2-3 t. (10ml-15ml) fresh lemon juice
Tabasco, salt and pepper, to taste
Belgian endive (optional)

Halve the eggplants lengthwise, and brush the pepper and eggplants with olive oil. Grill (low fire) until blackened and very soft, about 20 minutes.

Cool in a closed paper bag, then scrape the blackened skin from pepper and eggplants.

Scoop eggplants into a bowl and squeeze juices from skins into it. Blend in half the pepper and the remaining ingredients (be sure to drain the olives), reserving two tablespoons cilantro. Add a little olive oil and lemon juice if too thick.

Put into serving dish. Add the remaining pepper (chopped) and stir. Adjust seasonings to taste.

Garnish with cilantro and serve on Belgian endive boats.

Makes about 2 cups (serves 6 approximately).

Summer Serviceberries
16" × 16" (41cm × 41cm)
Private collection

Savor the
Summer Mood

After picking the garden, I take stock of how much my art has shaped my yard and how it in turn has nurtured my art. Once you decide where your creative voice speaks most loudly, things snowball. Though I happily paint gifts from friends' gardens, nothing gives me more pleasure than simply stepping outside my studio for something to paint.

As my wife and I have expanded our gardens, we put in new plantings with an eye toward subject matter. Hanson's sand cherry, golden elderberry, antique roses and a new maple tree will all provide me with good paintings in the future.

HERE AND GONE

Though the transition between seasons is gradual, certain subjects are icons of the season, particularly the cherries that ripen all too slowly, then are gone all too fast!

This typifies summer; the pace is fast as things have their day before something pops up in their stead. Painting from life reminds me of nature's pace. There's a richness to be savored in these fleeting encounters, and when I miss out, it just makes me anticipate their brief appearance next year.

Shouldn't I get tired of painting the "same old thing" every year? The answer, of course, is that there is no same old thing! Each sunflower has its own personality, and not only are no two alike, no one stays the same, either. The sunflower painted two days ago is a quite different character within forty-eight hours. It grows, fills out, and the sweet smell of pollen fills the room.

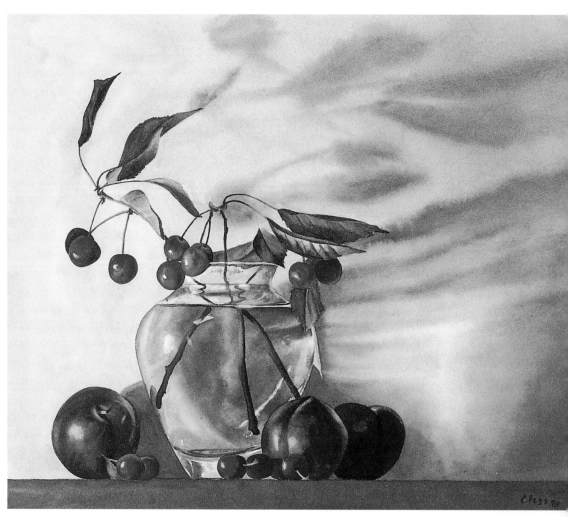

Summer Medley #9
13" x 16" (33cm x 41cm)
Private collection

SUMMER SUBJECTS

With all their varieties, I could probably work most of the summer just painting sunflowers! But there is so much else: strawberries and cherries give way to peaches and peppers; petunias and pansies make a season-long appearance; irises come and go early on.

FINDING YOUR SUBJECTS

If you don't garden, and don't want to garden, but you like the seasonal produce it offers, you might get by with what's available at your local grocery. Or explore farmer's markets and your local parks department. Make friends with gardeners at the local parks, and they might well be willing to share the bounty. Make sure to tell them that you're an artist! Depending on where you live, it might also be possible to buy "shares" of a farmer's crop. For a lump sum per growing season, you receive a weekly share of the pickings.

SUMMER LIGHT

The long days of summer also bring a different quality of light. Despite blinds and skylight shades, the studio is brighter than during the winter. And, of course, this light comes early and stays late.

I paint flowers much more in summer than the other seasons, and for the most part, I place them in clear vases. I love the quality of light blazing through a vase, and often a simple cast shadow on the wall is the best way to catch this type of effect.

WORKING FROM LIFE OR FROM PHOTOS

If you work from life, consider whether you have the time to finish before the subject moves or wilts. If you choose to tackle something and are unsure you'll have time to finish, it's probably wise to take photos so you'll at least have a reference to fall back on.

COPING WITH CHANGE

Here are a few tips that may help you out when painting subjects that move or wilt before your eyes:

1 **Plan in chunks**: Look at an area of your composition that could be filled with flowers that complement something else in the design. Instead of worrying about individual flowers, see it as an overall big shape.

2 **Refine the shape**: If you don't like the relationship of one shape and color to another, move objects around, take them out, and put in new ones until you see a good shape that works with one already painted.

3 **Prop it up**: Sometimes your subjects just won't "sit" the way you want them to. A trick I learned from Cézanne is to use pennies or other small coins to prop things up the way I want them.

4 **Refrigerate it**: If you're working on a painting of perishable fare that's going to stretch over several days, don't put subjects in until needed. Set them in place to see that they work in the design, then put them back in the refrigerator until you need them.

5 **Cheat**: If you have a large bowl to fill, you don't have to buy five pounds of cherries. Place a plate of appropriate size just inside the rim of the bowl, then dump in the cherries. You won't have to use nearly as many!

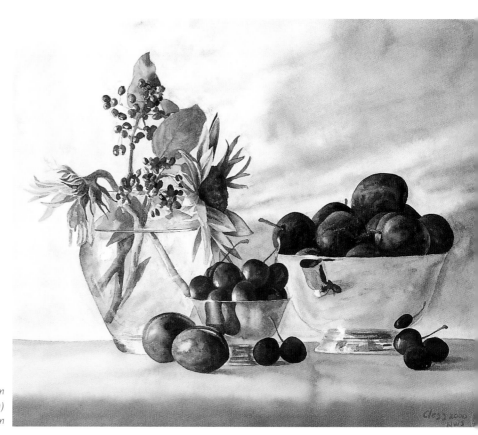

Sunflowers With Viburnum
14" × 16" (36cm × 41cm)
Private collection

Choose a
Summer Color Palette

As summer progresses, there's still plenty of green to be seen, but red is what I'm really looking for because it means one thing in particular—tomatoes! Anything I can do to speed up ripe tomatoes is worth a try. One of the best ways is simply to raise the right varieties. I mainly grow Heirlooms because of their exceptional flavor, but most of them also produce well. No hybrid I've seen can touch the Russian cultivar Stupice (Stoo-peach-ka) for earliness, and it has a good flavor for an early one. In a good year I pick my first by the end of June.

To be fair, though, red isn't the only color among my favorite tomatoes. Evergreen tomatoes are a bright green when ripe (feel one to test for ripeness) and a Black Krim tomato looks like it's been in a fight—just like the color of a black eye!

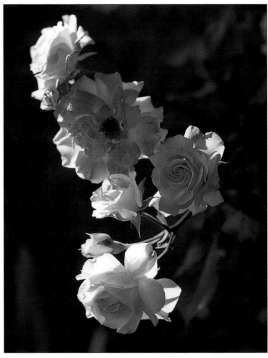

Take the Time to Smell the Roses
Remember, roses aren't always red. Take the time to look around you and see all the amazing colors just waiting to be explored. Try using those pinks to capture these beautiful blossoms.

Think Pink
Summer is a season of pinks, as well as reds. Though Cadmium Red and Cadmium Red Medium are nice reds, Quinacridone Red makes a pretty pink.

Quinacridone Red

Cadmium Red Medium

Cadmium Red

Fighting for Attention

If the two colors are nearly perfect complements of equal intensity, neither dominates and they "fight" for attention as shown here with Cadmium Red versus a mix of Hansa Yellow Light and Phthalo Blue.

Bold Statement

You can avoid having colors fight for attention by adding a little of the hue that you want to dominate to the other hue. With just a little Cadmium Red mixed into the green (Hansa Yellow Light plus Phthalo Blue), the green is slightly grayed out, and the red dominates. You can always make a pure hue appear even brighter by placing a duller complement nearby!

Subtle Energy

Sometimes, though, you want a red that whispers rather than shouts. Here's a warm earthy red (Quinacridone Burnt Orange) that contains quite a bit of yellow. Because it contains that yellow, adding it to your blue (Phthalo Blue) makes a rich green that harmonizes well with it, but still lets the red glow!

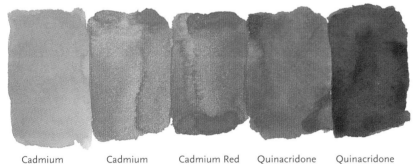

| Cadmium Orange | Cadmium Red | Cadmium Red Medium | Quinacridone Red | Quinacridone Magenta |

Orange and Purple Power

Since most reds aren't pure—they lean toward orange or purple—think of oranges, violets and purples as hues that extend the range of your summer reds. Warm them with orange, cool them with blue.

Quinacridone Magenta

Cadmium Orange

Cadmium Red

Cadmium Red

Color Impact

Though you can model a form adequately with one red, you can make it much more appealing by changing the temperature of the red!

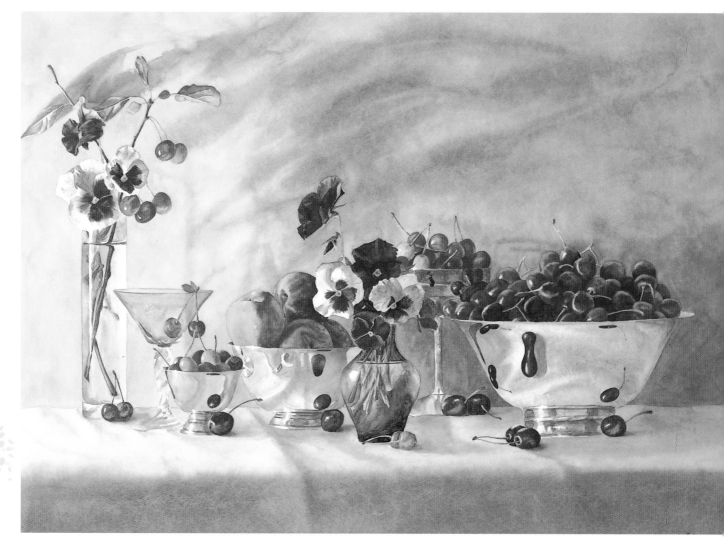

Garden Medley #6
22" × 30" (56cm × 76cm)
Private collection

Celebrate The
Profusion of Summer

This painting is a celebration of the abundance of
summer. Flowers and pie cherries from my yard
are complemented by fare from the market.
Though this is a busy composition, the quiet
expanse of cloth and the large negative space above
the fruit and flowers allow rest for the eye.

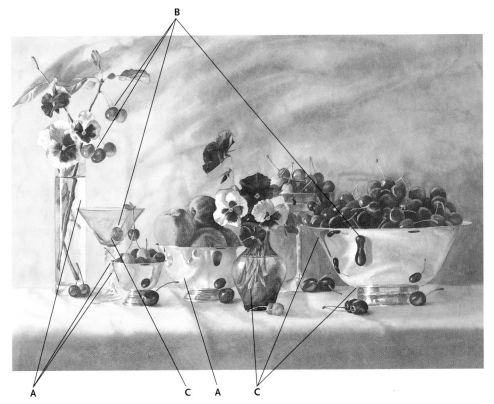

Abstract Punch

Even though I'm a representational painter, I readily make use of abstraction in my work. If you arrange shapes to be reflected, like this, be careful in case you make an accidental "smiley" face!

A A variety of lost and found edges provide movement through adjacent areas and help to create a feeling of light and airiness.

B Cherries dangling and reflecting in unusual places give a playful feeling to the painting, as well as providing extra movement into shapes that might otherwise be too empty.

C Though the reds dominate, enough green occurs for complementary impact; even small areas of reflected green have an impact when its overall use is so small.

Horizontal and Vertical

Even with all its activity, this design is simply structured. The eye enters at either the upper left or the pansy near the center—the only intrusions into the negative space that comprise the upper half of the painting.

If you enter at the center pansy, you rotate back left to the pansies, cherries and leaves, then sweep back through into the busy area with the massed fruit and flowers.

With all the overlapping shapes, it's fun to explore this busy area before reaching the edge of the silver bowl at the far right. Then, you encounter the secondary horizontal movement back along the base of the bowls, occasionally venturing upward into the vertical diversions provided by reflections, stems, etc.

The eye takes a break, traveling through the negative expanse of light and shadow above the main activity, then entering again. With the sweeping dive from the upper left into little hills and drops across the way, this painting's design is like a roller coaster ride!

demonstration
REFLECT YOUR SURROUNDINGS WITH SILVER

Materials List

PAPER | 80-lb. (170gsm) cold-pressed paper

PAINT | Burnt Sienna Carbazole Violet Gamboge • Nickel Titanate Yellow Quinacridone Red Ultramarine Blue Yellow Ochre

BRUSHES | nos. 4, 5 and 10 rounds • 1-inch (25mm) flat

Water and silver have great similarities: They take on the color of their surroundings, and the patina on the surface of a silver vessel is like the leaves and dust motes disturbing a perfect reflection in water. However, the curving surface of a silver bowl or pitcher distorts the reflected image, and care must be taken to draw the reflection the way it appears, not the way you think it should look.

The color of silver is dependent upon what it is reflecting. If you drape a black cloth around a shiny silver bowl, "silver" is basically black. A secondary factor is whether the silver is freshly polished or has acquired a patina. If patinated, the color can vary from a Burnt Sienna to a Charcoal.

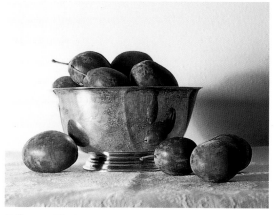

Reference Photo

1 Create a Background With One Wash

Mix Nickel Titanate Yellow, Yellow Ochre, Gamboge and Carbazole Violet. Apply a graded wash using your 1-inch (25mm) flat working from left to right. Work around the highlights, slightly darkening the wash as you move to the right. Then use the darkest mixture to begin painting the cloth at the bottom edge of the shelf. (If the paint flows upward into an area you want to remain light, just pick it up with a clean, damp brush. It's best to have a hair dryer at the ready, too, so you can fix the wash in place when it looks good to you.)

2 Paint the Silver and Cloth

Use the same basic mix as in step 1—with the addition of a little Ultramarine Blue in the darks—to paint the silver bowl. Working first wet-on-dry, then wet-on-wet, start to develop the bowl, which is actually the color of the cloth! Use a no. 10 round, switching to a smaller brush at the edges.

Dry the bowl, then work on the base with a wet wash and the same color mix. Drying that, use drier strokes of the same color mix to develop the darker accents on the base. Add a little Quinacridone Red and Carbazole Violet to your mix to paint the reflections of the plums onto the base of the bowl.

Wet the entire cloth area with a clean brush and use the same silver color mix to start refining it, darkening the lower portion of the painting and laying down shadows to the right of the bowl and plums.

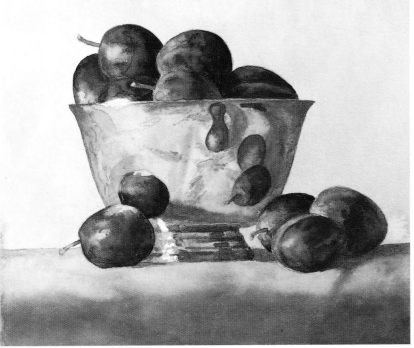

3 Add the Patina

Look on pages 118-119 for how to paint the plums and their reflections.

Use a no. 4 round and a dark mix of the cloth color from step 1 to adjust the shadows under the plums, so they don't appear to float. Then, using a dry brush and a little Burnt Sienna and Yellow Ochre mix, drag it lightly across the bowl in a few areas. From a distance, it will appear as the patina on the surface of the bowl. The reflections, though odd, are a large part of what makes silver look like silver.

89

FOCUS ON CHERRIES' INTENSE COLOR

Materials List

PAPER | 80-lb. (170gsm) cold-pressed paper

PAINT | Burnt Sienna (optional) · Cadmium Orange · Cadmium Red Light · Cadmium Red Medium · Cadmium Yellow Light · Carbazole Violet · Nickel Titanate Yellow · Phthalo Blue · Quinacridone Red · Ultramarine Blue · Yellow Ochre

BRUSHES | nos. 4, 5 and 10 rounds

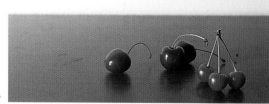

Cherries' deep, intense color and shiny, reflective surfaces make them strong focal points in any composition. And since they can be grouped in a variety of ways, from a single cherry to a big bowlful, you can determine their impact by the quantity and arrangement you choose.

Reference Photo

1 Plan the Placement

Even though this is a simple composition, pay attention to design. You can place a cherry near the middle if you provide a way out. Weight the stems toward the right side of the composition. Place the small cherries slightly lower than the others to avoid a boring, straight line all the way across.

2 Work Through Shapes

Always be aware of chances to combine steps that will save time and simplify the painting process. Start with the background and the cherries, since they share a common foundation color. Mix a pale orange from Nickel Titanate Yellow and a little Cadmium Orange. Using your largest brush when you can, paint the entire surface with this wash. Work carefully around the highlights on the cherries and the light sections of the stems.

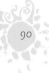
90

RECIPE TIP

I grow my own pie cherries, Montmorency and Northstar. Since most cherry pies are too sweet for me, I like the tartness of these, and they also make for a great cherry chipotle sauce to serve with pork chops or tenderloin.

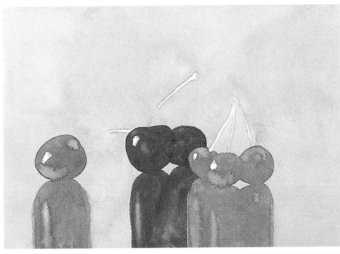

3 Establish Middle Values

Using Cadmium Red Medium for the cherry to the left, apply a fairly concentrated flat wash to the entire cherry and its reflection. Next, rinse the paint from your no. 4 round and leave it slightly wet. Touch the brush to any light areas of the cherry and to the highlights' reflections underneath, lifting paint from those areas. Clean the brush between touches, until enough color is lifted. Repeat the process for the other cherries, using Quinacridone Red, Cadmium Red Medium, Carbazole Violet and a little Phthalo Blue for the middle two cherries and Cadmium Red Light for the pie cherries.

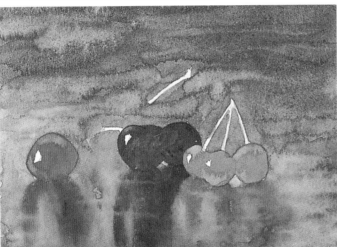

4 Create the Background

Add Cadmium Orange and Ultramarine Blue to some of the existing red-orange already on your palette. Try not to mix it too thoroughly; a little variety in the color is nice. Starting darker at the top, work your way down the paper with this mix, moving around the cherries and stems. The paint should be wet, but with a lot of pigment. Swish your brush back and forth enough to soften the edges of the reflections. You can enhance the "wet" look by touching the paper with a clean brush and a little water.

5 Accent the Impact

Work on individual cherries and establish the shadows. Use more violet for the larger Bing cherries and more Cadmium Red Medium for the smaller pie cherries.

At this point you'll see that the cherries still don't look "real." The small reflections, especially on the edges of the cherries, are still missing. Use a paper towel to soften the edges of the highlights and lift the other edges and reflections. Paint the stems with a wash mixed from Yellow Ochre and Nickel Titanate Yellow, adding Cadmium Yellow Light and a little Phthalo Blue to part of it. Keep the color a light yellow on the lit side and darker green for the shadow areas. Finally, paint the stem ends, using an already-mixed brown color or Burnt Sienna.

TURN PEACHES INTO TOMATOES

Materials List

PAPER | 80-lb. (170gsm) cold-pressed paper

PAINT | Cadmium Red Cadmium Red Medium Carbazole Violet Gamboge • Nickel Titanate Yellow • Raw Sienna • Ultramarine Blue • Yellow Ochre

BRUSHES | nos. 4, 5 and 10 rounds

As your understanding of values and edges increases, you can begin looking for the key characteristics that define some subjects. Peaches, for instance, might be defined largely by their edge quality—soft with fuzz. Tomatoes have shiny skins, giving them a completely different surface appearance. Let's see how easy it is to use this knowledge to turn a peach into a tomato!

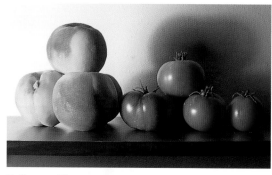

Reference Photo

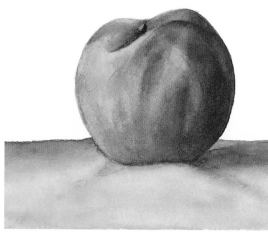

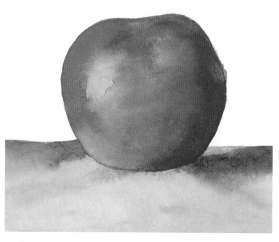

1 Paint a Peach

Mix individual puddles of Nickel Titanate Yellow, Gamboge, Cadmium Red, Yellow Ochre and Carbazole Violet. Lay in a wash of Nickel Titanate Yellow and Gamboge, adding Cadmium Red and Carbazole Violet as you work into the shadows.

Dry the paper, then work into the dry paper, developing the stem cavity with the mix you used for the shadow side, with the addition of more Cadmium Red and Carbazole Violet.

Lay down strokes of Cadmium Red and Gamboge to develop the striated patterns on the peach. This may take two or three steps, drying between each step.

If you like, you can give the peach a foreground with a simple wash mixed from Nickel Titanate Yellow, Gamboge and Raw Sienna. Use a no. 10 for the foreground wash and your smaller brushes for the detail areas, such as the cavity.

2 Begin the Change

Mix a big puddle of saturated Cadmium Red, Cadmium Red Medium, Gamboge and Carbazole Violet. Using your no. 10 round, paint this mix into the peach. Lay down a lot of color, and lift an area for the highlight. You can also begin to modify the shape, making it rounder at the top. As you lay in the darks, the peach's lightest value begins to look like a highlight on the tomato!

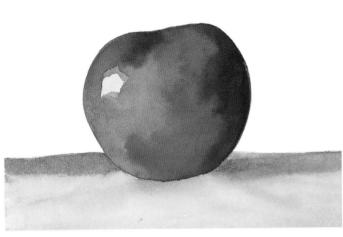

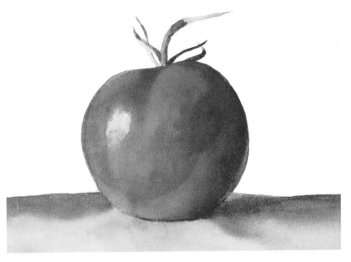

3 Establish the Darks

Using the same mix as in step 2, make another pass, working totally around the highlight and going darker in the shadowed areas. Don't worry if the colors appear too dark, because you'll lift them in the next stage.

4 Finish the Switch

Using a paper towel, lift some color to establish the little crease at the top center of the tomato, as well as all the other lights. A tomato's skin is shiny, causing it to reflect the light value of the cloth beneath it. Make sure to soften the highlight; this aids the illusion of light bouncing off the surface, rather than looking like a hole in the painting.

Paint the stem with a mix of Ultramarine Blue and Nickel Titanate Yellow. Apply the yellow first, then the darker green, working in a couple of stages if needed. Just like peach fuzz for a peach, a tomato's stem is one of its defining characteristics!

FRIED GREEN TOMATOES WITH DIPPING SAUCE

At some point, every gardener has an excess of green tomatoes.

4 medium green tomatoes
2 eggs, whipped

2 c. (470ml) seasoned* corn meal
canola oil

DIPPING SAUCE INGREDIENTS

5 T. (75ml) chopped cilantro
4 T. (60ml) good quality olive oil
3 T. (45ml) white vinegar
2 T. (30ml) soy sauce

2 T. (30ml) molasses
½ t. (3ml) minced jalapeno
Pinch kosher salt

Slice the tomatoes about ¾-inch (2cm) thick, discarding ends. Dip them into egg, then dredge with cornmeal.

Meanwhile, heat about a ½-inch (1cm) of oil in a large skillet on high, almost to smoking. Reduce to medium high and fry tomatoes in batches until golden brown. Drain on paper towels.

In a small bowl, whip up all ingredients for dipping sauce. Spoon over tomatoes and serve.

Serves four

*Seasoned cornmeal: Add a generous pinch of salt and a tablespoon or two of paprika and cumin or turmeric.

Eggplants Can Teach a Lesson About Scale

Materials List

Paper | 80-lb. (170gsm) cold-pressed paper

Paint | Cadmium Orange Carbazole Violet Cerulean Blue · Cobalt Blue · Gamboge Indian Red · Nickel Titanate Yellow Phthalo Blue

Brushes | nos. 4, 5 and 6 rounds · 1-inch (25mm) flat

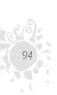

Eggplants come in a bewildering variety of shapes and colors (you can grow orange and pink varieties), as well as sizes. In the photo, you can see how ridiculous the little Oriental eggplant appears against its more traditional—and much larger—companion. In these situations feel free to make changes to fix the problems of scale.

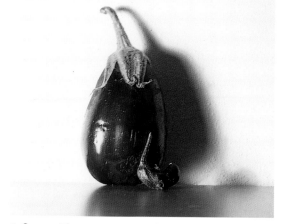

Reference Photo

1 Tone the Paper

Make diluted, separate puddles of Cadmium Orange and Cobalt Blue. Using your 1-inch (25mm) flat, stroke in the orange on the left side of the paper, working from top to bottom. Without cleaning your brush (this will prevent the blue from being too bright), pick up some of the blue and cover the rest of the paper—no need to work around anything.

Use a no. 4 round and a mix of Cerulean Blue with a little Carbazole Violet, and start the stem of the small eggplant wet-on-dry. Dry the paper, and using the same mix—but much more saturated for the darks—paint the small eggplant, wet-on-wet. Lift the color if it flows into the areas where it doesn't belong.

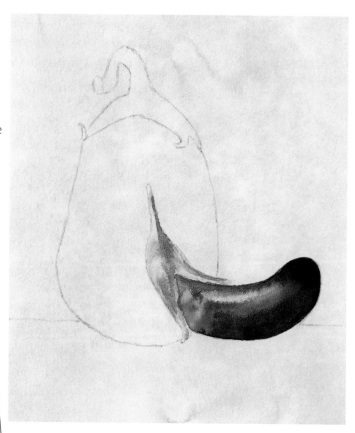

Good or Greasy

If you're frying eggplant, it really does matter whether you salt it first or not. Gastronomic scientists (yes, there is such a field) have found the reason why: Eggplants have large, water-filled cells with small air pockets all around. Heat collapses the cells, allowing oil to rush in to fill the air pockets. Salting the eggplant before cooking collapses the cells and the air pockets, so there is no place for the oil to go. Voila—crisp, nonoily eggplant slices!

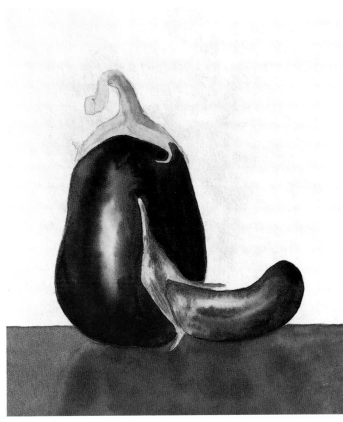

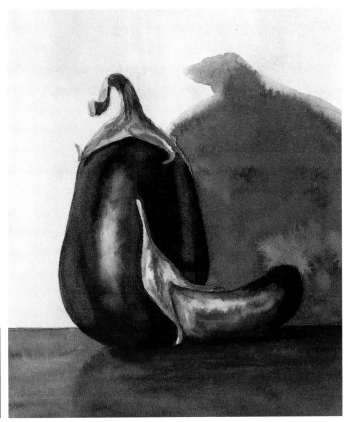

2 Paint Strong Darks

Mix a very strong puddle of Cerulean Blue, Carbazole Violet and Indian Red. Make sure it's as dark a wash as you can mix—only enough water to keep it moving. Wet the large eggplant with your large brush, and a smaller one if needed around the edges, and paint the whole eggplant wet-on-wet. Don't worry if it seems too dark everywhere except the highlight. You'll lift color next.

Since the stem of the small eggplant will all of a sudden appear very bright, tone it down in a repeat of the first step. Start the stem with a light Nickel Titanate Yellow wash, adding a little Phthalo Blue added to a portion.

Using your 1-inch (25mm) flat and a mix of Gamboge, Indian Red and Carbazole Violet, start the shelf wet-on-dry.

3 Model the Planes

Use a paper towel to lift and establish the edge transitions and reflected light on the large eggplant. Use a no. 10 round for the big changes and a no. 4 to adjust edges along the highlight. To soften the highlight, touch a clean, damp brush to its edges and lift with a paper towel. Dry, then if it is still too bright, run one stroke across it with a clean, damp brush. Blot immediately if you drag too much color over the highlight.

Repeat step 2 for the stem and shelf, mostly wet-on-dry for the stem. Darken your shelf mix with more Carbazole Violet and Indian Red if needed and anchor your eggplants with darker shadows.

Finally, make a simple mix from Cobalt Blue and Cadmium Orange, and paint a fairly saturated wash on the shadow on the wall wet-on-dry, then wet-on-wet as needed to cover thoroughly. You should be able to use the 1-inch (25mm) flat except where the little edges meet. Don't worry if the wash doesn't dry evenly—it'll be visually more interesting if it doesn't!

Sunny Flowers
Sing

My wife plants most of the beautiful roses we have, and I plant annuals in with the veggies and around the house. Flowers attract garden helpers, such as the small trachanid wasps that enjoy a picnic of aphids. I love the intense colors of petunias.

Marigolds and nasturtiums are supposed to help repel aphids. Most of my flowers reseed themselves, but I also make sure to plant plenty.

However, growing up in Kansas, I think I have a legitimate claim for saying that sunflowers are the plant world's best symbol of summer. And they smell much better than roses. By the way, Kansas's highest point—at the nosebleed-inducing altitude of 4,039 feet—is Mount Sunflower!

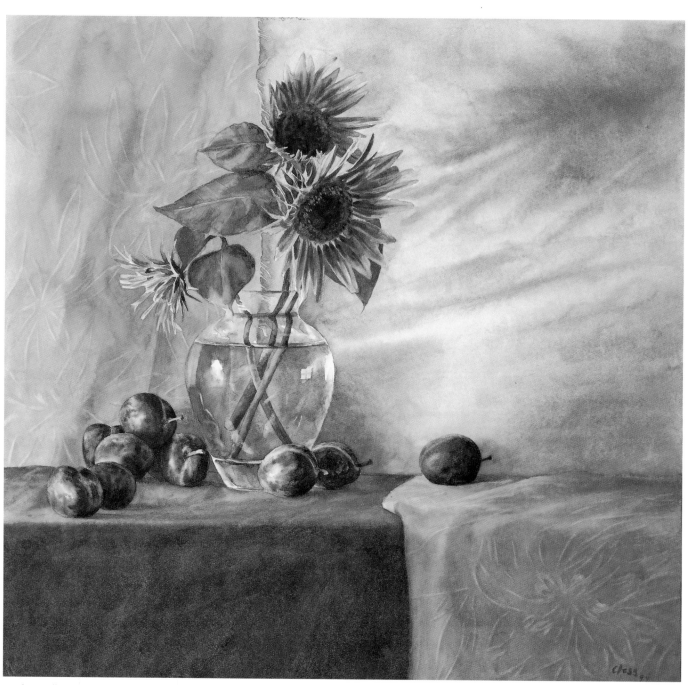

Garden Medley #2
19" × 20" (48cm × 51cm)
Private collection

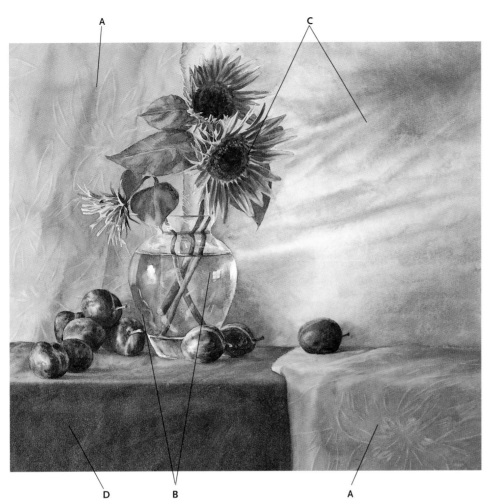

Tie It Together

This is a good example of using the background to make a centered design work well. Without the breakup of negative space it provides, this would be a relatively boring composition.

A The pattern in the cloth repeats the shape of the sunflower petals. The gold harmonizes with the flowers, while providing a complement to the plums.

B Attention to small details in the vase—for instance, the plums' and window's reflections onto it—contributes to creating the illusion of glass.

C The shadow repeats the shape of the flowers and balances the blaze of light just below.

D The large, dark expanse helps to anchor the painting, and relates to both the dark values of the plums and the green leaves.

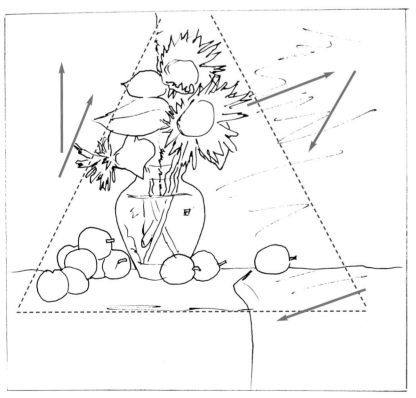

A Rectangular Skeleton

If you were to take away the sunflowers, vase and plums, this would still be a good painting! Notice not only how each rectangle formed by the cloths' edges is a different size, but that each boundary roughly follows the rule of thirds. Look also at how the two gold cloths play against each other, balanced by the other diagonal opposition of light and dark. With this as a foundation, it's hard to miss.

As in many of my designs, the mass of the foreground is framed by a large triangle, just about guaranteeing that the eye will pay attention to the shapes within. The arrows indicate just a few of the directional indicators that help move you to other areas. Ideally, you should provide something of interest—and a path to get there—in every square inch of your paintings. Granted, that's tough to do!

Materials List

PAPER | 80-lb. (170gsm) cold-pressed paper

PAINT | Burnt Sienna
Carbazole Violet
Cadmium Yellow
Nickel Titanate Yellow
Raw Sienna
Ultramarine Blue
Yellow Ochre

BRUSHES | nos. 4, 5 and 6 rounds

Most flowers are complex shapes that require careful drawing. Their shapes, however, can sometimes create compositional problems. For instance, the center of a sunflower often makes a "bull's-eye" that's hard for the eye to leave. You can change these shapes as needed, perhaps painting the center of one sunflower and the petals of another or painting leaves where you want them to go rather than where they are.

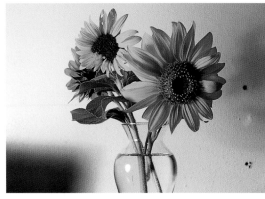

Reference Photo

1 Plan Your Shape

By varying the negative shapes of the petals and painting a leaf that moves the eye from the center, you'll create a more interesting study. Use your no. 6 round and switch to a no. 4 for the edges. Work your way across the flower with Nickel Titanate Yellow wet-on-dry, changing to Cadmium Yellow as you go. Apply a little Yellow Ochre to the center and Burnt Sienna to the dark of the petals.

2 Watch the Edges

Dip enough paint from your wells to create a graded mix with them all. Yellow Ochre and Burnt Sienna should dominate, but add a little Carbazole Violet or Ultramarine Blue for the darker areas. Work wet-on-dry with a no. 4 or no. 5 round around the entire flower, watching the edges carefully so paint doesn't flow into the lightest areas. Let the paint run together where soft or lost edges occur.

98

3 Develop the Center

You can use your larger brush to lay in a wash of Yellow Ochre, Raw Sienna and Burnt Sienna to the center of the sunflower. Then, into the wet paper, apply a darker passage with Carbazole Violet added to the mix to start the shadows across the center. Put down a darker Burnt Sienna/Carbazole Violet mix around the right edge of the center, pulling some of the color into the darks of the petals. If it wants to flow back into the right edge of the center, use a moist, clean brush to lift paint from the area, or blot slightly with a paper towel.

4 Add Final Details

Repeat the previous step to refine the center, adding a little Ultramarine Blue to the mix this time—it will add a little green that relates to the stem and leaves, providing more interest.

Using the petal mix from step 2, apply the final darks to edges between the petals and the shadow to the right side of the center.

Paint a mix of Ultramarine Blue, Yellow Ochre and Nickel Titanate Yellow on the stem and leaf. Be careful to keep the bottom of the stem quite light; otherwise, the eye will be unsure which shape is dominant—the stem or the leaf to the right.

PETUNIAS ARE PERFECT FOR LIFTING COLOR

Materials List

PAPER | 80-lb. (170gsm) cold-pressed paper

PAINT | Burnt Sienna
Cadmium Orange
Cadmium Red
Cadmium Red Medium
Carbazole Violet
Cerulean Blue · Nickel
Titanate Yellow
Phthalo Blue
Yellow Ochre

BRUSHES | nos. 4, 5 and 6 rounds

Petunias can take on almost any shape and color, so it's hard to give a "recipe" for painting them. Just make sure the center cavity, from which the pistil comes, is basically in the middle of the flower. Petals vary in length, but if the cavity isn't well centered, the drawing's going to look awkward. About the only thing true of all petunias (all I've seen, anyway) is their "softness." Even in a bright light, strong highlights are almost nonexistent. This makes them ideal subjects for painting by lifting color.

Reference Photo

1 Paint the Foundation Colors

Using your largest brush for the interior and a smaller brush at the edges, put down a fairly saturated wash on the left flower with lots of Cadmium Orange and a little Nickel Titanate Yellow. Let it run a little to add texture. Repeat the process, using Nickel Titanate Yellow with a very small amount of Phthalo Blue for the stem. Use Nickel Titanate Yellow with a small amount of Cadmium Orange for the center flower. Use Cerulean Blue with a little Carbazole Violet for the last petunia.

2 Deepen the Values

Following the same process as in the first step, paint the petunia to the left, adding Cadmium Red, Cadmium Red Medium and Carbazole Violet to the mix. The paint should be saturated, with just enough water to flow easily. Add the darker mix to the shadow areas and to the center of the flower, then touch a few of the lighter areas—to start creating light-to-dark transitions—using a clean, moist no. 4 round. Repeat this process for the center flower, working around the center, but add Yellow Ochre to the mix. Use the same flower mix, with Carbazole Violet added, for the last flower and work around the edges where the petals fold over. You can suggest the center of the flower with a very dark stroke, making sure the paper is still wet so it softens the edge.

3 Pull Back the Lights

Now that you have all the darks you need on the paper, it's time to retrieve the light areas that will model the flowers. Using your no. 4 round, paint the light shapes with a little clear wate. Place a clean paper towel over the top and press firmly to lift the color. It may take several passes to pull out the lightest areas. Do this with all the flowers, then finish the stem with the addition of a little orange to suggest the reflected color from the left flower. Paint the center of the middle flower with Burnt Sienna and a little Carbazole Violet. Lay in a few dry strokes, softening if needed, to finish the light edges of the last flower. Notice how offsetting the flower to the left and overlapping the other two adds interest to even this simple study. By the way, petunias smell awfully nice, too!

OLD-FASHIONED ROSES ADD AN AIR OF FAMILIARITY

Materials List

PAPER | 80-lb. (170gsm) cold-pressed paper

PAINT | Burnt Sienna Cadmium Red Cadmium Red Light Carbazole Violet Gamboge · Nickel Titanate Yellow Phthalo Blue · Quinacridone Red

BRUSHES | nos. 4, 5 and 6 rounds

The open petals of antique roses seem friendly, and the bushes themselves are hardy and are often adapted to native conditions. My wife has a lot of roses, but the old-fashioned ones thrive best. It seems I never remember their names, even though she's told me a zillion times.

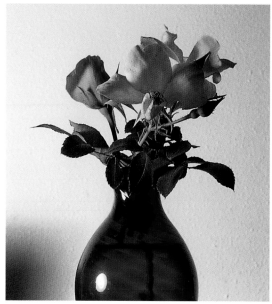

Reference Photo

1 Orange vs. Pink

Using your no. 6 round and a smaller brush where needed for control, paint the two flowers with a wet wash of Nickel Titanate Yellow. While the wash is still wet, establish the difference between the orange and pink roses by adding Gamboge to the left rose and Quinacridone Red to the right. Lift color if it floats into the lighter areas.

2 Create Crisp and Soft Edges

Work carefully around the hard edges that model the petals, painting the lightest areas of the orange rose with Gamboge and gradually adding Nickel Titanate Yellow, Cadmium Red Light, Cadmium Red and Carbazole Violet for the darker areas. Let the colors mix in a random fashion to re-create the transitions of the real rose. Do the same for the pink rose, using a mix of Nickel Titanate Yellow, Carbazole Violet and Quinacridone Red.

3 Add Small Details

Using the same mix from step 2, refine the darks in the orange rose. You can either work around the lighter areas or lift them later. Model the stems with a Nickel Titanate Yellow and Phthalo Blue mix, adding a little orange for reflected color.

Refine the darks on the pink rose with the mix from step 2, modeling the form a bit more. Paint the stems of this rose as you did for the first flower. Then, paint the center with your smallest brush and a dark Burnt Sienna and Carbazole Violet mix, using only enough water to keep the pigment transparent. As you finish the center, you'll see how the flower moves quickly from looking very unfinished to complete!

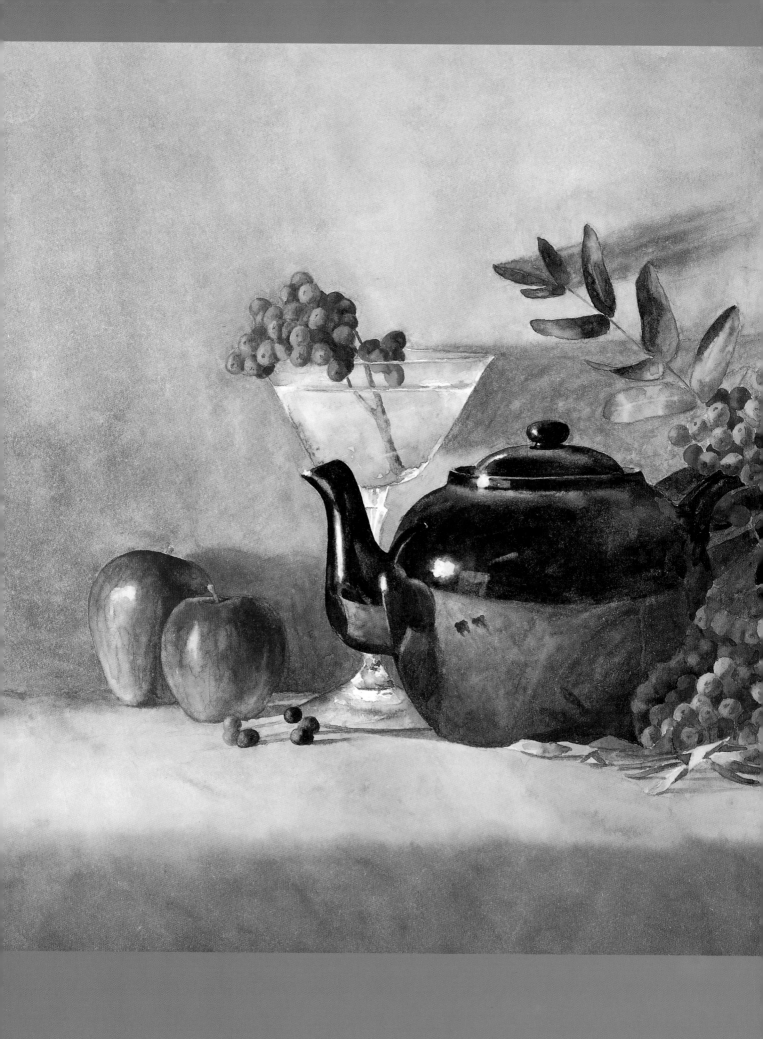

Autumn

Autumn is my favorite season, and October is my favorite month. I think most artists probably have a preference for certain color combinations, and I happen to be a huge fan of autumn's burnt oranges, golds and reds, often still juxtaposed with complementary greens. All things being equal, the more of an impact your subject has on you, the better you'll paint. Perhaps I'm not the best judge, but year after year, my favorite paintings tend to be done in the autumn.

OYSTER DRESSING

2 jars fresh oysters (10 oz. each [280g])
½ lb. (227g) bacon
3 large stalks celery
1 large onion
8 slices stale, cheap white bread

1½ T. (23ml) sage
½ t. (3ml) fresh ground pepper
1 T. (15ml) tarragon
1 t. (5ml) paprika

Chop onion and celery, then sauté in butter until slightly soft. Tear the bread and put in a mixing bowl with celery, onion and seasonings.

Tear bits bacon and sauté until done, but not browned. Add oysters and juices to skillet and break into chunks.

Dump into mixing bowl and stir well. If consistency isn't right, add more bread or water.

Refrigerate until time to cook. Place in an ovenproof dish and bake, covered, alongside the turkey for the last hour of cooking at 325°F (163°C).

Serves six.

*Clegg 2000
NWS*

Autumn Medley #3
14½" × 18½" (37cm × 47cm)
Private collection

Harvest the
Autumn Mood

As summer winds down, the days get shorter, the nights get cooler, and I hope an early frost doesn't bring a premature end to my tomatoes! But even if one does come, it's fun to look into the compost pile, where my best squash generally grow, and see the ones that had been hidden by their huge leaves.

For a gardener, everything is fulfilled in the autumn. In some climates, weather can still be summerlike and allow an extended picking of ripe red peppers, tomatoes and the last of the pole beans. It's time to harvest those crops that have been maturing for months: dig the potatoes, pick the winter squash, pull up sweet carrots and cut bitter radicchio.

If you like to cook, there's no better season. Grilling outdoors isn't the sweaty enterprise of mid-July, and the cooler nights give an excuse for the occasional soup or stew. The garden has reached its zenith, and you can take time to can green tomatoes, tomatillos, peppers (which I dry, too), salsas and bread-and-butter pickles.

Keeping a Connection

Gardening is a lot of work, but the rewards—visual and culinary—are worth it. If you extend your efforts by freezing, drying and canning, you can eat from the garden year-round.

Canning is the most time intensive, but also the most satisfying method of storing food. I feel like the glass jars are containers of time. When I open a jar of dilled beans, I'm getting back the fifteen minutes of work that that jar represents: blanching and chilling the beans, sterilizing the jars and lids, adding the peppers, dill, garlic, seasonings and the vinegar-and-salt solution.

In a day and age when almost anything we want can be found ready-made at a store, it is rewarding to maintain a connection with at least some of the food that sustains us. And when I open a jar of salsa in January, the work it took to make it certainly feels worthwhile!

A Visual Feast

In the final tally, though, the most rewarding aspect of gardening for me has to be the pleasure it gives me as an artist. Walking through the paths, looking at the squash, the corn and the tall sunflowers, is all tremendous inspiration for my work.

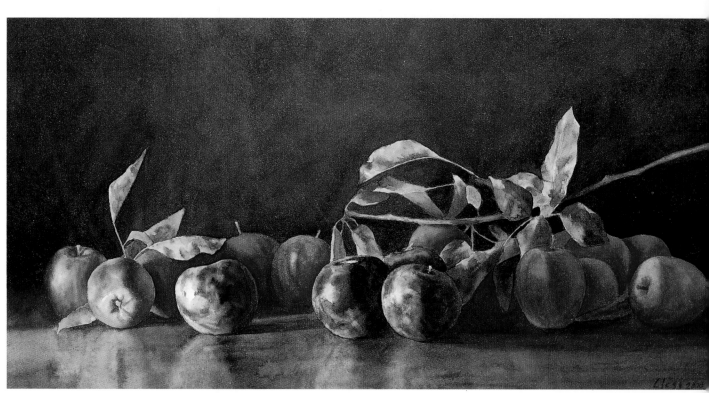

Black Plums With Windfalls
10" × 20" (25cm × 51cm)
Private collection

Autumn provides beautiful subjects: mountain ash berries contrast first with a green spray of leaves, then yellow and gold as they turn. Sumac leaves turn a glorious red. Apples, plums and pears are all interesting in shape and color. Friends provide me with intriguing fare, especially the Italian plums that are my favorite autumn subjects.

It's easy to just enjoy the autumn colors and fail to see how truly beautiful common things can be when you really study them. Walk through a park and pick up a few acorns and a handful of oak leaves. Cut a branch of honeysuckle berries or a cluster of mountain ash berries. Study a pumpkin and you'll see there's more to it than just orange.

As you take stock of the many subjects that autumn has to offer, think ahead to the winter, as well. Cut and dry autumn branches for later use. Many of the berries that are interesting fresh are also worth studying after they dry. Cut and save seed pods and silver dollars. Indian corn and gourds will be there waiting for you long after their availability is gone. Save a few spent sunflower heads; they're complex and beautiful.

NATURAL APPEAL

To really capture the true beauty of autumn, stay away from the grocery store aisles! The polished and waxed perfection you see there bears little relation to the real world. When you pick an apple or plum fresh off the tree you have something truly worth studying. Each has a dusky frost that gives way to a shining surface as you rub a finger across it. Take advantage of that!

As I arrange an autumn composition, I make sure to rub the fruit, making a surface gleam here, leaving it alone there. Remember, nothing is accidental in a good arrangement. Stage it and light it—and even rub it—selectively.

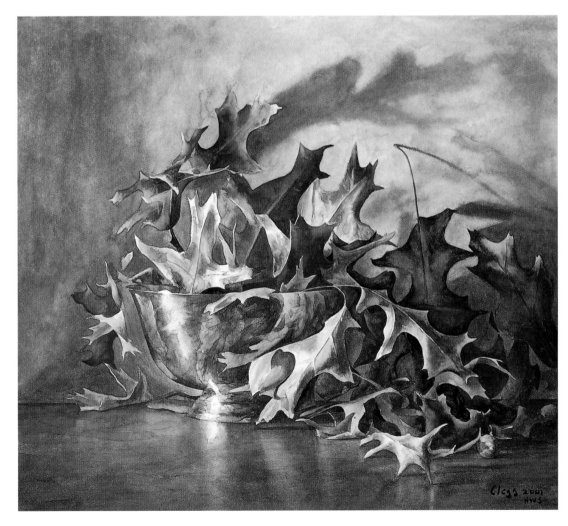

Leaf Dance
16" × 18" (41cm × 46cm)
Private collection

Choose an
Autumn Color Palette

As summer gives way to autumn, the eye's gaze moves upward, enjoying the foliage highlighted against a blue sky. The hot pinks of roses give way to a more understated warmth, comforting as squash soup on a cool evening. While an occasional note of pure red remains, earth tones are the hues I more often find myself using this time of year.

Quinacridone Gold

Quinacridone Burnt Orange

Burnt Sienna

Raw Sienna

Yellow Ochre

Five Favorite Earth Hues

All of the quinacridone pigments are clean, intense, transparent hues. Quinacridone Gold and Quinacridone Burnt Orange are the workhorses I rely on in all seasons, but in autumn the most. Autumn foliage is rarely a pure orange or red, and these two hues are just the right shift down from bright oranges and reds.

Burnt Sienna is muted by comparison, but it settles out nicely in washes, making for textural effects that require no work at all. And as the season progresses, "brown" becomes more of a force as the leaves lose their color. Burnt Sienna is a red that serves as a bridge to cooler hues. With a little blue it quickly becomes an earthy gray.

Raw Sienna and Yellow Ochre serve as the high and low notes of the season. Except in brightest light, I rarely need a yellow of more intensity than Yellow Ochre. Raw Sienna serves well for the shadow side of leaves and branches, and is useful in muting mixtures with too much purple or red in them. It also settles out beautifully, becoming an active partner in the painting process.

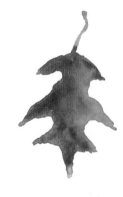
Raw Sienna and Yellow Ochre

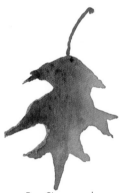
Burnt Sienna and Yellow Ochre

Leaf Appeal

Here are a few of the possibilities these colors offer. Raw Sienna and Yellow Ochre make a muted yellow passage, and the sienna settles out so nicely that you scarcely need to create any other detail. Burnt Sienna and Yellow Ochre combine for a nice gold, and the quinacridones are likely all the red you need. Finally, a melange of all five colors does a pretty good job of modeling objects in the light. Where shadow prevails, blues and purples enter the fray.

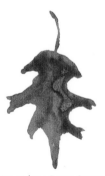
Quinacridone Burnt Orange and Quinacridone Gold

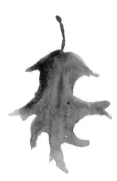
Raw Sienna, Yellow Ochre, Burnt Sienna, Quinacridone Burnt Orange and Quinacridone Gold

Quinacridone Burnt Orange and Phthalo Blue	Quinacridone Gold and Phthalo Blue	Burnt Sienna and Phthalo Blue	Raw Sienna and Phthalo Blue	Yellow Ochre and Phthalo Blue

Earthy Greens

While many artists go straight for their pure yellows when mixing greens, many other hues work well, especially when the green is not very bright. Autumn needs its share of green, too, and you can see that all of these hues, except Burnt Sienna, will combine with Phthalo Blue to mix a green.

Quinacridone Burnt Orange combines to make a green that's pretty near gray, but still recognizably leaning towards green. Quinacridone Gold mixes with the blue to make a clear, muted green. It's one of my favorite tube colors for mixing greens and I rely on it as much for that as I do for its nice golden hue. Burnt Sienna is the odd one out, making a gray that just won't turn green. Raw Sienna mixes with the blue to make a gray-green, still leaning to the green side, if only slightly. And Yellow Ochre, as you would expect, yields an earthy green that's okay, but a bit chalky compared with the one that Quinacridone Gold makes with the Phthalo Blue.

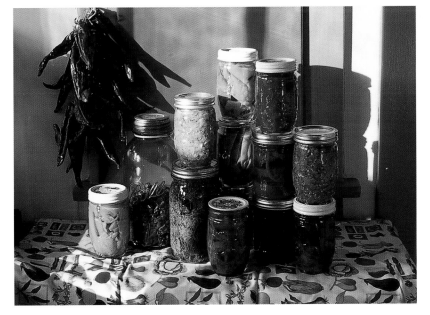

Preserve the Colors of the Season

Canning not only allows you to enjoy your autumn harvest throughout the year, but many of the jars echo the season's colors. You might want to paint a still life of salsa before eating it.

Design with
Abstract Interest

Some subjects, while perhaps also beautiful, interest me mainly for the abstract designs they offer. When I look at Indian corn, I mainly see its possibilities for controlling movement through the weave and flow of the shucks. I try to arrange it to best advantage, of course, but I don't believe I've ever painted it literally. I always move, make up,

ignore and otherwise reconstruct the shape of the shucks to move the eye where I want it to go.

In this painting, I tore off a shuck from another ear of corn to place diagonally across the red corn to break up an otherwise too boring, dark, hard-edged passage, and in several other areas I simply made up the shapes I wanted. The little strand moving from the right edge of the top ear of corn into the shucks above is an example.

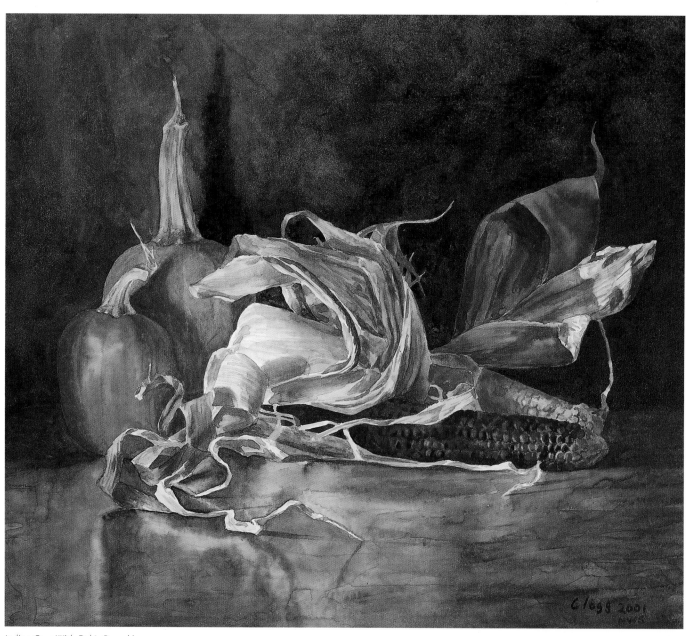

Indian Corn With Deb's Pumpkins
16" × 18" (41cm × 46cm)
Collection of the artist

Negative Shapes Are Key

If you are not continually aware of the impact negative shapes can provide your work, you might miss ready opportunities to increase the visual impact of your image. I think this is a particularly good example of negative shapes at work.

A The movement from a warm red-orange to a darker green-gray keeps the large "rest area" interesting. The vertical stem divides the large, negative shape at the top into a dominant area (right) and a subordinate area (left).

B All these interlocking negative shapes repeat each other in both shape and value and help to provide rhythm to the design.

C Without this stem intersecting the expanse to its left, the eye would be forced to circle within the shucks and pumpkins with no clear avenue into the negative space around it. Though the lost left edge of the smaller pumpkin helps, that in itself is not enough.

Simple Activity

This is a busy painting, what with the interwoven shucks and all, but the design is relatively simple. As the solid lines indicate, the overall movement within the image is provided by a large reverse **S** curve, balanced by a long diagonal that extends from the upper right shuck passing across the corn and ending just below the left pumpkin.

The dotted lines show just a few of the echoing curves and diagonals (sometimes both), but they really occur all over the painting. I don't think you can find a single shape that isn't repeated somewhere else. For instance, the tall pumpkin stem is repeated by the small, vertical shuck occupying a similar space opposite it. Looking at the arrows, you can see that some of these shapes also serve as "traffic police," telling you to move into and out of negative space, depending on which direction the eye is traveling.

MORE TEXTURE LESSONS WITH WINTER SQUASH

Materials list

PAPER | 80-lb. (170gsm) cold-pressed paper

PAINT | Cadmium Orange
Carbazole Violet
Gamboge • Nickel
Titanate Yellow
Ultramarine Blue
Yellow Ochre

BRUSHES | nos. 4 and 6
rounds • 1-inch
(25mm) flat

Squash are one of the easiest vegetables to grow. If you have a compost pile, throw a few of your favorite winter squash seeds in there and you'll be amazed at what might happen.

Though they aren't exactly pretty, squash are interesting enough when you start studying them—gnarly and knobby with intriguing patterns and colors. I have no idea what kind the pair pictured in the reference photo at right are—they were compost pile "volunteers" that came up on their own.

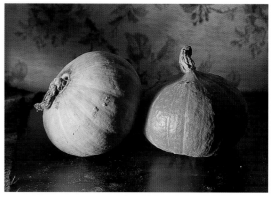

Reference Photo

1 Work Through Shapes

Combining steps when you can speeds up your work and challenges you to accomplish more in one stage than you might otherwise try.

Use a 1-inch (25mm) flat or a no. 4 round to apply a light orange wash over the squash and their reflections. Working wet-on-wet, use a mix of Yellow Ochre, Gamboge and Cadmium Orange for the lighter areas, keeping the colors somewhat separate so one or the other can dominate in a given area. Use a Cadmium Orange and Carbazole Violet mix for the darker shadows. Then use a clean, wet brush to draw in lines to begin indicating form.

2 Refine Shapes

Use small and medium rounds to repeat step 1, working around the light areas to build up the darks. Dry, then work wet-on-dry to paint the stems. Use Ultramarine Blue added to your orange mix for the dark sections. Dry, and then lift the upper edge of the left stem to better define it.

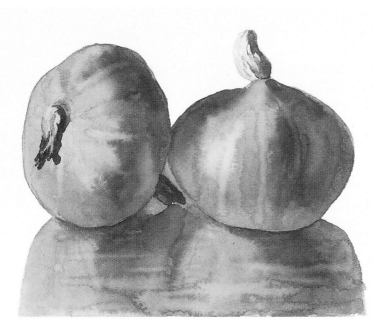

3 Give It a Seat

With less water, use your shadow mix from step 2 to paint the darkest shadows that "ground" the squash on the bottom, keeping them from floating on the page. Keep the wash going, adding more water to the mix as you model the lighter areas. Then use a brush loaded with clear water to drop in the horizontal lines that break up the reflection.

4 Final Touches

Use a clean, damp brush and paper towel to lift the reflected light areas at the bottom of the squash, as well as any of the veins that need more definition. Add a few dry strokes to the darker edges of the veins, if needed. To add texture, dip a small brush into your orange mix and flick it lightly with the tip of your finger over the squash. Finally, add a simple wash of Nickel Titanate Yellow with a little violet to the entire sheet around the squash. This will mute any stray flecks from your spattering and provide a simple border to the study.

FAST BUT GOOD

Cut an acorn squash in half and scoop out the seeds (good toasted). Place a pat of butter, a minced garlic clove, salt and pepper in the cavity. Top it with a round ball of country sausage. Bake, uncovered, at 350°F (177°C) until squash pierces easily, about an hour and a half (check after one hour). Let cool slightly, scoop flesh out, and serve with the sausage. Serves two.

demonstration
INDIAN CORN TEACHES A SECRET ABOUT SELECTION

Materials list

PAPER | 80-lb. (170gsm) cold-pressed paper

PAINT | Burnt Sienna
Cadmium Orange
Cadmium Red
Cadmium Yellow
Carbazole Violet
Gamboge · Indian Red
Naples Yellow · Nickel
Titanate Yellow
Quinacridone Burnt
Orange · Ultramarine
Blue

BRUSHES | nos. 4 and 6
rounds · 1-inch
(25mm) flat

One of the clear differences between painting and photography is the act of selection. As you can see, the photo at right records details of the individual kernels that would require enormous patience to paint—and wouldn't necessarily make for a good painting anyway: too boring and repetitious.

My main interest in Indian corn is the wonderful shapes of the husks. I nearly always change them for design reasons, introducing them into negative space to move the eye where I want it to go. Your main challenge with this subject should be to paint enough of the ear of corn to make it believable but not literal. At least it's a subject that holds still!

Reference Photo

SEEING SIMPLY

Indian corn is one of the most complex, detailed subjects you might ever try to paint. The husks are full of minute striations, curves and folds, and you can see each kernel of corn. The good news is that all these small shapes are part of larger ones, and squinting (as usual) helps to solve the problem. Squint as you look at the corn and you'll see it's mainly one big shape. The shucks are also large shapes with a few darker edges and shadows separating them from one another. If you draw and paint these large shapes and edges accurately, at a distance you'll clearly see Indian corn, without indicating a single kernel.

1 Get It Right, Right Away

Use your 1-inch (25mm) flat to apply a graded wash of Naples Yellow across the sheet, dark to light (from left to right), then dry it. Next, make little puddles on your palette of the reds, yellows and oranges, keeping them separate. Mix Ultramarine Blue with Burnt Sienna for another. All should be fairly concentrated; you can always add water.

Paint the corn with a light yellow wash, adding little drops of individual colors to begin to indicate kernels; meanwhile, apply a more diluted mix of the same colors and apply it to the reflection and table, using a big brush to spread it. Soften the edge of the wash. The corn should be only slightly moist by now; use your small round with the brown/blue mix to indicate the rows of corn. Apply additional small touches of all the colors to indicate more kernels. This approach requires you to work like greased lightning with an absolute control of the relative wetness of the paper. If it's too dry, the corn will have edges that don't soften, losing their suggestiveness. If too wet, they bleed entirely into each other, losing their detail. Use a no. 4 round for the small touches that develop the kernels.

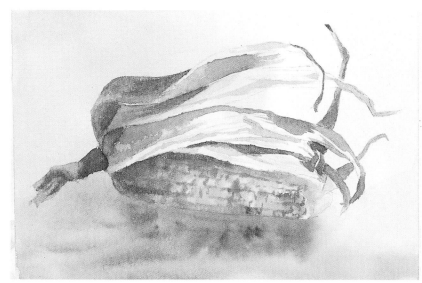

2 Develop Edges

The corn husks are cooler in some places, and warmer in others, depending on the degree of light and shadow. Paint these areas with two mixes: one with Burnt Sienna and Ultramarine Blue (with the blue dominating); mix the other with Naples Yellow and Carbazole Violet (use stronger yellow).

Paint the individual shadows, softening the edges where appropriate. Small strokes along the grain of the husks can indicate their texture. Dry the paper in between passages where hard edges meet. Use your no. 6 round where you can, switching to your no. 4 round where needed

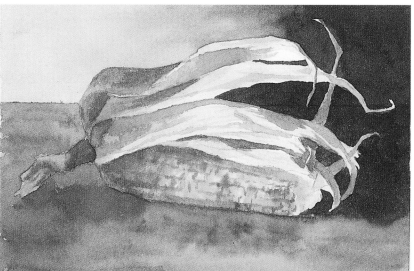

3 Work With Negative Shapes

Tone down the husks with a light Naples Yellow wash and let it dry. Mix a dark puddle of Indian Red, Ultramarine Blue and Gamboge. As you paint the shapes behind the husks, you'll see them pop out. As you move across the upper left, soften the edge into the yellow already there. Continue to the bottom edge of the corn, painting its cast shadow. Using the same brown/blue mix from step 1, paint the table to its edge on the upper left, adding the cast shadow under the lower left of the corn. Use your 1-inch flat (25mm) for large areas like the table.

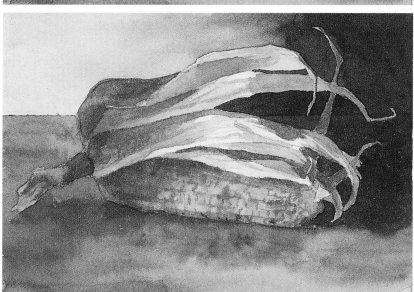

4 Subtle Accents

Paint a fairly strong Gamboge wash over the upper tabletop edge on the right, softening it as you move down. Then put an orange wash over the corn. While wet, add a wash mixed from orange, red, yellow and violet (a warm "mud" color) diagonally to the left side of the corn, creating a shadow. Finally, tone down the right tip of the corn and paint a few vertical strokes to indicate more kernels. The shadow on the corn creates a dominant/subordinate shape within it, and the Gamboge wash separates the table edge from the background, both small but important design elements.

Awe Inspiring
Autumn Splendor

As I've mentioned, sometimes my main attraction in painting a subject is its abstract appeal. However, there are also those paintings that are composed of things that are just extraordinarily beautiful. When I initially set this arrangement up, my overwhelming reaction was, "That's gorgeous." Subjects which generate that level of excitement and intensity generally turn out to be among my best works, and this one is no exception.

PLAYING WITH LIGHT

Bring the autumn sun indoors to show off your subjects. In this case, I wanted to showcase those flashy leaves. I also wanted to accent the light, so when the time came to paint the cast shadows from the leaves by the pitcher's handle, I had to move my light source as though they weren't casting a shadow. A small "cheat" made a huge difference in the feeling of light in the painting.

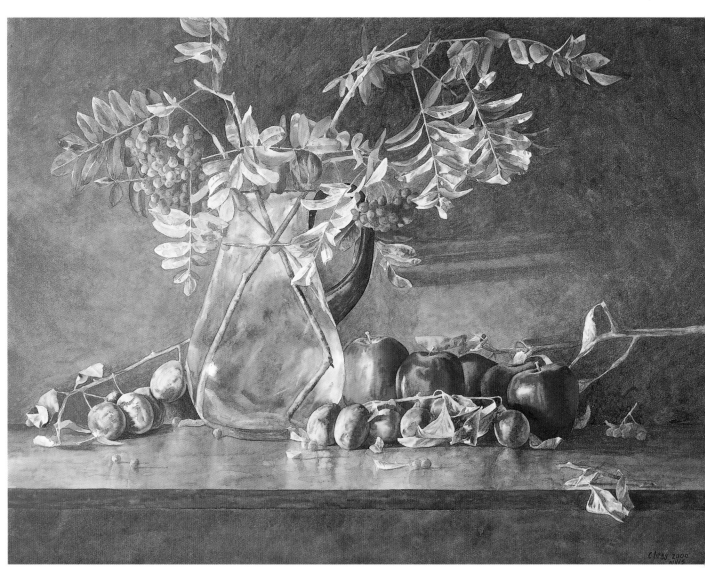

Mountain Ash With Greenbluff Plums
22" × 30" (56cm × 76cm)
Private collection

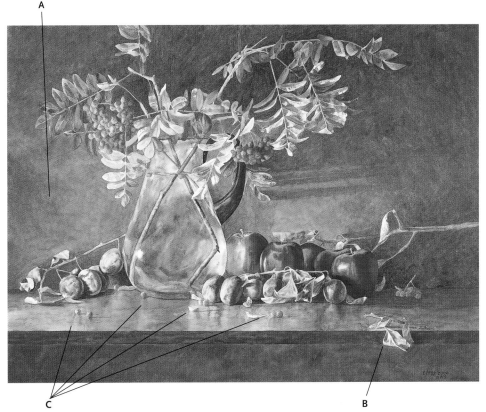

Quiet Complements

This is one of my favorite paintings, one that I think sings rather than shouts. As usual, composition was a main concern, but, after that, I just enjoyed painting these wonderful colors.

A The muted green-gray of the background is just enough to pop out the warm golds, oranges and reds in the foreground. Too much green and it would compete; too little and the painting would be bland.

B This small shape not only echoes the strong diagonal created by the branch and right side of the pitcher, it is very important for breaking the long horizontal edge of the shelf. Cover it up with your thumb and you'll see that the design isn't nearly as effective.

C These small accents are all but invisible when you squint, yet they play a vital role in moving the eye as well as echoing the golds and oranges from above.

Supporting Movements

Just as musical harmony is built on tone, so is a good painting. Here, the first note is the long horizontal of the shelf. Although there are a variety of ways to minimize its visual impact, I deliberately left a long expanse in order to set up the balancing echoes above it. All of the supporting horizontal notes are required or the rhythm is lost.

Supporting that movement is the strong skeleton of the well-placed pitcher and the *X* design that provides dynamic diagonals to offset the stability of all the horizontals. Finally, each branch of the mountain ash acts as a directional arrow, moving the eye through the composition.

PAINT DUSKY HUES WITH ITALIAN PLUMS

Materials list

PAPER | 80-lb. (170gsm) cold-pressed paper

PAINT | Cadmium Orange
Cadmium Red
Carbazole Violet
Cerulean Blue · Indian
Red · Nickel Titanate
Yellow · Ultramarine
Blue · Yellow Ochre

BRUSHES | nos. 4 and 6 rounds

Italian plums should be just about irresistible subjects for any artist. Their dusky, soft blue-gray contrasts with the purply reds that emerge when the plums are rubbed with your thumb. Like all kinds of small objects, they can be grouped and massed for minor or major notes in a composition.

Plums are best taken straight off the tree, with their gnarly branches and leaves. However, if you want to paint "fresh" leaves, plan to finish them the same day you cut the branches; by morning they'll look quite different!

Reference Photo

1 One Large Mass

Besides its design function, linked shapes often make the painting process easier. Mix a wash of Cerulean Blue and Carbazole Violet with a little Nickel Titanate Yellow to gray it. Apply it to all the shapes. While the wash is still wet, add a little Ultramarine Blue to the mix and drop it into areas that will be darker. You can also add a little Cadmium Red and Cadmium Orange. Lift the highlights with clear water if too much paint flows into them.

2 A Separate Shape

Since the plum on the right is separated from the others by a hard, light edge, paint it next. Wet the whole plum, then apply your light Cerulean Blue mix as needed for the lit side and a mix of Carbazole Violet, Ultramarine Blue and Indian Red for the darkest values. Lift as needed to save the lightest values. Working wet-on-wet like this is a matter of trial and error. Usually, after applying and lifting color, at some point the wash will look just right. Have a hair dryer ready at that point to fix the wash.

118

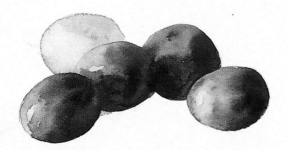

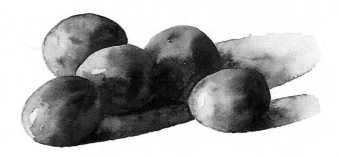

3 Linked Shadows

Repeat step 2, only this time work through all the shapes to paint the center three plums. Be careful not to use too much water, especially where defining the cast shadows on the second two plums. As the wash dries a bit, lift out any lighter areas. Dry it, then paint the last plum.

4 Cast Shadows

Use the dark plum mix to paint the shadows underneath the plums, reserving the darkest darks for just under the bottom edge of the plums. Remember that the bottom shadow has to connect on the other side of the lower right plum. It helps to draw a line through the plum, then erase it, to make sure the oval connects. Use your no. 4 round next to the bottom of the plums, and switch to a no. 6 as you move away.

5 Final Touches

Finally, add a little Yellow Ochre to your mix to paint the stems. Small wet-on-dry strokes indicate where the frost has rubbed off the plums. Soften some of these with clear water at the edges.

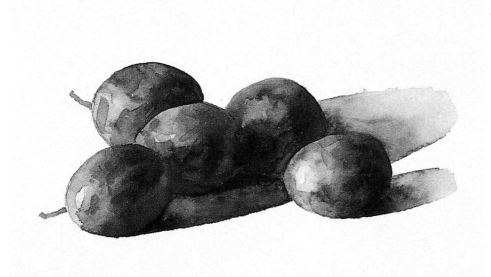

SIGNATURE DETAILS CREATE OAK LEAVES

Materials list

PAPER | 80-lb. (170gsm) cold-pressed paper

PAINT | Burnt Sienna
Cadmium Orange
Indian Red · Nickel
Titanate Yellow
Raw Sienna
Ultramarine Blue
Yellow Ochre

BRUSHES | nos. 4
and 6 rounds · 1-inch
(25mm) flat

Leaves are interesting, abstract shapes, and the only way to make them believable is to pay attention to their outside contours. It isn't really the amount of detail on the interior that makes a leaf look like a leaf, though a few "signature" details can help, like the stem and the vein running down the center.

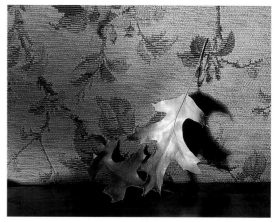

Reference Photo

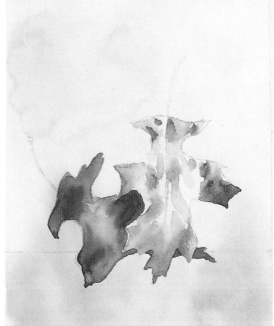

1 Local Color

Use your 1-inch (25mm) flat to cover the paper with a wash of Nickel Titanate Yellow and a little Burnt Sienna. This will establish the lightest areas on the leaf to the right. Next, pick up a bit more Burnt Sienna and a little Indian Red, and float it in to start the table surface. Let it bleed into the leaf on the left since it also contains that color.

2 Establish Small Edges

Much of the feel of leafiness comes from the little independent edges that occur as a leaf curves and changes form. Place small puddles of all of your colors on your palette, letting them run together a bit but keeping part of them pure, too. Place small, dry strokes all over the yellow leaf, establishing those little edge planes. While the paint is still wet, soften some edges if they need to run together, and drop darker pigment into spots that require it. Let the paint run. Repeat with the other leaf, this time with Cadmium Orange, Indian Red and Nickel Titanate Yellow. This leaf has softer edges, so let more of the color run together.

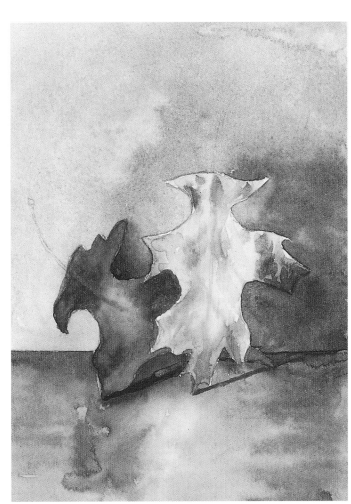

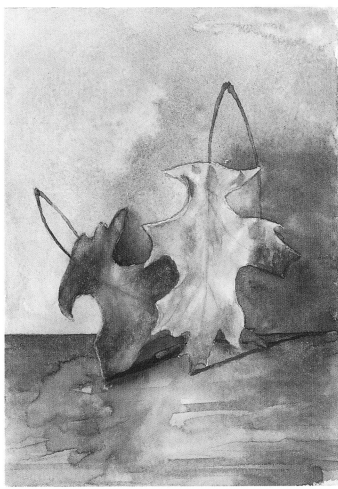

3 Start the Background

Using your 1-inch (25mm) flat, except where small edges meet, float in a melange of all your colors to start the tabletop. Use more yellow under the lighter leaf, redder elsewhere. Dry it and paint the wall with a graduated mix of Ultramarine Blue, Cadmium Orange and Nickel Titanate Yellow. The table should get darker and bluer as you move to the right. Use the red mix to paint the cast shadows under the leaves. Painting the negative shapes around the leaves begins to pop out the light values.

4 Telling Touches

Use a small brush and a dark red to paint the stems, being careful to keep them darker on the shadow side. With one stroke, using the orange/blue mix, paint the cast shadows. While wet, drop a little more color in closest to the stems, where the shadows are darkest. Lift out small lights on the leaves, then to give them more warmth, put a pure Cadmium Orange wash over the left leaf and Yellow Ochre over the other. Finally, a few wet-on-dry strokes enhance the shininess of the table.

demonstration

ORCHARD APPLES ARE NEVER ORDINARY

Materials list

PAPER | 80-lb. (170gsm) cold-pressed paper

PAINT | Burnt Sienna Cadmium Red Carbazole Violet Cerulean Blue Gamboge · Nickel Titanate Yellow · Raw Sienna · Ultramarine Blue · Yellow Ochre

BRUSHES | nos. 4 and 6 rounds · 1-inch (25mm) flat

When you look at the reference photo, you'll notice the huge difference between the orchard apples (foreground) and the ones from the store (background). Grocery apples are okay in a pinch, but their heavily waxed perfection looks fake. If you want to paint apples and have to use grocery fare, try at least to find unwaxed organic ones. Or wash off the wax with soap and let the apples sit on the counter for a week or so. They'll start to acquire that surface duskiness, and then you can selectively polish areas for eye appeal when painted. Apples may seem to be just generic shapes, but there is much more going on. Some apples are more rounded than others, some have more clearly defined "shoulders." Getting these subtleties right will help define the kind of apple you're painting.

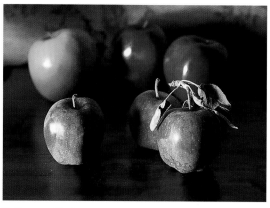

Reference Photo

1 Foundation Washes

Use your 1-inch (25mm) flat and quickly paint a light Nickel Titanate Yellow wash over the entire sheet. This establishes the color and value of the brightest highlights. Next, mix a wash from Nickel Titanate Yellow, Cadmium Red and Cerulean Blue, allowing the red to dominate in some areas and the blue in others. Apply that to all the apples, looking for areas where more red goes. Dry, and use a small brush to put a light yellow and Cerulean Blue wash on the leaves and a Burnt Sienna and yellow wash on the stems.

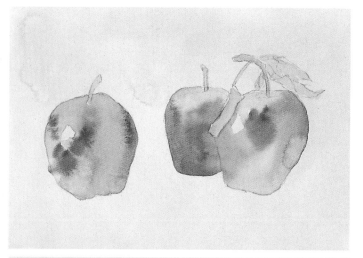

2 Establish Planes

Create separate puddles of the basic mix, adding blues and Raw Sienna in one and Cadmium Red and Ultramarine Blue in another. Working around the highlights and the stem cavities, apply a wash to each apple, utilizing some of each mix. The red is brighter where an apple has been rubbed. Pay attention also to how the apples lighten from top to bottom, picking up reflected light. Lift color from the light sides if needed, and drop in a little extra yellow if the reds spread too far. The darkest blue/red mix goes to the shadows on the right side of each apple.

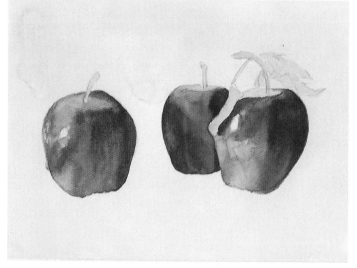

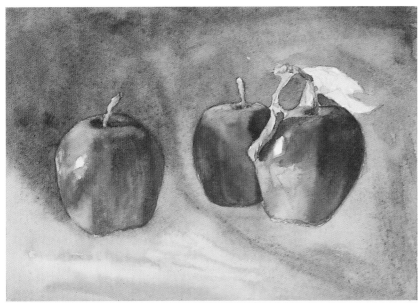

3 Model Apples and Start the Background

Use the same dark mix—mostly Ultramarine Blue, Cadmium Red and a little Raw Sienna—to paint the cavities of the apples. Soften the edges with a clean, damp brush. Paint the stems with clear water, then touch a Burnt Sienna/Ultramarine Blue mix to the right edges. It should soften and provide a transition to the light side. Use a mix of Ultramarine Blue and Gamboge to start the leaf in the light.

Next, mix Nickel Titanate Yellow, Gamboge, Yellow Ochre, Raw Sienna and Carbazole Violet. Apply a graded wash to the background, adding the darker colors as you go. Draw in a few strokes with clear water to suggest folds in the cloth.

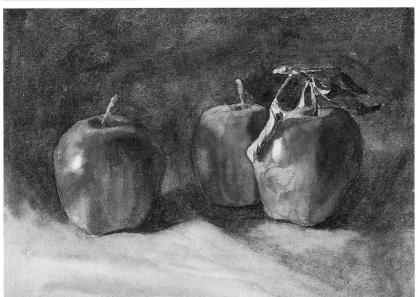

4 Cast Shadows, Final Touches

Use the background mix to paint the cast shadows under the apples and adjust the cloth folds. Even though the background just fades out, the cast shadows under the apples provide a place for them to rest. With an Ultramarine Blue and Gamboge mix, paint the dark leaves. Be careful of the light edges or they'll lose their form. Finally, adjust the apples by deepening the reds and lifting the lighter areas. Develop their characters with small, vertical strokes with a little yellow.

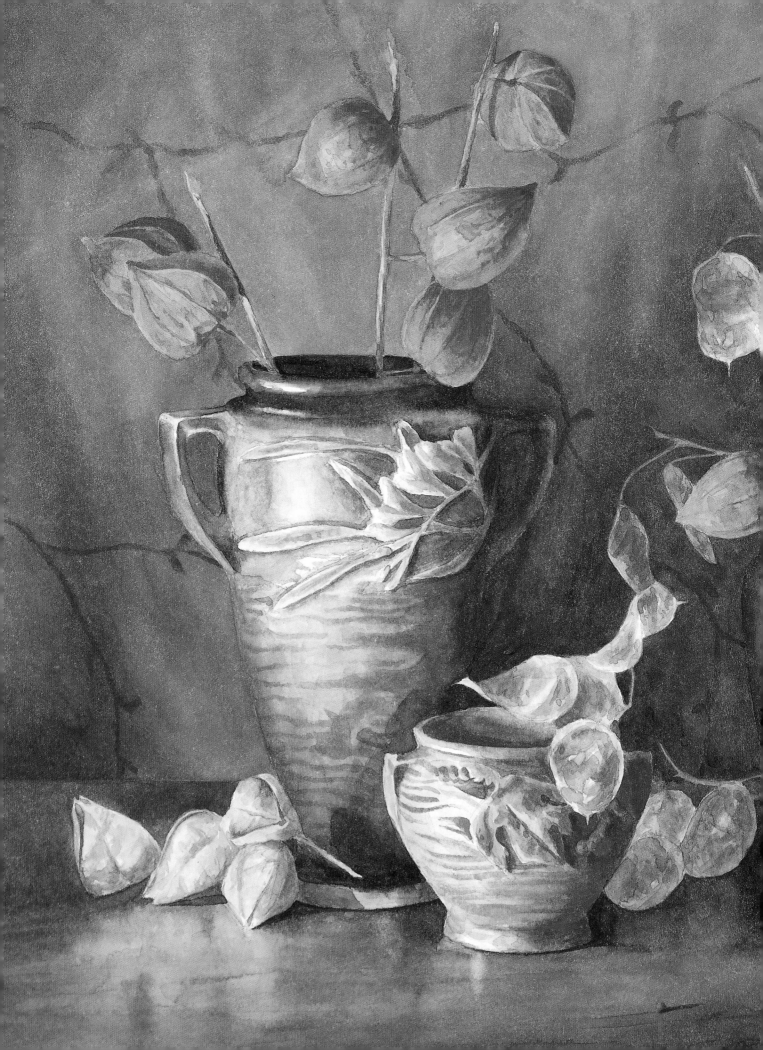

Putting it all together 6

No matter your skill level, you should attempt paintings that really challenge you, at least occasionally. The challenges can take different forms. For instance, try to do something in one hour rather than ten if your inclination is to paint slowly. Conversely, if you tend to paint fast, slow down and really study something.

 "Putting it all together" means different things to different artists, depending on their level of experience. Here are two fairly complex paintings, each approached differently, that describe how I painted them over a number of steps. You've already learned a bit about painting these subjects; now see what you can do yourself!

GRILLED GAZPACHO

I make this dish in midsummer, when everything comes from the garden. It's best after the flavors meld, so wait at least four hours before serving. I like to grill the evening before and finish it up the next morning.

Grilled items:
10-12 ripe medium tomatoes
2 medium onions
½ c. (120ml) olive oil

½ t. (3ml) kosher salt
1 summer squash, seeded (12- 16 oz. [336g-448g])
1 t. (5ml) fresh-cracked pepper

Raw items:
2 large, 1 small cucumber
2 small yellow crooknecks
18 cherry tomatoes
1 large ripe bell pepper
1 large paprika or Anaheim pepper
2 T (30ml) fresh chopped parsley

4 T. (60ml) fresh chopped basil
4-8 T (60ml-120ml) balsamic vinegar, to taste
4-12 dashes Tabasco, to taste
kosher salt, fresh cracked pepper, to taste
3-4 c. (720ml-960ml) chicken stock

Coat the veggies with oil, salt and pepper. Grill until soft and well browned. Save all the juices from the tomatoes and refrigerate overnight, or while prepping other ingredients.

Thinly slice the small cucumber and squash; quarter the cherry tomatoes. Roughly chop half of the peppers, reserving the rest.

Remove veggies from the refrigerator and puree in a blender, along with the large cucumbers and reserved peppers. Put everything into a large bowl, add stock (I prefer to use homemade stock) to desired consistency, and adjust seasonings. Serve well chilled.

Serves ten to twelve.

Rookwood and Roseville
16" × 18" (41cm × 46cm)
Private collection

demonstration
SUMMER'S FINALE

Materials List

PAPER | 80-lb. (170gsm) cold-pressed paper

PAINT | Azo Yellow · Burnt Sienna Cadmium Orange · Cadmium Red Cadmium Red Medium · Cadmium Yellow Light · Carbazole Violet Cerulean Blue · Gamboge · Indian Red Nickel Titanate Yellow · Phthalo Blue Quinacridone Burnt Orange Quinacridone Gold · Raw Sienna Ultramarine Blue · Yellow Ochre

BRUSHES | nos. 4, 6 and 12 rounds · ½-inch (13mm) and 1-inch (25mm) flats

When doing a large painting, go after the most changeable elements first. Do only the minimal amount of drawing absolutely necessary, but don't be sloppy about it. The initial line placing a vase, for instance, might not be symmetrical— but should still be of correct height, width and placement.

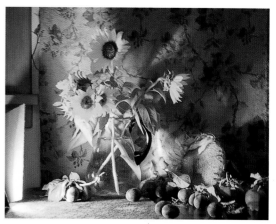

Reference Photo
At summer's end there is still a chance of finding strong flower growth. Long-lasting flowers and fruits from the orchard combine to produce the feeling of summer's last warm rays.

1 Complete a Drawing
This line drawing is shown darker here than what I would generally use when completing this painting. Follow this drawing as a guide as you paint the coming steps, but make your drawing lighter.

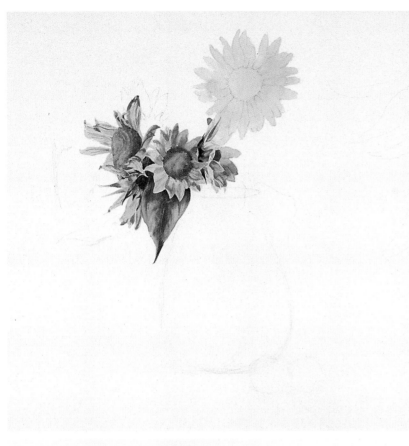

2 Start With the Flowers in the Vase

Mix a graded wash using Cadmium Orange, Nickel Titanate Yellow, Azo Yellow, Cadmium Yellow Light, Gamboge, Yellow Ochre and Carbazole Violet. These are the colors needed for the sunflower petals and interior.

Paint a foundation wash of Nickel Titanate Yellow over both the sunflowers and leaves and let dry. Use the yellow mix from above—adding more Yellow Ochre, a little Quinacridone Gold, but use less Carbazole Violet—start working from petal to petal. Use your no. 12 round brush as much as possible, switching to smaller as necessary. Move from petal to petal, working wet-on-dry, softening edges as needed. Make sure to dry any sharp edges between the petals, but many of them can run together. You don't need to paint every petal separately.

Paint the centers of the two flowers on the left wet-on-wet with your no. 12 round and a mix of Yellow Ochre, Gamboge and Carbazole Violet. Lift color if it bleeds into the light areas.

Using your no. 12 round and a mix of Phthalo Blue, Azo Yellow, Gamboge and Ultramarine Blue on the leaves, working wet-on-wet. Lift out lighter veins and accents after the wash dries.

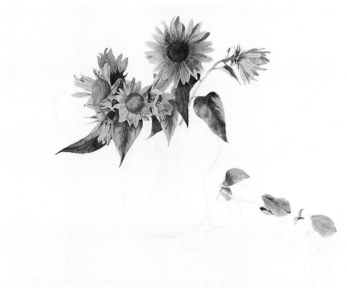

3 Extend the Movement

Repeat the same process from the previous step to continue the flowers and leaves in the vase. Vary the values of your washes to give light and shadow to each petal and leaf.

Add Raw Sienna to the yellow mix from step 2 to paint the dark center of the upper sunflower. Continue painting all the leaves wet-on-wet with the green mix from step 2. Use you r no. 12 round, switching to a smaller brush as necessary.

4 Link Shapes

Finish the plum leaves with your green mixture, carefully working around any light edges.

Start the cluster of plums with an initial wash of Cerulean Blue, Carbazole Violet and a little Nickel Titanate Yellow, working through all the shapes. After it's dry, work separately from plum to plum with a darker wet-on-wet wash of the same colors, establishing the shadow sides of them. With the addition of a little Indian Red to that dark mix, paint the dark accents of the plums wet-on-dry softening the edges where needed.

Use a mix of Burnt Sienna, Nickel Titanate Yellow and a little Carbazole Violet to paint the plum stems wet-on-wet using your no. 4 round.

Paint the sunflower stems wet-on-wet with the green mix from step 2 plus a little more Cerulean Blue and Nickel Titanate Yellow. Use your no. 12 round. Since the water's surface mainly reflects the sunflowers' leaves, use the same green to paint it.

Something needs to fill the space to the right of the vase. A large spent sunflower should work nicely. Draw it on a piece of tracing paper and lightly tape it to the surface. This visual aid will help you decide if the that this idea works well or not.

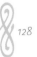

128

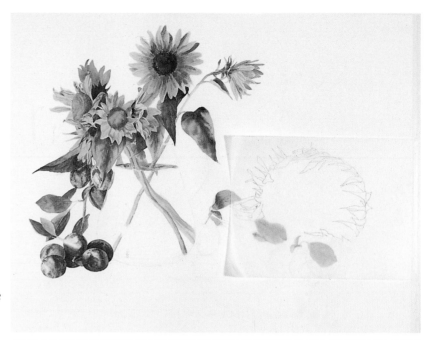

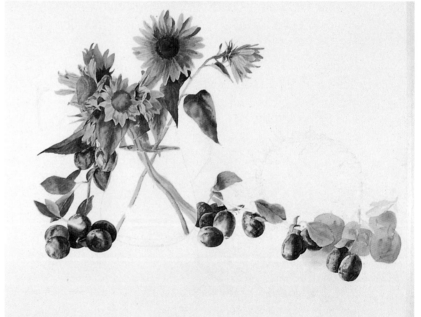

5 Develop the Plums and Apples

Finish painting the plums while you still have all the right pigments on your palette.

Then, mix a puddle of Nickel Titanate Yellow, Cadmium Red and a little Cerulean Blue and lay in a first wash over the apples. Work through the shapes, but pay attention to areas that will remain lighter. Lift color if needed.

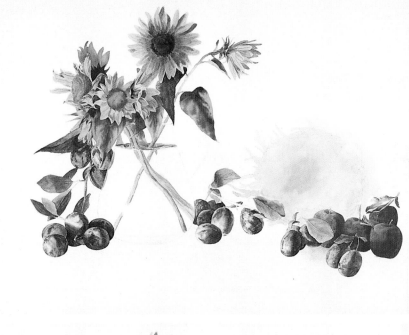

6 Make Use of Complementary Color

Complete the apples with the mix from step 5, adding Ultramarine Blue and Cadmium Red Medium for the darkest areas. Paint each apple wet-on-wet, allowing edges to merge where values are the same. The apple on the lower right should be the only one that really stands out by itself. Run the others' edges together a bit and soften them.

Use a little of the Yellow Ochre and Burnt Sienna for the stems, and the same green as the other leaves for the apple leaves.

Paint the apple cores separately with the apple mix, using more Ultramarine Blue to darken it (only if necessary). Soften the edges that indicate the curve of the apple.

Apply a foundation wash to the large sunflower with a light yellow wash using Yellow Ochre, Nickel Titanate Yellow and a little Gamboge with your 1-inch flat (25mm).

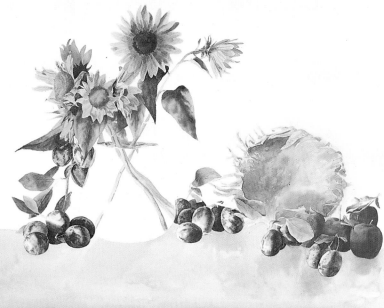

7 Work on Balancing Shapes

To develop the large sunflower, use the same approach as for the other sunflowers to paint the outer petals, then start the interior with a wet-on-wet wash, working around any lighter petals. You will use the same mix—but add a little more Gamboge and Carbazole Violet to the mix, and use less of Azo Yellow and Cadmium Yellow Light—to achieve the dried-out look of the large sunflower. Notice how the flower not only adds interest to the negative space it occupies, but it also echoes the rounded bottom of the vase.

Use your largest brush to apply a light yellow wash of Nickel Titanate Yellow, Gamboge, and a little Carbazole Violet over the entire foreground cloth. Add a little Ultramarine Blue and Indian Red to the mix to start the table, and use your plum mix to start their reflections.

8 Begin the Background

Continue to refine the center of the sunflower, working around the small, wilted, spiky leaves on the right side. To help develop the seed head's texture, apply intermittent strokes of a mix of Gamboge, Carbazole Violet and Raw Sienna and small strokes of clean water, which will add and displace pigment. Any "accidental" drips and runs will just help its appearance from a bit of a distance.

Mix a large puddle of Nickel Titanate Yellow, Gamboge, Indian Red, Quinacridone Burnt Orange and a little Ultramarine Blue. Use the largest brush you can to start the background, switching to smaller rounds when needed to work around petals, etc. Don't worry if it's not completely even; additional washes will take care of that.

Use the same mix as in step 7 to continue the tabletop, switching to your plum mix to refine their reflections.

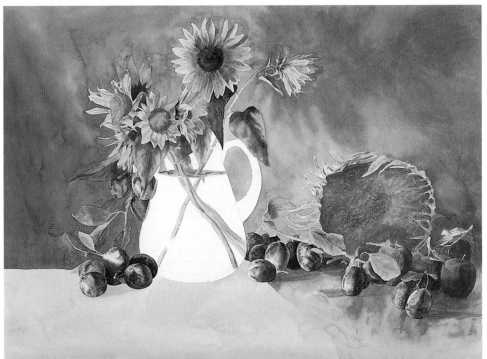

9 Develop the Background

Continue to develop the background, applying washes to build up the dark value on the left especially. The washes should include more of the red/blue on the left and more of the yellows on the right, which will help to create a more interesting warm/cool temperature change, as well as a difference in value. As the washes build, your repeated brushstrokes should begin evening out the color.

10 Adjust Shadows and Develop the Foreground

Use your darkest sunflower mix to paint over its right side, lifting and adding darker accents to adjust the small, wilted leaves.

Use your background mix to further tone down the whole background to the right of the vase.

Use a large, flat brush to develop the tablecloth's surface. Use the background mix with the addition of Quinacridone Gold and only a little of the blue. As you apply the washes, scrub the paper vigorously with your brush. This will raise the nap of the paper a bit, helping to suggest the cloth's texture. Between washes, on dry paper, scrub a wet brush and blot with paper towels to suggest folds on the cloth.

Then use the background mix, with more of the red and blue, to further develop the table and its darker edge, painting over the reflections.

Get a jump on the next step, and use your plum mix to paint their reflections on the vase.

11 Work on the Vase and Water

Using the same mixtures as in previous steps for each area, continue the cloth and table, refining them to near finished states.

Since water in a clear vase is essentially the same color and value as its background, it helps to have finished the background before working on the vase. Add light washes of background color to the vase, work around any highlights on the vase. Paint each area of the vase separately, using a combination of wet or dry strokes to develop reflections, etc. Add blue and purple to the background mix to add reflective color to the base of the vase.

The small oval of the water's surface is very important, especially the water's edge; lighter on top with a dark edge underneath. Use a mixture of Ultramarine Blue and Carbazole Violet to paint the handle, working around and lifting highlights.

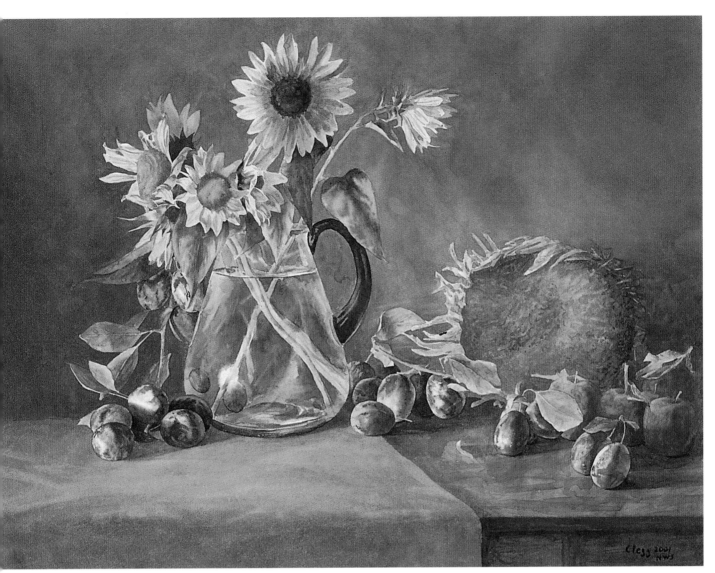

12 Model the Vase and Add Final Details

Refine the surface of the glass by lifting small strokes here and there, where reflections occur. Deepen the darker values using your same background mix. Finish the base of the vase with wet-on-dry strokes using the same colors from step 11.

The last 10 percent of a painting is always the most important. Use your cloth and tabletop mixtures to paint the cast shadows from the plums, making sure to anchor them with darker values directly underneath. Small wet-on-dry strokes enhance the reflective surface of the table.

At this point in a painting, forget about what you necessarily see and only think of what the painting needs. If the vase still doesn't seem reflective enough, you may want to both add dry strokes and lift others to adjust it until it feels right. Finish other small details, such as twigs, stems, and the plums' reflection on the vase, if you've missed them up to this point.

Last of the Sunflowers
22" × 30" (56cm × 76cm)
Private collection

demonstration

WINTER'S BEAUTY

Materials List

PAPER | 80-lb. (170gsm)
cold-pressed paper

PAINT | Cadmium Orange · Cadmium
Red Light · Cadmium Yellow Light
Carbazole Violet · Cerulean Blue
Gamboge · Indian Red · Naples Yellow
Nickel Titanate Yellow · Phthalo Blue
Quinacridone Gold · Raw Sienna
Ultramarine Blue · Yellow Ochre

BRUSHES | nos. 4, 6 and 12 rounds
½-inch (13mm) and 1-inch (25mm) flats

Subjects like this are worlds apart from the previous painting's changeable fare. Everything in this type of arrangement will stay just the way it is—no matter how long it takes to paint—so your approach can be a bit different, from starting with a complete drawing to developing everything at more or less the same time. With everything in its place, there's no need to worry about what goes where!

Reference Photo
For this commissioned painting, the clients wanted to include a few of their antique pottery vases—we chose two Roseville vases on the left and the Rookwood piece to the right. Since the commission occurred during the winter, I complemented it with some of my usual seasonal fare—dried seed pods, Chinese lanterns and silver dollars.

134

1 Establish a Good Foundation

No matter your style, a good drawing is essential to your eventual success—if you can't draw it well you won't paint it well, either! Try to work out the particulars before starting. If you compare this drawing to the reference photo, you'll see that I eliminated some of the Chinese lanterns and changed the placement of others. Just because it's really there doesn't mean you have to paint it in! You should always think of where an object will best suit the dictates of good design.

When you have the opportunity to complete a finished drawing before beginning to paint, take full advantage by seeing how the shapes vary in size, and echo and balance each other. If it doesn't look good at this stage it probably won't later on, either! Make sure the design is good and take the time to do the best drawing you can. The finished work will benefit from the care you take right from the beginning.

2 Establish Lightest Values

When there's no pressing reason to paint something first, a good practice is to work from light to dark, developing the overall image. By working on the image as a whole you can constantly compare relative values, and by building them at more or less the same time you also eliminate the possibility of bleeding colors by touching a dark edge with your brush while painting a lighter area next to it.

Prepare separate puddles of Carbazole Violet and Nickel Titanate Yellow; Carbazole Violet, Raw Sienna and Nickel Titanate Yellow; and Cadmium Orange, Ultramarine Blue and Nickel Titanate Yellow. Allow colors to remain somewhat unmixed so you can vary them as needed. Start with a no. 6 round brush and paint the stems of the silver dollars and Chinese lanterns with Nickel Titanate Yellow and a little Carbazole Violet. Don't worry about staying in the lines; the background will be much darker. Start the flowers on the large vase using touches from each of the separate puddles as needed.

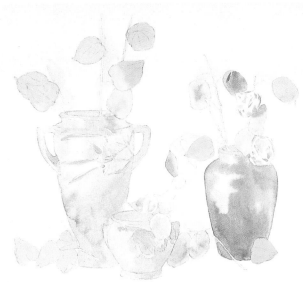

3 Toning Down

Use the largest brush you can for the broad passages, switching to a no. 4 round where smaller edges meet. Mix Nickel Titanate Yellow with a little Gamboge and wash it over the Chinese lanterns and the berries on the small vase. Mix Nickel Titanate Yellow with a little Cerulean Blue and paint the green leaves on the small vase, working around the highlights. Add a little Naples Yellow to Carbazole Violet and Nickel Titanate Yellow and apply over the seed pods to the left of the large vase.

Next, mix a big wash with Carbazole Violet, Cerulean Blue and Nickel Titanate Yellow, and apply to vases on left, working around the highlights. Add a little Ultramarine Blue to the mix and wash over the Rookwood vase on the right, lifting highlights if they bleed.

4 Begin the Cloth Background

Draw a horizontal pencil line to indicate the table edge. Mix a big wash of Cadmium Orange, Yellow Ochre, Carbazole Violet and Nickel Titanate Yellow to make a warm, grayed orange. Use a 1-inch (25mm) flat brush when you can and a no. 4 or no. 6 round to paint around the smaller negative spaces. Apply it to the entire background, not worrying about drips, runs, etc. Not only are they unimportant right now, but they often are helpful later on in suggesting folds in the cloth backdrop.

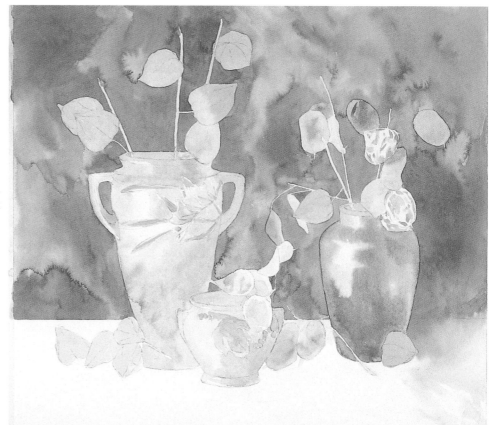

136

5 Develop Values

Begin to refine the silver dollars. Mix a darker version of your silver dollar wash from step 2, using more Raw Sienna and Carbazole Violet. Mix a dark gray from Cadmium Orange, Ultramarine Blue and Nickel Titanate Yellow, leaving it partly unmixed. Use this mix to supplement your silver dollar mix, darkening some of the silver dollars to push them back into space. Continue to define details of the silver dollars and flowers on the tall vase, using no. 4 and no. 6 rounds.

Add Phthalo Blue, Ultramarine Blue, Cadmium Yellow Light and Gamboge to the green leaf mix from step 3 and use various mixtures from these colors to refine the leaves.

Then mix a wash of Gamboge and Cadmium Orange to develop the Chinese lanterns. Add this Chinese lantern mix and Naples Yellow to the green leaf mix to develop the seedpods to the left of the large vase.

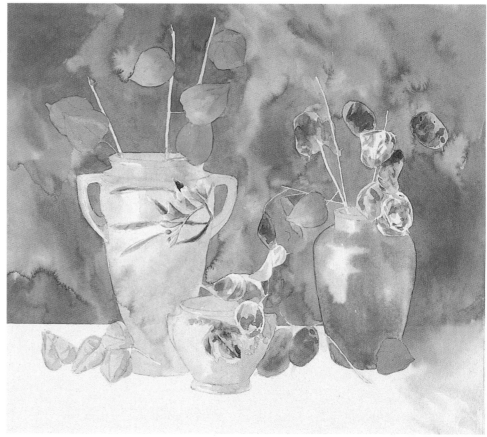

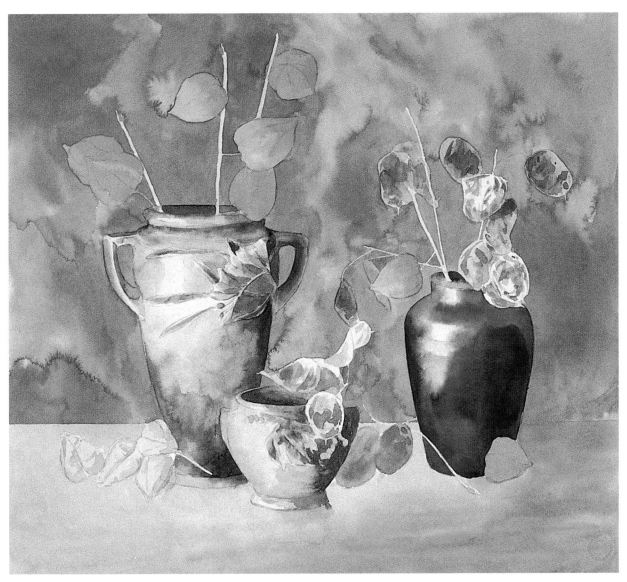

6 Begin the Foreground

Use a 1-inch (25mm) flat and smaller brushes if needed to begin the foreground with your Chinese lantern mix and a little extra Nickel Titanate Yellow on the left. Add Indian Red to the mix as you work to the right, which is more in shadow.

Mix a graded wash (see page 16) with Cerulean Blue and Ultramarine Blue. Mix another wash of the same colors and gray it with Cadmium Orange. Use these mixes to model the large vase, adding touches of the Chinese lantern mix as reflected color. Add a little Nickel Titanate Yellow to the mix as you work on the small vase, and add more Ultramarine Blue and Carbazole Violet to the same mix to further darken the Rookwood vase on the right.

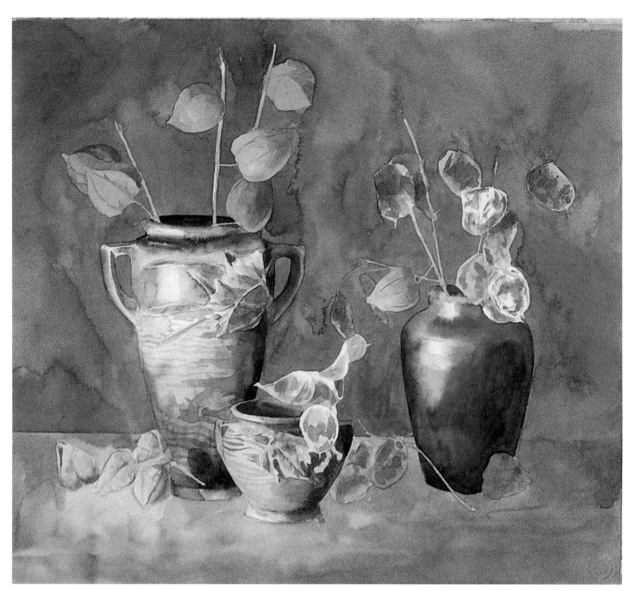

7 Work on Reflections

To develop the reflections on the vases, use the previous mixes to refine the patterns, softening edges, darkening shadows and drying between washes as needed.

To begin the reflections of the objects on the tabletop, you'll need some of all of their colors. Mix a melange of color, including the vase and seed pod mixes, plus one of Gamboge, Cadmium Orange and a little Ultramarine Blue. Mix another one with Indian Red and Ultramarine Blue. Paint the foreground with clear water, and apply the mixes to the tabletop, letting them flow together and blotting or lifting where needed if the darks run into lighter passages.

Develop the structure of the Chinese lanterns, working around highlights and rib edges that stand out. Add a little Cadmium Red Light and Carbazole Violet to the Chinese Lantern mix for the darks.

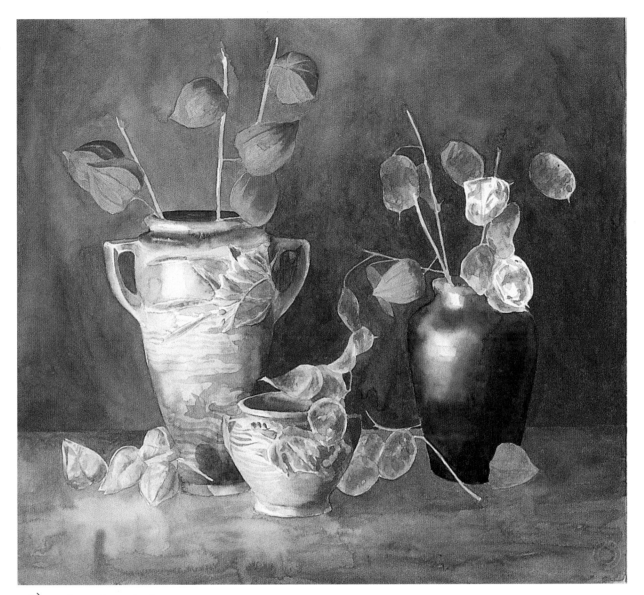

8 Develop Values Further

Model the silver dollars using the same mix for the silver dollar stems from step 2, pushing the darker ones back into space and adding small details to all of them. Darken the green leaf mix with Ultramarine Blue and a little Carbazole Violet to darken the seedpods. Add Indian Red with a touch of Carbazole Violet for the berries on the smallest vase. Tone down all of the stems with Nickel Titanate Yellow and a little Carbazole Violet, adding a little green for the Chinese lantern stems.

Develop the darks in the background. This will enable you to more accurately judge which foreground objects look right and which still need to be darkened. Mix a background wash with Yellow Ochre, Cadmium Orange and Carbazole Violet, with Nickel Titanate Yellow added to part. Gradually build up the background values, switching from your 1-inch (25mm) flat to smaller brushes as needed, softening the edges as you go, and drying anytime you need a dry area to rest your hand on.

Tone down the Chinese lanterns using washes of previous Chinese lantern color mixes. They should blend into the background when you squint your eyes. Continue building values on the seedpods, and model more darks on the patterns of the vases.

Darken the foreground by mixing small quantities of vase and seedpod colors, moving from the left with Gamboge and Nickel Titanate Yellow to the right with Indian Red and Ultramarine Blue.

Darken the vase on the right, lifting around the highlight as needed.

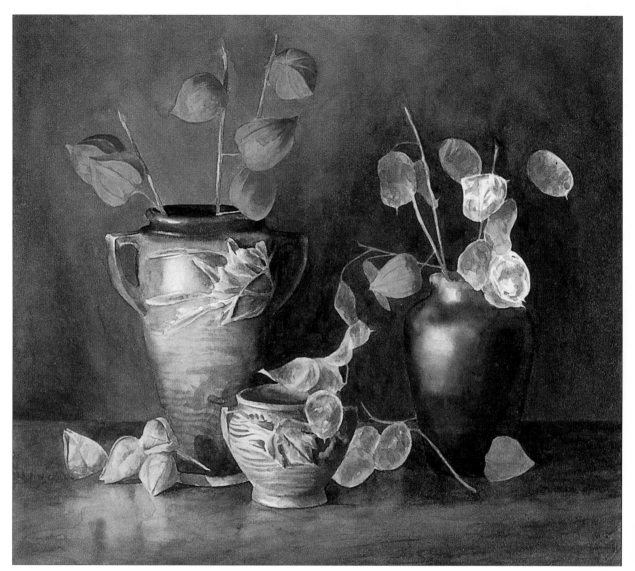

9 Check Your Temperature

The darks of the background still need to be deepened. Mix a saturated wash of Yellow Ochre, Cadmium Orange, Gamboge, Carbazole Violet and Raw Sienna, and deepen the values on the lower diagonal of the background. The background has been built entirely with the same mixes so far, and bringing a subtle warm-to-cool transition into it will help it enormously. Mix a large wash of Cadmium Orange, Gamboge, Nickel Titanate Yellow and a little Carbazole Violet. Apply it to the upper diagonal section, using a 1-inch (25mm) flat whenever possible. Brush some of it into the darks, as well, for a soft transition.

Use your previous mixes to darken the Roseville vases, adding Naples Yellow to the mix for the tall vase, where the blue is slightly grayed out. As you darken the shadow sides to blend into the background, add a little Cadmium Orange to the mix.

Anchor the foreground objects with your previous mix, adding a little more Indian Red and Ultramarine Blue to paint their shadows. Bring the seedpods to near completion. Some stems still stand out too much. Use a mix of Cerulean Blue, Carbazole Violet and Nickel Titanate Yellow, keeping each somewhat separate, to darken the stems, pushing some further into shadow.

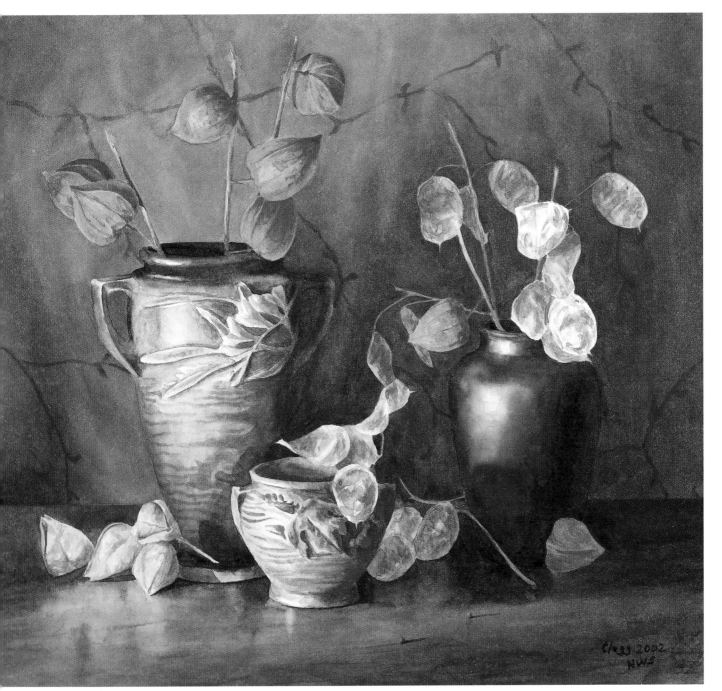

10 Turn the Background Into Cloth

Use whatever old brush you like, and brush back and forth to lift areas with a little water, raising the nap of the paper. Next, lift color with a paper towel, establishing lit areas of the fabric. Mix a light wash of Nickel Titanate Yellow, Naples Yellow, a little Gamboge and a little Quinacridone Gold, and apply it wet-on-dry over the lifted lights of the cloth. Blend it slightly into the darks. Repeat this several times to establish the movement from warm to cool in the cloth.

Using your previous mixes, take care of unfinished areas, particularly the neck of the vase on the right, the lower right Chinese lantern, and the small details of the stems, silver dollars and patterns of the vases.

Use your Chinese lantern mix to paint a couple of small bittersweet berries in the foreground, including their shadows.

Mix a wash from Gamboge, Nickel Titanate Yellow, Carbazole Violet, Indian Red and a little Cadmium Red Light and use it to paint a faint branch and leaf pattern on the cloth.

Finally, with your foreground mix, lay a series of wet-on-dry strokes over the foreground, drying between each layer. Use a lot of additional Nickel Titanate Yellow and Gamboge in the mix to help warm the foreground, helping to relate it with the warmth of the Chinese lanterns. You're done!

Rookwood and Roseville
16" × 18" (41cm × 46cm)
Private collection

Index

More great watercolor instruction
from North Light Books!

Take advantage of the transparent, fluid qualities of watercolor to create startling works of art that glow with color and light! Jan Fabian Wallake shows you how to master special pouring techniques that allow pigments to run free across the paper. There's no need to worry about losing control or making mistakes. Wallake empowers you to trust your instincts and create glazes rich in depth and luminosity.

ISBN 1-58180-487-3, PAPERBACK, 128 PAGES, #32825-K

Create your own artist's journal and capture those fleeting moments of inspiration and beauty! Erin O'Toole's friendly, fun-to-read advice makes getting started easy. You'll learn how to observe and record what you see, compose images that come alive with color and movement, and make a travel kit for creating art anywhere, at any time.

ISBN 1-58180-170-X, HARDCOVER, 128 PAGES, #31921-K

Packed with insights, tips and advice, Watercolor Wisdom is a virtual master class in watercolor painting. Jo Taylor illustrates every important technique with examples, sketches and demonstrations, covering everything from brush selection and composition to color mixing and light. You'll learn how to find your personal style, work emotion into your work, understand and create abstract art and more.

ISBN 1-58180-240-4, HARDCOVER, 176 PAGES, #32018-K

Here's all the instruction you need to create beautiful, luminous paintings by layering with watercolor. Linda Stevens Moyer provides straightforward techniques, step-by-step mini-demos and must-have advice on color theory and the basics of painting light and texture-the individual parts that make up the "language of light."

ISBN 1-58180-189-0, HARDCOVER, 128 PAGES, #31961-K